The Video Activist Handbook

Thomas Harding

The Video Activist Handbook

Pluto Press
LONDON • CHICAGO, ILLINOIS

First published 1997 by Pluto Press
345 Archway Road, London N6 5AA
and 1436 West Randolph, Chicago, Illinois 60607, USA

British Library Cataloguing-in-Publication Data
A catalogue record for this book is available from
the British Library

ISBN 0 7453 1174 1 hbk

Library of Congress Cataloging in Publication Data
is available from the Library of Congress

Designed and produced for Pluto Press by
Chase Production Services, Chadlington, Oxford, OX7 3LN
Typeset from disk by Stanford DTP Services, Northampton
Printed in Great Britain

Contents

Acknowledgements

A big yip goes to all those brave enough to wade through my various drafts, and who helped get the text in order, in particular: George Marshall, Oliver Tickell, Tim Lewis, Carla Lesche, Enda Murray, Richard Herring, Amanda Harding, Helen Denham, Gerbrand Oudenaarden, Neil Pike and Lydia Dagostino.

Many thanks to Belinda Salmon Harding for her brilliant illustrations, to Paul O'Connor, Nick Cobbing, Adrian Arbib, Gary Essex, Adrian Short, Greenpeace Communications and Diane Neumaeier, the photographers who contributed their work to the book, and to all those who wrote a 'profile' for the book: Roddy Mansfield, Sukanya Pillay, Catherine Wheeler, Kevin Doye, Velcrow Ripper and Heather Frise, Joey Manley, Gloria Walker and Mel Gunasena. Thanks also to Jane Turner of *Ethical Consumer*, and to Ben Rogers and Craig Bennet of the Environmental Investigation Agency.

Thanks especially to Pops Yashimoto for his ideas for the 'Screening strategies' section in Chapter 10. In his notes he wrote, 'These are the screening secrets of the Headcleaner Posse amassed through painful experience of screenings, video happenings and dodgy raves in warehouses and fields from Wolverhampton to Woollomolloo. Guard them with your life!'

Much respect to all who have contributed to **under**currents over the years. In particular, Zoë Broughton, Ted Oakes, Jamie Hartzell, Kevin Doye, Simon Steven, George Marshall, Shanti Prava, Gary Essex, Sanri Kenner, Dillon Howitt, Roddy Mansfield, Corrie Cheyne, Correy Vest, Ceri Fielding, Hazel Fairbrother, Sri Gunasena, Luke Winsbury and Hugh Warwick.

A special thanks to Carey Newson who helped initiate the project all that time ago.

More thanks to Anne Beech, Robert Webb, Emma Waghorn, and all the staff at Pluto for doing such a good job. (Let's get Time Warner to back this one!)

A huge smack on the smackeroos to Paul O'Connor, my comrade-in-charms, who has always been there when he needed to be, and without whom **under**_currents_ would not be around today.

A huge 'That's incredible!' to my sister Moo, with whom I started all this silly video stuff, to my parents, who have always supported me in my work, and to my grandmother Elsie Harding, who provided the funds to enable me to carry out the research in the USA and Australia for this book.

And of course, the biggest yip of all goes to Debora Cackler, my wonderful wife, who encouraged me to spend three months away from home to research this book, who helped edit it once written, who has always supported **under**_currents_, and without whom I would not be possible.

Thomas Harding

Preface

My disillusionment with mainstream television came to a head in Rio at the Earth Summit. From there it was a helter-skelter ride that concluded with my falling in love with a camcorder and working full time as a grassroots video activist.

In June 1992, I travelled to Brazil to take part in the UN Conference on Environment and Development (UNCED), or Earth Summit as it was commonly known. My trip was paid for by the Television Trust for the Environment (TVE), who I'd been working with for two years as a researcher on television documentaries. I had just completed a contract as Associate Producer on *Rainbow Reports* – a series that was shown on the BBC and 100 other broadcast channels around the world. It was time for a break.

In Rio, I joined up with a bunch of international youth delegates who were fed up with the lack of progress at the Summit. When George Bush said that 'the American way of life is not up for negotiation', we decided it was time for action.

On the last day of the Summit, fifty of us entered the conference centre, walked to a patch of grass in the centre of the building, sat down, linked arms and denounced the entire proceedings as a 'sham'. Journalists and police soon swarmed around, jostling to see who could get to us first. Three guards grabbed my arms and carried me away. Just as I was being taken out of the public area a familiar face appeared above mine and said 'Thomas, what are you doing? We were looking all over for you!' It was my boss from TVE. No concern for me. No sympathy for the action. 'It's time I got out of television', I thought to myself.

After all, what good is making television programmes that get shown late at night, to minority audiences, slipped in between the boxing highlights and next year's fashions? What concrete effect did such

programmes have? Where was the 'social change' that so many documentary-makers talked about? And were TV documentaries the best use of my and other people's limited time and money? I believed the answers to these questions were none, little, nowhere and probably not.

Anyway, I was sick of the bureaucracy and political claustrophobia of the television industry. At best it was uncommitted, at worst conservative. What's more, I was tired of living a double life: my activist work on the one hand – I had been involved in campaign work for years – and my television career on the other. I had to integrate these somehow. I decided I would become a freelance issue-based video producer.

When I got back to the UK I began working with grassroots groups to get their 'missed' stories into the news. I still believed that television was the distribution vehicle that would gain maximum effect. With the availability of the new good quality low-cost Hi8 camcorders, I found that I could shoot the stories as well as produce them. I was excited by this, as it meant I could go and just do it – research and video a story – without having to wait around to raise money or get a television commission. This of course flew in the face of industry conventions, which require that each person has one role (mine up till then had been as researcher/producer), and which strongly discourage role-swapping.

My first big success came later in the summer of 1992, with a story I shot for World Television News (WTN). It's hard to describe the fear and intimidation I felt when I made that first phone call to try to sell them the story. I had never had any training in how to shoot, had access to only a domestic camcorder, and had no experience of working with the news. I asked them if they would be interested in a feature about an anti-environmentalist conference that was about to take place in the United States. I was half dismayed when they said they were interested in the story but couldn't commit to taking it until they saw the images. Later I learnt that this was as good as it gets for most freelance video work. At the time I felt the whole venture was a great risk. However, I decided to give it a go, and travelled to the States with my sister to cover the story.

We flew to Washington DC, and spent a week with 300 loggers, hunters and off-road vehicle enthusiasts, who were in town to lobby politicians to reduce (yes, reduce!) environmental legislation. After a

few days of videoing, my sister flew back to Europe to return to her job. I was alone. Could I really do the whole thing by myself? I wasn't sure.

I drove down to South Carolina to interview shrimp fishermen who were complaining that laws to protect sea turtles were hampering their trade. I remember the shock of carrying out the interview by myself for the first time. With the camcorder set up on a tripod and me crouching next to it asking the questions, I was able to establish an intimacy I never could accomplish with the large crews I had worked with before. When I returned to London, WTN took the story and I just about covered my costs.

Later that year, I joined up with Jamie Hartzell, who I'd worked with at TVE, and who was equally committed to using the visual media to bring about concrete results. We spent many afternoons slurping down warm tea in the greasy-spoon café next door to the office we worked in, discussing the best way to use video to bring about change. Our greatest aspiration at the time was to use a camcorder to help a local group get a set of traffic lights installed. Small ambition perhaps, but to us this was the height of achievement – to be able to see that video had a tangible impact.

I continued trying to get stories onto the news. But I was beginning to get frustrated. News editors wanted stories that were sensational, full of conflict, perhaps even violent. The first question I was always asked when I called a news station was: 'How many arrests were there?' In one particular week I found that I was able to sell footage to both my local TV news programmes of a man who survived being trapped in a lift (a 'miraculous escape story'), but unable to sell footage of over a thousand Ogoni massacred in Nigeria. I looked at what I was doing and kept asking myself 'How does this bring about change?' It wasn't looking good.

Then in the autumn of 1992, I received a letter from some activist friends in Malaysia. They suggested I get in touch with a group in Hampshire who were trying to stop a golf course being built on their land. This group turned out to be the Bramshaw Commoners Association, a group of villagers who had 'common rights' over the Weavers Down Common near where they lived.

At first we thought of making a broadcast programme. 'It would make a great programme for BBC's *Open Space* or Channel 4's *Cutting Edge*,' we said to each other. We sent off some proposals but heard nothing back from the commissioning editors. Should we give up on

the campaign and move on to the next broadcast proposal? Not this time.

The breakthrough in our thinking came when Jamie and I travelled to Hampshire and decided that we should try to meet the group's needs rather than our own (which were those of the traditional television producer). We learnt that their biggest problem was lack of community support and alleged corruption within the District Council. We devised a media campaign with two of the lead commoners, Mary and Dickie, which would meet their needs. We helped them get press coverage in national newspapers, and interviews on the local radio. We helped them organise a stunt for the District Councillors' visit to the site. Mary brought geese and cows onto the common to prove that the land was still being used for grazing, and we videoed it. We began calling the District Councillors and asking them questions. We doorstepped the manager of the local golf course. We vox-popped the locals in the village pub.

This had a great impact on the campaign. People began to take Mary and Dickie more seriously. The District Council was less willing to deal with the golf club and other organisations started giving their support. Finally, we captured video evidence of the club knowingly killing endangered species on the land. The footage was used by the RSPCA to prosecute the golf club. This put a final stop to the development plans. We had won. We never did get a commission from the TV channels; in fact the BBC made a six-part series advocating the beauty of the sport, called *Golf in All its Glory*.

This was the first step. We knew we could no longer rely on mainstream television. From there we concluded that if we wanted to disseminate visual messages beyond the community involved we would have to set up our own distribution mechanism. We dreamt of being able to run our own public access cable show. But such outlets weren't available in the UK. We decided to set up the country's first ever news service distributed on video cassette. We chose this mechanism because over 80 per cent of households had a VCR at home, it was relatively cheap and, perhaps even more important, we could completely control the editorial line of the product.

We went to some of the most exciting campaign sites in the country – for example the No M11 Link Road campaign in East London – and began collecting footage. We made contacts with other video activists, and began to coordinate our work.

We then bought an edit suite, a computer-based SVHS suite. (Oh what joy!) This was a huge leap forward as it meant we were able to reduce our 'out of house' costs to a minimum – because editing takes a large part of a traditional documentary budget. We eagerly set to work compiling the footage we'd collected. Not only did we have to learn how to work our new toy (it kept crashing!), we also had over 100 tapes to plough through. We couldn't believe how much as yet unseen video work was going on out there.

After eight months in the edit suite, and last-minute nerves when we almost aborted the whole project ('No one's going to like it', we told ourselves), we launched the first edition of the **under**currents alternative news video in April 1994. Ninety minutes of high-energy, passionate, in-yer-face action. Not what you see on television. We made 250 copies, sent out over 10,000 fliers and prayed someone would take notice of what we'd just done. We didn't get an order for three months. What an anticlimax!

Then things began to change. Orders started coming in. The media picked up interest. 'The Pathé News of the 90s', said *Time Out*, 'Compelling', said *The Independent*, 'Smart work', said *ID*, 'Raises two grubby fingers to the mainstream media', said the *Guardian*. Suddenly, we had to make more copies. We ran off another 250.

Since then, **under**currents has published six issues of the video magazine, over ten hours of the 'news you don't see on the news'. We have trained over 500 people how to use camcorders in their campaigns. Many of these have supplied their footage to our 'street news' compilation, or have made their own features using our VHS–VHS edit suite. We have also helped set up two other video magazines in the Netherlands and Australia.

We sell over 2,000 copies of each issue, almost all are mail-order from our database, and – based on 15 to 20 people watching each tape (passing the tape to friends, groups screenings, etc.) – we estimate that we have an audience of over 40,000 people per issue. Not to mention the millions who see the footage we have sold from our archive to national and international television. It's amazing what you can do with a camcorder!

There are three reasons why I have told you this story. First, I wanted to underline the tremendous need for this work. Television – the most powerful form of communication available today – is becoming increasingly centralised and commercial and marginalised voices are

less and less likely to be heard. At the same time new technology is giving activists communication opportunities never available before.

Second, I wanted to show how anyone can learn how to operate a camcorder successfully. All that you need to become a true video activist is the necessary equipment, practice to develop the required skills, and, perhaps most importantly, inspiration.

Third, I wanted to explain why I've written this book. When I started to use video for change, I had to learn everything by trial and error. I couldn't find a book that provided the tips I needed for my activist work. There were plenty of guides telling me how to get the white balance right and how to make a wedding video, but none on how to become a video activist. With this book I hope to fill that gap.

The aim of *The Video Activist Handbook* is to show people working on environmental and social justice issues how they can use video in their day-to-day efforts. The book assumes no prior knowledge in using video. It is structured so that beginners can learn basic skills and ideas, while offering people with some previous experience suggestions on more sophisticated video strategies. This book will help you, whether you just want to video the occasional community event or need to document a long-running protest campaign, whether you intend to sell footage to television news or are planning to screen a campaign video at a rave.

Good luck and happy videoing!

Thomas Harding
January 1997

What is Video Activism?

'We can become more possible than they can powerfully imagine.'
(Jim Chambers, No M11 Link Road campaign)

Over the past ten years, we have seen the proliferation of a new breed of social organiser: the *video activist*. The term 'video activist' means different things to different people, but in this book it is used to mean a person who uses video as a tactical tool to bring about social justice and environmental protection.

In the hands of a video activist, a camcorder becomes a powerful political instrument that can deter police violence. An edit suite becomes a means for setting a political agenda. A video projector becomes a mechanism for generating mass awareness.

Perhaps the best known example of video having a direct social consequence is the beating of Rodney King in Los Angeles in 1992 (see Chapter 5, p. 65). Footage of the beating taken by a person who happened to be standing on the balcony of a nearby block of flats at the time sparked off riots in the streets, was broadcast around the world and was subsequently used to prosecute the Los Angeles police officers involved. People suddenly realised the power of the camcorder.

This type of 'witness video' is only the tip of the iceberg. Video activism encompasses a broad grouping of individuals. The people involved, the methods used and the energy committed all vary enormously – ranging from the local resident who occasionally uses her cousin's camcorder to record community meetings, to the full-time campaigner who tries to sell footage of every protest to local television, to the overseas aid worker who includes footage of a refugee camp with his monthly report, to the lawyer who uses video evidence to help her

client get off false charges. Despite such variations, video activists are united by purpose and practice. They all realise the power of the visual image and make use of this power to bring about change in their communities.

A BRIEF HISTORY OF VIDEO ACTIVISM

There's nothing as good as a success story to inspire people into action. Equally important, perhaps, is that people like to feel that they are part of a tradition. It adds validity to their work and gives confidence in tricky situations. What follows, therefore, is a bit of historical background to video activism.

Even at the beginning of cinema, film-makers were using cameras to capture the world around them and effect change by showing their completed films to audiences. The first films ever made, by Louis Lumière in 1895/96, were documentary in form. People jumped back in shock when they saw the 'Arrival of a Train', and were amazed when they witnessed 'Workers Leaving the Lumière Factory'.

In the 1920s, Russian film-makers developed the documentary as a means of raising awareness. Dziga Vertov, who was editor of the newsreel *Film Weekly*, sent camera operators to the far corners of his country to catalogue people struggling through civil war, famine and rapid social change. He then distributed the newsreel as widely as possible, through 'agit-trains', 'agit-boats' and town screenings.

In the UK, in the 1920s and 1930s, the GPO (General Post Office) Film Unit, led by John Grierson, focused on documenting everyday reality. The rawness of such footage became a political force. For instance, their film *Housing Problems* – which focused on the need to demolish and replace derelict slums – featured slum residents speaking for themselves, in their own kitchens, rather than 'voice of god' narration. This had a huge impact on the attitudes of the audience and contributed to a change in the government's housing policy.

Meanwhile, in the United States, Hollywood exerted a monopoly control over cinema distribution. This reduced the opportunities for dissident voices to be heard. The political significance of this reached its peak in 1931, when Fox Corporation issued a statement that none of its cinemas would be allowed to show newsreels of a controversial nature. In reaction to this, labour groups set up their own screenings – Workers Film and Photo Leagues. They soon began generating

their own material and exchanging films. Out of this network developed a whole generation of advocate film-makers.

Around this time, an important debate developed among social theorists as to whether film had a negative or positive impact on social change. At the centre of the debate were Walter Benjamin and Theodor Adorno, both from the German Frankfurt School. Benjamin argued that film could be used to educate and mobilise the masses, and was therefore a tool for social change. Adorno argued that it was indeed a powerful tool, but that it could be used by anyone, not just leftwing activists, and probably more effectively by those already in power since they had more resources. He claimed that it was therefore a double-edged sword. He also said that the best use of film would be to show alternative realities rather than blunt social realism, as Picasso did with painting. This would prompt people to be critical of their lives. Benjamin called Adorno an elitist and said he missed the point. This debate has continued to run through film and video history ever since.

Returning to the history of using film for political purposes, during the Second World War both Allied and Axis powers used film to arouse passions and patriotism. For example, the Germans produced a *Weekly Review*, with stirring music, emotional narration and highly charged footage. But film was also used to catalogue human rights abuses. Footage shot by Yugoslav and Polish partisans documenting concentration-camp atrocities was used as evidence in war-crimes trials. Similarly, American and British troops found Nazi 'home movies' – for instance, a vicious pogrom against the Jews in 1941 Stuttgart – which were later used at the Nuremberg trials.

It was in the 1960s that film became a popular tool for grassroots organising. Using the newly available light 16mm cameras, film-makers worked to reduce the technical baggage between them and their subject, so that the 'truth' would emerge more easily. One example of this type of work was '*cinéma vérité*', where film-makers provoked people into action (for example, by asking people walking on Parisian boulevards: 'Tell us – are you happy?') rather than simply observing them. Another powerful example took place in Canada, when the National Film Board trained and equipped Mohawk Indians. The Mohawk crew filmed a protest about the free passage of goods between Canada and the United States. They recorded the confrontation between police and native Americans, including the arrest of some of the leaders of the protest. The footage was then edited into the film *You are on Indian Land*. This film was a huge success with audiences,

won a hearing for the native Americans in Ottawa, and brought a new unity to the people.

By the 1970s, documentary work for social change was dramatically boosted by the arrival of video cameras. The new cameras – in particular the Portapaks and U-Matics – were small, easy to use and relatively cheap. Unlike film, video tape could be re-used and the cameras needed only one person to operate them. A new breed of 'guerrilla' video-makers, at first in the United States and then elsewhere in the world, began to appear on the streets. They recorded Vietnam protests, civil rights marches, environmental disputes and women's rights rallies. Groups like New York's Downtown Community Television Center gave free training to local citizens. In its first seven years the centre instructed over 7,000 people, in English, Spanish and Chinese.

THE CAMCORDER REVOLUTION

So much for history. What about today? Video activism truly came into its own in the 1980s and 1990s when there was an explosion in the use of video to bring about political change across the world.

In Brazil, unions set up screens in town squares and show the latest 'alternative' news from around the country. In Denmark, anarchists run a weekly cable show giving voice to the 'underground' scene. In the Czech Republic, anti-mining campaigners video their actions and then make campaign videos out of the footage. In Tibet, dissidents capture Chinese exploitation of their land and smuggle the tapes out of the country. In Kenya, human rights groups record evidence of torture on video and give the tapes to forensic scientists for further examination. In the UK, anti-road activists video police evicting them from tree-houses and sell the footage to television news.

It could be argued that the apparent explosion in the use of video over the past two decades is illusory – people are doing what they always have done – and that it seems new to me because I am a newcomer to the activity myself. This may be true, and I acknowledge that writers tend to claim that things are 'new' because they want to be seen as sailing in uncharted waters. Nevertheless, I do believe that there has been a fresh development in the use of video over the last few years: a dramatic increase in the number of people involved in video activism.

This sudden rise in video activism is a result of a number of factors: (a) a new wave of activism; (b) the failure of the mainstream media to adequately cover social and environment justice movements; (c) improvements and availability of video equipment.

New wave of activism

Over the last 15 years, the number, diversity and vigour of popular movements has increased around the world. From the velvet revolutions of Eastern Europe, to the gay and lesbian rallies in San Francisco, to peasant farmers demonstrating against the General Agreement on Tariffs and Trade in India, large numbers of people have been involved in bringing about change, and wherever there's been an action, a video activist is likely to have been near by.

Such actions have tended to be different in character than in earlier years. Whereas labour and national independence struggles have continued undiminished in some countries, in many places the activist momentum has moved to more single-issue campaigning. A good example of this is the UK (see the table below), where campaigns on the environment, animal welfare and human rights have become increasingly vigorous and – perhaps as important for this book – visual. Large numbers of small group actions, such as banner-drops, lock-ons and office occupations, are increasingly replacing small numbers of large group rallies and marches. This trend towards more decentralised but colourful organising has encouraged the growth of video activism.

Membership of UK civil organisations

Amnesty Intl.	40,000 (1987)	127,000 (1995)
Friends of the Earth	75,000 (1988)	200,000 (1995)
Greenpeace	80,000 (1987)	420,000 (1995)
National Trust	1,000,000 (1980)	2,200,000 (1995)
Trade Unions	13,000,000 (1979)	7,000,000 (1995)

Sources: *Deficit in Civil Society*, Foundation of Civil Society, Birmingham, 1996; Amnesty International British Section.

Behind these popular movements lies an increasing awareness of global crisis. A whole generation of people grew up in the knowledge that the very existence of the planet was under threat by nuclear

weapons. Now there is an added threat, global warming. Many people, when asked to explain their decision to get involved in video activism, say that they felt it was the best way of dealing with the problems facing the world.

Anyone reading this book will almost certainly be aware of the problems they are talking about. Nevertheless, it is always worth reminding ourselves of the trouble we're in, and it is important to think of the people behind each statistic (the following data originates from various UN sources and is collected in Worldwatch Institute's *Vital Signs*, 1995 and 1996):

- As a result of global warming, the ten hottest years on record have all occurred since 1980.
- There were over 27 million refugees in the world in 1995.
- There were almost three times as many wars in 1994 as at any time in the 1950s, and twice as many as in the 1960s.
- There are still over 40,000 nuclear warheads in the world.
- The world lost 8 per cent of its tropical forests, which provide habitats for 50 to 90 per cent of the world's species, during the 1980s.
- Over 100 million people living today have no shelter whatsoever.
- In 1960 the richest 20 per cent in the world received 30 times more income than the poorest 20 per cent. By 1991, this group received 61 times more money.
- In 1995, women held only 10 per cent of seats in national parliaments, just 3.5 per cent of world cabinet ministers were women, and women held no ministerial positions in 93 countries.
- Studies suggest that between one in five and one in seven women in the United States are victim to a completed rape during their lifetime.

Such trends may well get worse in the near future. And in response there will be a greater and greater need for popular action, and a mirrored need for video activist support.

Failure of mass media

The second main cause of the growth of video activism has been the failure of the mainstream media to cover adequately the global crisis

we're experiencing and the mass movements that have emerged in response to this crisis.

Why are the mainstream media – in particular, television – important to all this? The reason, of course, is that the mainstream media play such a crucial role in modern societies in helping people form opinions and, as a result, make decisions.

In 1990 a Mori survey found that television and newspapers are more significant than friends, family, politicians and other sources of information when it comes to influencing opinion, and that television journalism, in particular, is the main source of people's information about the world (McNair 1996). According to research carried out by Barrie Gunter, 'Around two-thirds of the mass public of modern industrialised societies claim that television is their main source of national and international news' (quoted in McNair 1996).

During the 1960s and 1970s, it was relatively easy to get local and national television in the UK to cover a group's activity or issue. All you had to do was issue a news release, run a press conference, drop a banner, and television coverage would be assured. However, in the 1980s and 1990s, this changed radically. Broadcasters increasingly cut down on their coverage of 'progressive' issues. This may have been because they had become anxious about being seen as impartial and unbiased. Or it may have been because they had grown more conservative under the force of the rampant commercialisation that had swept through the industry.

When we think about the 1960s, we tend to have images of protests, anti-war demonstrations and civil disobedience. Though we do see some similar images today, their scale and prominence is far less now than it was then yet, in my experience, and according to many who have lived through both periods, activism and counterculture are thriving today, perhaps more than ever. This is echoed by Richard Neville – founder of 1960s underground magazine *Oz* – in his autobiography *Hippy, Hippy, Shake* when he visits an activist free festival/rave in Byron Bay, New South Wales: 'At this nineties knees-up for eco-dreamers, bodies are bared and tribally painted, dolphin charms play around suntanned necks, eyebrows and navels are pierced and decorated with amulet ... "it's happening all over again" says another knarled veteran of the sixties "with bells on".' The only explanation is that television covers non-mainstream politics more rarely and more superficially now than it used to.

A group of environment and development organisations in the UK
– including Oxfam, Christian Aid, Friends of the Earth and the World
Wide Fund for Nature (WWF) – became so worried by this situation
that they decided to do carry out some research to see how coverage
of their issues was changing over time. Their Third World and
Environment Broadcasting Project on UK television (*What in the World
is Going On?* 1995) found that:

- two-thirds of all news reports about the developing world focus
 on just three countries;
- reports from the developing world account for just under 10 per
 cent of all broadcast news;
- conflicts, disasters and politics account for 90 per cent of all
 news and currents affairs reports from developing countries;
- documentary output on international topics had fallen by 40 per
 cent across all four UK channels between 1990 and 1994.

At the same time, there have been specific trends relevant to each
issue. This has made it very difficult for groups to win airtime if their
issue isn't 'sexy'. For instance, in many countries, pictures of starving
African babies were seen as a crowd puller in the mid-1980s, but a
few years later television executives decided that viewers were bored
of such images and were suffering from 'fatigue'. Similarly, during the
'green boom' in the late 1980s, environmental concerns were all the
rage, entire programmes were dedicated to these issues, environmental
journalists were appointed for the first time, and awards specific to
environmental programmes were set up. By the early 1990s, most of
this had gone. Fashions came and went: AIDS, homelessness, Eastern
European orphans, land mines ... What next?

As an example, here is a situation I experienced personally. In
1995, I tried to make a news feature for Channel 4 News about the 3
million Kurdish refugees who had been forced out of their villages and
had their homes burned by the Turkish army. The then foreign editor
said 'I am not interested in Turkey, I want African stories.' That was
that. If I wanted to get a story on the UK's leading news programme
it had to be from Africa.

Whatever the reasons for the changes in the broadcast industry,
over the past decade many activists have decided that television has
not sufficiently covered their campaigns. At the same time these
activists discovered non-broadcast uses for video – such as educational

features and gathering evidence on wrongdoers for use in court – which television could never be expected to fulfil but which were nevertheless important. There was a vacuum that needed to be filled. Hence the emergence of the video activist.

New technology

Perhaps the biggest reason of all for the rise in video activism has been the vastly increased availability of cheap, high-quality video equipment.

True, portable video equipment was around in the 1960s and 1970s – and was used by social change groups to great effect – but it was not until the emergence of the 8mm and SVHS camcorders of the mid-1980s that video activism began truly to proliferate.

What was different about these cameras was that they were much smaller, easier to use, cheaper and of better quality than earlier models. They also had better features – like 'steady-shot', instant playback, long-life batteries and swift autofocus. Perhaps even more importantly, the big corporations that had developed the new technology decided to sell it to a mass domestic market and therefore made it widely available.

You could now go into a shop in Bradford, Brisbane or Birmingham, Alabama, hand over the equivalent of $1,000, and have yourself an almost broadcast-quality camcorder kit. According to BREEMA (British Radio and Electronic Equipment Manufacturers Association), by 1992 there were over 3 million camcorders in British homes (one in seven households), 6 million in Germany and 15 million in the United States. And contrary to some expectations, people were using these camcorders on a regular basis. In a 1995 survey by consultants GfK of 10,000 UK households, it was found that 35 per cent of people use their camcorder at least once a month, 36 per cent two or three times a year, and 27 per cent use it on special occasions.

Next came huge improvements in editing equipment. Cheap, easy-to-use VHS domestic edit suites replaced the more expensive industry-standard U-Matic suites. Then came the personal computer edit suites, nicknamed 'video toasters' after a particular brand of suite, which were not only cheap but gave the added facilities of digital effects and titling.

Finally, new distribution opportunities became available. Microwave technology helped Kurdish rebels to broadcast their own videos in Northern Iraq. Public access cable networks enabled gay and lesbian

groups to syndicate their shows nationally in the United States. Tenants of housing estates in France ran weekly screenings to each other using the new cheap, single-beam video projectors. Environmental activists in Australia designed Web pages to carry video images of their latest pro-cycling protests.

Camcorder ownership in Western Europe

Year	Sales (millions)	In use (millions)	Homes (millions)	Penetration (%)	Obsolete (millions)
1990	2.8	7.9	145	5	0.04
1992	3.7	14.9	148	10	0.2
1994	2.5	19.4	149	13	0.7
1996	2.7	21.7	151	14	1.6
1998	3.5	23.7	154	15	2.5
2000	3.4	25.2	156	17	3.0

Source: GIGA Information, supplied by Sony Marketing UK.

Of course, there are further possibilities to come. In the future, social and environmental movements will have even more tools to use in their efforts to bring about change in their communities. For now though, I shall stick with what is being used by video activists today. This book is about how you can use such technologies. You may choose to roam through its pages, finding the sections that interest you. I strongly recommend, however, that you read Chapter 2, 'Strategy', before going any further. In my experience, strategy is the one area where video activists are most lacking in knowledge and skills. Without strategy you will have no impact. And if you want to be a video activist you must, if nothing else, have an impact.

How I became a video activist

by Roddy Mansfield

I'd always had an interest in journalism, yet it wasn't until I purchased my first camcorder that I realised I could contribute to the mainstream and alternative media.

In February 1994, after working as a shop assistant at Boots for six years, I saw a Channel 4 documentary on fox-hunting and

Photo 1.1 Roddy Mansfield at the No M11 Link Road campaign site, London
(photo: Nick Cobbing)

badger-baiting, which had been videoed with a camcorder. The scenes of purposeless cruelty I witnessed left me in no doubt as to the impact a camcorder could have when placed in sensitive situations. The footage was instrumental in making me question society's attitude towards animals, and within a few months I had purchased a camcorder and was videoing fox hunts with my local hunt saboteur group. The number of camcorders now carried by both hunt saboteur and League Against Cruel Sports members has led to a decrease in the level of violence offered by both terrier-men and hunt-supporters.

By 1994, I regularly travelled across London to Wanstead to video the actions that were taking place as part of the No M11 Link Road Campaign (Photo 1.1). After a while the campaign began to receive increased media attention, mainly as a result of activists sending footage into local TV news stations.

One incident I won't forget was seeing a line of police officers burst out laughing upon realising that a very distressed protester had lost his flute, which was probably the only source of income he had. As soon as I pointed my camera in their direction and they realised that they were being videoed they suddenly decided it wasn't so funny after all.

As the Criminal Justice bill loomed over the horizon, it became apparent that a whole section of society, whole cultures even, would be criminalised and those of us in the protest 'n' party movement, of which I was now a part, would be turned into outlaws. Yet the silence from the mainstream media was deafening. It was then that I heard about the non-profit alternative news video **under***currents*, which was put together by activists with their own camcorders. I was soon contributing footage of demos, actions, marches, hunts and the police. I even took my camcorder for a wander around the Houses of Parliament!

It was not until the summer of 1995, however, that I began to notice a gradual shift in the attitudes of the police towards camcorder activists. You are now threatened with arrest for obstruction and officers deliberately try to block your view when an arrest is being made. On 7 July 1995, I travelled to the Marsh Estate in Luton where I heard that young Asians were rioting about police violence. At two o'clock in the morning I was out on the streets when I noticed riot police taunting the youths. 'Can't you throw better than that?' they yelled, and 'Let's have some more petrol bombs!' I couldn't believe it. They were actually encouraging the youths to riot! I started

recording, but then the policemen saw, and three of them ran at me. 'I am a journalist!' I shouted, and showed them my ID card. They ignored me and began hitting me with their truncheons and shields. They then took my camcorder, smashed it and stole the tape. I picked myself up and spent the next hour taking down the police officers' numbers to identify them later, and finding witnesses. I also found a documentary crew and asked them to document my injuries and record my testimony. A few weeks later I lodged an official complaint, and won Legal Aid to take the police to court for damages.

Some people express concern that an army of activists wielding camcorders increases society's 'Big Brother' factor. Yet if you attend any action today, whether it be a tree-sitting at Newbury, stopping live exports or sabotaging a hunt, you'll be videoed by the police, private security guards and detective agencies working for the government, all of whom are compiling secret files on us. That's spying on people. Yet when I see a security guard assault someone, or a police officer use unreasonable force, or a fox being torn apart, or a 400-year-old tree being destroyed, I'll be the first one to video it. That's not spying on people; that's justice!

Now, six years after leaving the shop assistant job, I work as a freelancer doing undercover video work for broadcast television, and I am out on the streets working with activists to get their issues to a wider audience.

The Strategy of Video Activism

Over the past few years, there has been a great deal of discussion about whether people should use camcorders at demonstrations and campaign events. Though some people recognise the benefits of video in providing alternative sources of information, others see it as a dangerous threat to their ability to organise.

In England, this debate reached a climax at the Courthouse, Brighton, in 1995. People gathered to decide whether to invite camcorder users to their future activities and campaign events. Exponents of both sides of the argument were asked to put forward their views, which can be summarised as follows. First, the arguments against:

- Footage could be taken by the police and used to incriminate others at the action.
- There are now too many people with camcorders and not enough activists.
- Selling the footage to television will sensationalise and distort the action.
- The police have security camcorders so we don't know who's who anymore.
- People are using videos to advance themselves not campaigns.

And the arguments for:

- Footage taken at the demo can be used to get people off charges like false arrest.

- Selling footage to television can get the issue to a wider audience.
- Video can be edited into empowering campaign films.
- Video cameras can calm things down if police or security are getting hot-tempered.
- Footage can be used later to evaluate how an action went and what could be changed.

The debate was useful in that both sides got a chance to air their views. In the end, though, it was agreed that camcorders are a double-edged sword. Sometimes they are useful, sometimes they are a problem, depending on the purpose they are put to.

Clearly, then, the first thing a video activist must do, before going out on the streets and starting to record, is define his or her purpose.

FINDING A PURPOSE

There are many community groups and campaign organisations with access to video equipment, but few that use them effectively. Too often people take their camcorders to a protest, vigil, overseas project or community event and shoot hundreds of hours of footage. Nothing more is done with the material. The result is tapes stacked high on shelves in the back room of the office or tucked away in a bedroom.

Why does this happen? The main reason is lack of purpose. Without purpose there is no strategy. Without strategy there is no social change. Without social change there is no video activism.

Where do video activists find purpose and strategy? They find it in a group with real needs. These could be the need for more people, the need for more money, the need to attract more mainstream media attention, or even the need to carry out more research. Either way, once the needs are defined, purpose and strategy become readily identifiable.

This process is true whether the video activist is part of a group or is helping from outside. Without the needs to ground and direct effort, any video work is going to end up being senseless, inefficient and ineffective. The classic example is the person who turns up to a meeting, videos the entire process and then, having no idea how to use the material, stores it at home.

To work to a group's needs, a video activist must involve the members of the group in the decision-making process. This can take

many forms, from casual advice to full participation in the video production itself, but at the very least it must include some form of needs assessment at the start and some form of evaluation at the end.

Suppose, for example, that a group of residents is trying to stop an opencast mine being built in their village, and that, luckily, one of the residents has access to a video camcorder. What might happen is that, at a regular meeting, the person with the camcorder suggests that she can help out with video work. 'What should I do? What needs to be done?' she asks. The group replies that the most urgent thing is to impress the developers that the residents are passionate about the problem. The person with the video could then suggest collecting video testimonies from all the residents and sending this to the developers.

Some video activists who do a lot of work with the same group, which has needs that change over time, or who work with a number of groups, develop a 'menu' of services that they can provide. This enables them to adjust their video support according to what is required by the group. The menu might include:

- gathering evidence for use in courts (i.e. witness video – see Chapter 5);
- shooting for television (see Chapter 6);
- making a campaign video to be screened to politicians, local residents, etc. (see Chapters 8 and 9);
- organising a video letter with testimony from villagers to go to the developer's CEO (see Chapter 11);
- training campaigners to use camcorders to gather their own footage (see Chapter 12);
- training the group to improve their interview techniques.

From this, the group and the video activist would then match needs to resources to see what it is possible to achieve and thereby devise a purpose and a strategy. This can be summarised as a five-point process:

1 Work with a specific identifiable group.
2 Find out their needs.
3 Devise a media strategy.
4 Make it happen.
5 Evaluate.

Work with a specific identifiable group

You should always choose to work with a group that is affected by a particular injustice, rather than an intermediary group that is supporting the group suffering the injustice. People working at the 'coalface' of an issue that affects them will have real needs, not just intellectual needs, which makes it much easier to devise a strategy that can bring about tangible change. A good indication that you are engaged directly with the group is having the home telephone number of one of the key organisers.

Find out their needs

It can often take some time to find out a group's needs, as the process can require intimacy and trust. Also, it may take some time to find the right person who can articulate the needs. Don't be surprised if you find that media support is not necessary and may even make things worse (which is often the case with documentary programmes). In such a situation, withdraw or offer a different type of assistance.

Devise a media strategy

It is important to devise a media strategy that will bring about tangible, measurable results that you can see in the short term. This may not involve production of a programme. Have a 'menu' ready to offer (such as interview training, camcorder training, public relations to get media coverage, witness video, video production, distribution, etc.).

Make it happen

At this stage you'll be ready to start doing whatever you've promised to do – whether it's running a series of interview training workshops or producing a campaign video.

Evaluation

Throughout the project it is important to have a mechanism for assessing how work is progressing. In particular, you should show any video in rough form to the stakeholders (the group, audience, contributors).

This approach is known by a number of names, including 'community video', 'participatory video', 'grassroots video-making' and 'campaign videography'. For the rest of this book I shall refer to it as the 'video activist approach' or simply 'video activism'.

**Photo 2.1 Video activists come in all shapes and sizes – George Marshall videoing a squat, Belgium, 1996
(photo: Paul O'Connor)**

TYPES OF VIDEO ACTIVIST

There are three main types of video activist, each having an equally effective strategy. I shall refer to them as the Insider, the Freelancer and the Trainer.

- The *Insider* is a member of a campaign/community group who uses video as part of the group's work. He or she will often have other tasks besides video work.
- The *Freelancer* is an individual who provides video support to a number of campaign/community groups.
- The *Trainer* is an individual who supports and trains other video activists.

Each of these strategies has its pitfalls and advantages. For instance, Insiders are more likely to take their video decisions according to the group's needs – and therefore be more effective – than Freelancers.

Photo 2.2 Zoë Broughton videoing police issuing a warning to anti-road protesters, Bournemouth, 1995 (photo: Adrian Arbib)

However, they might find it difficult to persuade the group to prioritise the video work and therefore won't have as much time or resources to do the work as Freelancers, who have video as their main project. Meanwhile, Trainers have the advantage of being able to multiply their own efforts by training others, but might be ineffective, as they spend so little time finding out what is happening at the grassroots level.

In general, however, those who remain video activists for a number of years tend to change roles. They may start their careers as Insiders, then move on to being Freelancers and finally, if they carry on for long enough, work as Trainers. Each of these stages requires new skills. Some of them can be commercially exploited (like selling footage to television or providing training), and used to support video activism financially (see Chapter 7, p. 125). However, the more commercially orientated video activists become, the harder it seems to be for them to meet the needs of the group they say they're working with.

COMPARING VIDEO STRATEGIES

In order to find out the benefits of video activism, it is useful to understand how conventional video-making takes place. By 'conventional video-making', I mean the process typically adopted by documentary and news producers. Such video-makers usually fund their work by winning commissions to make programmes for television or by gaining grants from local and national government arts bodies. Many of them are full-time professionals, making a living from their work. And many are ideologically committed to social change, even if in practice they don't contribute to it themselves.

Of course, there are different styles employed by such video-makers, but to simplify the discussion in a way that highlights what is useful for campaign and community groups, I shall maintain the dichotomy between the two types of process.

In its simplest form, the difference between video activists and conventional video-makers is that the former want to bring about change by gaining power for a group working in a community whereas the latter want to bring about change by advancing their careers and earning money (that is, gaining power for themselves). Conventional video-makers may use the rhetoric of video activists but, unless they fully engage with real needs, they will fail to make an impact.

The conflict between the agendas of conventional video-makers and video activists is spread across the entire production process. Here are common examples of when this conflict arises:

- A video-maker takes some shocking footage of a starving baby dying in the arms of a woman in a refugee camp in Africa. She takes the material back and edits it into a campaign video for the relief agency working in the camp. When she shows the finished product to the group, they say that the images are too negative and will add to the stereotypical images of African failure and dependency. The video-maker argues that to lose these shots from the video would be to lose the most powerful material and would jeopardise the chances of attracting a wide audience. The campaigners say that more important than audience size is the type of effect that the video has on that audience.

- A video-maker has some great footage of a banner-drop off a building. He wants to sell it to television because it will get the material seen by a wide audience and will bring in money to pay for his tapes and his camera repairs. It will also help him get contacts with the broadcast industry. But the campaigners are worried that the material includes footage of someone opening a window to get into the building. The material might incriminate the person and be used by the police to prosecute them.

- A video-maker approaches an asylum support group. She wants to help them. They say their biggest problem is harassment by the local police. She suggests an educational video. She says she might be able to get a grant from a charity committed to alleviating poverty. But it will take time to raise the funds to make the programme, and she is only going to be able to get money to make a video about 'life on the street', not about police harassment. The group says that what it really needs are several low-end camcorders with which they could catch the harassers. Furthermore, if a video is to be made, they want to control the message – they have had experience in the past of film-makers whose programmes have misrepresented them.

Making video programmes in a participative, activist way is extremely difficult. Working to a group's needs involves a conscious and often painful step away from both home movies and broadcast productions.

For wannabe TV directors, this may involve a rethink about their career development and their chances for reliable incomes.

The benefits of working to a group's needs are considerable. The video is likely to be:

- good for the group – as the video will meet their needs and not waste their time;
- good for the video activist – as the group will cooperate in the production since it's in their interest to get it made;
- good for the audience – as the video is likely to be more intimate and compelling;
- good for the sponsor – as there's a means of measuring success or failure;
- good for society – as the group will be empowered.

Of course, some of these benefits may be gained at the expense of the values of traditional journalism – independence, objectivity, balance. But if it's change you're interested in, not your career, then this shouldn't worry you too much. Such tools are always available when you want to use them tactically – for example, when you want to challenge a local politician, or when you want to present yourself as impartial in court (see Chapter 5) – so treat them as such, an option not a principle.

For some people this may seem revolutionary. 'Surely,' it is argued, 'professional journalists must be the guardians of truth, otherwise how can we rely on the "news" as a dependable source of information?' But of course the news is produced by humans, the production process requires decisions about what stories to choose and how to present them, and these decisions are influenced by journalists' value systems. In other words, news is the result of a large number of subjective decisions. Even a journalist who *tries* to be objective has to decide what objectivity is and how it can be achieved. (For a closer examination of some of these arguments, and examples to back them up, see Chomsky 1991, McNair 1995, Glasgow Media Group 1976 and 1995.)

Since the myth of objectivity is still prevalent in many circles, particularly in the mainstream media and the legal system, it pays sometimes to portray yourself as objective (see Chapters 5 and 6). Nevertheless, once you've accepted that the production of video stories

is subjective, then you can really get started in the exciting world of manipulating the media.

To start with though, as the stories and their interpretations become limitless, you'll need something to ground you in reality. If you are a video activist, of course, this is the needs of the group you're working with. For conventional video-makers, still bewitched by the myth of objectivity, it's their own set of needs and value system. As a result, video activism and conventional video-making end up looking very different.

Video activist method	Conventional method
Buy equipment to reduce costs	Rent equipment for each project
Identify a group that needs support	Come up with an idea in the shower one day
Work out group's needs with group	Attend cocktail parties to find out TV company or funder's pet causes
Ask group to cover additional costs	Approach TV company or funder for financial support
Devise strategy to meet group' needs	Develop programme to meet TV company or funder's needs
Revise project in light of local changes	Revise programme to suit lawyer's/accountant's agenda
Ask group with whom and where best to work	Find a place and people to suit the concept
Shoot and edit video over six months	Shoot video in three days and edit in a couple of weeks
Provide training to group in process	Build up skills of crew and producer in process
Screen to target audience	Broadcast programme to masses
Review project with group	Review project with TV company or funder

HAZARDS OF THE VIDEO ACTIVIST APPROACH

The video activist approach is not a foolproof or rigid formula. It will have to be altered and adapted to meet the needs of the local situation. There are also some problems inherent in its focus on people. They

can be summed up as having to invest time at the front end of a project, getting to know the people involved and working out the best strategy. Let's look at these problems in detail.

Choosing who to work with

Many people want to support efforts for social change in their communities but don't currently belong to any one group. There may be any number of good groups working in the area. Even if you already belong to a group, it may be tricky deciding which faction or individual to work with. Part of the problem is that working to the agenda of another person or group requires both risk and humility. It is relatively easy to read the newspaper, find a story, and send a crew to shoot a few interviews. It requires a leap of faith to sit down with members of your own community, ask them what their needs are, spend enough time with them to generate mutual trust, and then devise a media strategy together. There are no easy answers. It is essential, however, that you find people with real and identifiable needs, and that you feel comfortable and confident working with them.

Offering too much

What kind of commitment do you give? What kind of support do you offer? How do you match your resources to their needs? How do you ensure quality and impact without totally dominating the decision-making process? One of the worst fears of many video activists is that, having offered to help, they won't be able to deliver what they've offered. You can avoid this by developing a long-term plan, breaking it into bite-sized, achievable segments, and then reviewing the plan with the rest of the group as you get to the end of each segment. This may make the work seem less intimidating and will add a feedback mechanism to the process.

Defining needs

Many groups find it difficult to articulate their needs. Part of the job of the video activist may be to facilitate this process, as it could be the first time that the group has considered what its needs are. Here's an example from non-video organising work. In Albuquerque, New Mexico, members of the South West Organizing Project went door to door asking people about their problems. Many spoke of the dust on their cars in the morning; others talked of their children's asthmatic attacks; others referred to problems with their soil. After pulling the

information together, the organisers realised that all the problems came from a nearby chipboard factory. By uniting the neighbourhood through a common need – to reduce the pollution from the factory – the organisers were able to work with the community to force the factory to install expensive filtering equipment.

An issue without a group

Some video activists find an issue that needs support but say they can't find a group associated with it. This is usually because they haven't done enough research. Suppose, for example, that toxic waste is being dumped near a housing estate. There may not yet be a group campaigning to change the situation, but there will be more than enough local people to consult with and involve in any video project. The real problem may be that this will require much more work than simply going ahead and making a 'community' film without involving the community. If you want to be successful, you are going to have to make the extra effort.

Working with distant groups

Some people are tempted to work with groups located far away from their own communities. They may be attracted because of the people involved, or perhaps because they think the campaign is winnable. Either way, it's extremely unlikely that they can provide useful long-term support over such a distance. Not only will much of their time be wasted travelling, but their support will be limited because they won't know the lay of the land (so their tactics might be inappropriate), nor will they be likely to be able to react swiftly to an emergency.

An example from my own experience illustrates the folly of working a long way from home. In 1996 I travelled with a friend for eight hours from my home in Oxford to Newcastle upon Tyne. We had heard that the local council had installed the world's first closed-circuit television (CCTV) cameras in a residential neighbourhood. We had spoken to a local council employee and he had said that he was worried about the civil liberties aspect of this new technology and wanted to make a film about locals struggling against it. This had excited us since we were concerned about the explosion of CCTV cameras around the country for the same reason. When we arrived we went to the community concerned and were surprised that we couldn't find anyone opposed to the cameras. In fact, people were delighted with them because violence in the area had decreased dramatically since their arrival. Of

course it is possible to argue that the crime had been displaced to another area, but how could we make an anti-CCTV film when the locals were so in favour of it? We went home with no footage and our proverbial tails between our legs.

Such an experience can be demoralising and discouraging. But it is a lesson that points to the importance of working to other people's needs rather than your own. The obvious answer is to start close to home. This way, the risk is reduced, you'll know more about the local situation, and you'll know the right people to talk to.

There are some instances, however, when long-distance work can be useful, such as where a skilled video activist provides essential training and support to an inexperienced video activist on an infrequent basis.

3

Equipment

People often ask what equipment is needed for videoing. The answer is that it depends on what you're planning to do. If you're using camcorders for witness use then the cheaper the better, as the camcorder might get smashed or taken and you want to be able to afford to replace it. If you're collecting footage to sell to television, then you want a better quality camera with all the gadgets necessary to achieve the required standard.

This chapter provides a basic list of equipment, with suggestions for specialist videoing. It appears early in the book as many people don't get beyond the stage of getting their gear together. If you find all this technical talk boring, or if you know it all already, just skip ahead to the next chapter, which looks at how to get the best use out of your equipment.

FINDING A CAMCORDER

To begin with, you'll probably want to take a camcorder out a few times to assess how useful it will be. At this stage, at least, it makes sense to borrow one. Try some local contacts. Perhaps a member of your family bought one to video the kids growing up. Or maybe the school has one to record school events. Ask your local community centre, your neighbours, the parish church, the fire brigade, the youth club, the football team. The chances are there's one near you.

However, if you simply don't know anyone who has a camcorder, you'll need to either hire one or buy one. If you choose to hire, shop around to make sure you get the best quality equipment for your

money. Also, check that it is insured in case of damage or theft. Let me emphasise, however, before you spend your scarce resources, hunt around to see if you can borrow one.

THE BASIC KIT

To do video work you'll need a basic kit (Photo 3.1). Video equipment means more than simply the camcorder itself. Most of the other items listed below will be supplied with the camcorder; the rest you'll have to get separately.

- Camcorder – This can record and playback images and sound.
- Two batteries – One battery will come with the camcorder; buy another long-life one.
- Battery charger – This will come with the camcorder.
- Camcorder to TV/VCR cables – These should come with camcorder, and will allow you to watch footage on a TV screen and transfer material to a video player.

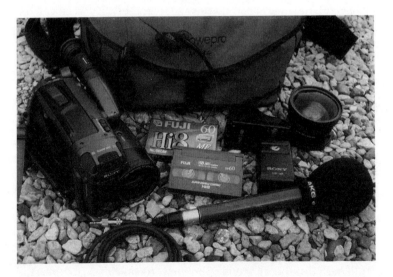

Photo 3.1 Basic camera kit (photo: Paul O'Connor)

- Tape – It's worth spending enough money to buy high-quality tapes (note that if you shoot on Hi8, Fuji is better and cheaper than Sony). Don't re-use tapes unless you're absolutely sure you don't want to use that footage ever again; the quality degenerates with each repeated use.
- External microphone – It is always better to have an external microphone as on-board mics aren't very good quality. External mics allow you to get up close for sound while standing back for the images (see p. 36).
- Headphones – These are very useful to ensure that sound is working. Try to get good ones that allow you to hear sound above background noise.
- Camera bag – This is vital for keeping the equipment safe.

Ninety-nine per cent of video activist work can be done with this kit. Having the entire kit will make a big difference to the quality of your video work, and I can't recommend highly enough that you take the whole kit along with you whenever you go out to shoot.

If you decide to buy, once you've bought this equipment, you won't have to hand out much more money – at least, not in large amounts. Tapes and repairs, however, will continue to be a never-ending source of indebtedness. A good quality 90-minute Hi8 tape costs between £8 and £12, depending on where you buy it. You can expect to pay £300 to £500 every 18 months on repairs.

CHOOSING A CAMCORDER

Choosing the right camera for your campaign work is difficult, because you'll have a number of different criteria: for example, price, resilience, features, quality and ethics. Your choice will depend on your intended use. For all but the most sophisticated strategies (i.e. broadcast documentaries) a one-chip Hi8 will be more than adequate. Equally, for most witness and campaign work, even a VHS camera will be fine. The most important thing is that you're out there videoing what is going on, rather than sitting at home waiting to buy the 'best' equipment so you can take 'perfect' images.

Here's a list of domestic and semi-professional video camcorders you can buy, in descending order of quality:

- Digital Video Camcorder (DVC) Stores to a small 6mm tape
- Hi8 High quality 8mm tape
- SVHS/SVHS-C Super VHS (C indicates small cassette format)
- 8mm Low quality 8mm tape
- VHS/VHS-C Tape used in domestic VCRs (C indicates small cassette format)

Note that the professional broadcast industry standard camcorder format is BetacamSP. This is far too expensive for most video activists to use. Digital cameras are relatively new. They record to a small 6mm tape, like the DAT (digital audio tape) cassettes. They are more expensive than the Hi8 cameras, but the quality is far superior – almost on a par with the broadcast-standard BetacamSP tape. They are also lighter than Hi8 cameras while having most of the same features (Photo 3.2).

Note that you can often buy 'three-chip' versions of the Hi8 and digital cameras. A three-chip camera means that it has three sensors (CCDs)

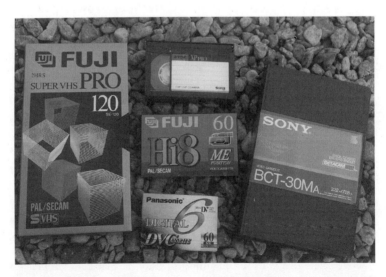

Photo 3.2 Types of tape format (l–r): S-VHS; SVHS-C; Hi8; DVC; BetacamSP (photo: Paul O'Connor)

for each of the three red, blue and yellow light ranges. This produces less 'flaring' and 'bleeding' of colours in high-contrast situations. However, although this is a desirable function, it is not necessary for most video activists.

If you're thinking about selling to television, requirements vary from place to place. Increasingly, television companies are happy to use quality Hi8 images, but nothing of lower standard unless it's truly sensational footage. Also, remember that the larger a station's audience (i.e. national as compared to local television) the better quality footage it will expect. But don't be fooled into buying more than you need. Save the money for repair and tape costs.

Ethics

When you choose which equipment to buy you may want to consider the ethics of the various manufacturers. Consumer pressure can have an enormous impact on corporate behaviour. The table overleaf is a rough guide to the ethics of some very large and constantly changing corporations. For more in-depth and up-to-date information, contact the Ethical Consumer Research Association (see p. 228 of Resources).

Working abroad

If you're going to be working with video in or from different countries, you need to be aware that tape standards vary, depending where you are. There are three main tape standards:

NTSC North America, Japan, Korea, most of South and Central America
PAL Most of Western Europe, Australia, Israel, China, India, parts of Africa
SECAM France, Eastern Europe, former Soviet Union, parts of Middle East and Africa

I learnt this the hard way. I went to Nicaragua to make a campaign feature about a development project funded by some American students. I borrowed the students' VHS camcorder to save money, and shot hours of material. When I returned home I found that I couldn't

Ethics of video equipment manufacturers

Brand/Parent company	Pollution	Environmental policy	Nuclear power	Animal testing	Oppressive regimes	Workers' rights	Armaments
Fuji		?			▲		▲
Samsung		■			▲		
Sony	▲	▲			■		
Aiwa/Sony	▲	▲			■		
Sanyo		?			■		
Panasonic/Matsushita		▲	▲		■	■	
JVC/Matsushita		▲	▲		■	■	
Philips	▲	■	▲		■	■	
BASF	■	?			■	△	
Canon/Fuyo	△	■	△	△	▲		□
Sharp/Sanwa	△	■	△	△	▲		□
Maxell		■	■		■		▲
Hitachi		■	■		■		▲
AGFA/Bayer	■	?	■	■	■	■	■

▲ quite bad
■ very bad
△ quite bad record of related company
□ very bad record of related company
? company has not yet been asked

Pollution – A square indicates that the company has been prosecuted for exceeding its emission consents or otherwise criticised for polluting activities. A half square indicates a lesser degree of polluting activity.

Environmental policy – A square indicates that the company has no written environmental policy statement, or did not reply to a request for one. A half square indicates that the company sent *Ethical Consumer* a statement, but that this contained no fixed targets.

Nuclear power – A square indicates that a company is involved in research into nuclear power, production or distribution of nuclear power and/or mining of uranium. A half square indicates production of nuclear-related equipment.

Animal testing – A square indicates a licence to vivisect or involvement in vivisection. A half square indicates that the company subscribes to the British Industrial Biological Research Association, which carries out contract animal testing for companies.

Oppressive regimes – A square indicates that the company operates in countries criticised by the Amnesty International 1993 report for (i) torture, (ii) extrajudicial executions or disappearances; (iii) prisoners of conscience; *and* (iv) in *World Military and Social Expenditures 1993* for 'frequent and official violence against the public'. A half square indicates that the company has been criticised under three of the four categories.

Workers' rights – A square or half square represents either problems of trade union recognition or commentator's criticisms of particularly heavy-handed response to industrial action, or criticisms that wage levels are not enough to live on, or dangerous working conditions.

Armaments – A square represents involvement in the manufacture or supply of weapons and/or other combat equipment. A half square represents the manufacture of non-strategic goods and products for the military.

Compiled from information given in the *Ethical Consumer Magazine* (issues 28, March 1994, and 43, September 1996). Both have research supplements for in-depth detailed background information on each company. All marks are given for behaviour within the past five years.

edit my footage on an English edit suite. I couldn't even view it on an English TV monitor. A few months later, I flew back to the United States and eventually hunted down a video production company in Minneapolis who let me edit during their off-peak hours – 5.00 to 8.00 a.m. While I was hanging around outside in temperatures of –90 degrees centigrade (with the wind) waiting for someone to open the door, I resolved that this wouldn't happen again.

So remember to check your video standards before you work out your production schedule. This means that, if you're sending a tape from the United States to be watched in Australia, the tape will either need to be converted from NTSC to PAL, or the people in Australia will have to find a VCR that can play more than one standard (sometimes called a 'multi-standard player').

Functions

There are a number of extremely useful functions that are not universal on camcorders. Look for the following in particular:

- manual focus, exposure and white balance (see Chapter 4, pp. 54–6);
- a lens that accepts wide-angle converters;
- external mic and headphone sockets;
- timecode display (in addition to the normal counter) – very helpful for editing (see Chapter 9, p. 151–2);
- display function, which sends what you see on the viewfinder to TV, including the counter reading;
- remote control, to enable you operate the camcorder like a VHS deck;
- manual sound – this is only available on a few domestic cameras, but get it if you can.

Functions such as titling, fading and digital effects are undeniably appealing. They are not important, however, and can be a nuisance if you don't realise they're on.

Sony now supplies over 75 per cent of the 8mm and Hi8 market, although other manufacturers' products are worth investigating for specialist needs. Hitachi, for example, makes good waterproof models. Canon makes camcorders with comprehensive manual functions and

the ability to swap lenses – for this reason photographers like them. Likewise, Panasonic and JVC make good reliable SVHS cameras. If you don't buy Sony, however, be aware that sharing accessories like batteries with other people becomes more difficult. And to be sure of getting a high quality product, it's wise to avoid buying brands other than the five main ones mentioned.

You can pick up a secondhand camcorder for 50 to 70 per cent of new price value. Some photo shops set up secondhand outlets. For instance, in the UK, Jessops operates a secondhand hotline that accesses a database of all secondhand equipment available at shops around the country, and offers guarantees. Another way to track

Photo 3.3 Types of cable (l–r): Scart; Mini-jack; BNC; Quarter Inch; Phono/RCA (photo: Paul O'Connor)

Different types of leads and cables
- Aerial
- Scart
- Phono/RCA
- Quarter Inch
- Mini-jack
- Y-C/S-Video
- BNC

down secondhand gear is through newspapers and magazines. A good source in Australia, for example, is the *Trading Post* (available at newsagents), which has listings of secondhand equipment. Make sure you get at least a three-month guarantee, because secondhand camcorders can be in a bad state (the recording heads are often worn out).

If you don't have the money to buy your own equipment but really want to, there is another option. Video activists can purchase and upgrade their equipment by pooling resources. If you band together with others in a similar position, you can share your funds to buy as much equipment as possible, which you can hire out at a small profit, and then use the earnings to buy new and better equipment.

SOUND EQUIPMENT

Sound quality is probably the most underrated aspect of non-professional video-making. Most people simply don't think about it when they are shooting. They equate video with images rather than sound. This is a big mistake, and goes a long way to explaining why people find it difficult to watch non-professional footage for any length of time.

Of course, the best way to improve sound quality is to be attentive to it (see Chapter 4, p. 57). But it helps if you have the right equipment.

Microphones

All camcorders come with their own built-in microphone. These vary enormously in sensitivity. Some pick up camera noise (the sound of the camcorder's own machinery in action), while others wouldn't register a jet aircraft taking off a few metres away. However, all on-board microphones suffer from poor range. This means that to record good sound with these mics you have to get very close to the source of noise (that is, within two metres). This has the obvious disadvantage of not allowing you to take wide shots with the camera.

As I've already pointed out, the answer to this problem is to use an external microphone (Photo 3.4). This has two main advantages: first, you can use better quality equipment; second, you can get up close with the mic while staying further away with the camera.

There are basically two main types of microphone:

- directional (or cardioid), which picks up sound in front of the mic and at some distance;
- omnidirectional (or omni, for short), which picks up sound in front, to the side and even behind the mic.

These can be used in different positions and places:

- on-board – attached to the camera;
- hand-held – good for journalist image but awkward if there is only one of you, and you need to avoid handling-noise (sound of hand moving on mic);
- boom – a long pole with a mic attached, held away from the camera and near the source of the sound; it is the best technique for getting good sound, but it requires two people;
- clip (also called 'lapel' mic) – usually attached to clothes of subject;
- radio mic – normally a wireless clip mic that transmits to a receiver some distance away.

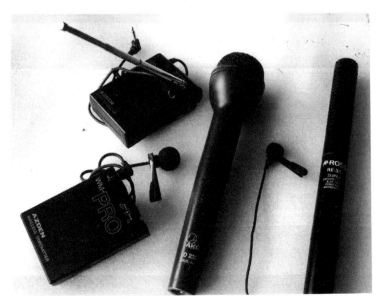

Photo 3.4 Common types of mic (l–r): radio mic transmitter receiver; omni; clip/lapel mic; directional (photo: Paul O'Connor)

Different external mics are useful for different purposes. For example, omni clip mics are great for static interviews. Directional mics are ideal for taking interviews where there is a high background noise (such as with someone taking part in a march). Omni mics are fine for recording ambient sound, music and narrations. Radio mics are good for interviews with people who are moving or who would be hard to get a cable to (for example, someone locked on to a bulldozer).

If you intend to buy only one external microphone, then a good quality directional microphone is probably the best buy. It will enable you to take interviews at a greater distance and will emphasise the sound of what the viewer will be seeing in front of the lens. While omni mics tend to pick up a richer sound than directional mics, their shorter range means that to achieve good sound quality in interviews you'll have to ask the subject to hold the mic.

When buying an external microphone, it is well worth spending the extra money to get a good quality product. You can buy a directional mic for under £30, but the sound quality will be poor compared to that of a mic costing £80 to £100. If you're willing to spend over £500 on the images, it is surely silly to scrimp on the sound. Senheiser – the television industry standard – make the best domestic directional mics (professional equivalents cost over £500). For omni mics it is best to go with the professional equipment. Try an AKG, available for just over £100.

Many domestic camcorders don't have a 'hotshoe' plate – the metal slot that lets you attach an external mic easily. To solve this, you need to get a bracket attachment with its own hotshoe plate, which screws into the bottom of the camcorder using the socket you use to fix it to a tripod.

Automatic/manual sound

One of the most disappointing aspects of domestic camcorders is that, almost without exception, they don't have a manual sound option. Some people claim that camcorder manufacturers stopped making domestic cameras with manual sound when they realised that professionals were buying them in preference to the more expensive 'professional' equipment.

As with all automatic versus manual issues, the distinction becomes clear when the input is variable. For instance, if you're interviewing

someone on a busy street, then while the person is talking the sound levels of passing cars are low, but as soon as he or she stops talking the street noise is automatically lifted to maintain a 'constant' level. This can produce an odd sensation of seasickness as sound levels rise and fall.

A simple solution, of course, is to move away from the road, but this is not always possible. A more cunning solution is to run the sound from the microphones through a sound mixer (an expensive piece of equipment), control the levels there, and then run the sound to the camcorder. If you do this, be careful. You'll have to change the input level from line to mic frequencies, and watch out for balanced/ unbalanced signals.

Manual sound levels would certainly be an easier option. Unfortunately, however, you almost certainly won't have a choice in the matter. In any case, for most people an external mic is more than good enough. (See Chapter 4, p. 57, for tips on getting good sound.)

Finally, some Hi8 camcorders have the additional option of PCM sound. This is higher quality than standard AFM sound. Only a few Hi8 edit players can record or play back this sound; therefore it is a useful but not important feature.

ADVANCED EQUIPMENT

There are a number of gadgets that will make your video work easier and give you more control over the sound and images you want to record. Here are a few options.

- Tripod – A tripod is very useful for shooting by yourself and doing interviews. It allows you to set up shot and then let the camera record while you sit next to it asking questions. However, be aware that tripods are too big and bulky for most action situations and tend to reduce videoing to dull, static images. It may be worth considering one of the small stills-camera tripods that fold up to the size of a pen. They will fit in your camera bag and can provide 90 per cent of your steady-camera needs.
- Battery discharger – Many batteries are nickel cadmium, and they suffer from memory effect, which means they lose storage ability if you recharge them before they are fully discharged. So, to avoid this effect, always use a discharger before recharging.

- Rain jacket – camcorders hate the rain.
- Battery belt/pack – These can last up to four hours and ensure adequate battery time for long shoots.
- Light – A light is essential for night-time shooting, though make sure that you don't give covert actions away with your glaring beam. The best models are halogen and attach to the camera on the hotshoe.
- Wide-angle lens – Most camcorders can take wide angle lens adaptors, which are good for action videoing. Make sure you can't see the edge of the lens when you're zoomed out.

LOOKING AFTER YOUR EQUIPMENT

To state what should be the obvious, you *must* look after your camera gear. Many people neglect this fundamental rule. I've seen people sit on their cameras, tip hot tea on their tapes, misplace key cables, and overcharge batteries. The keen video activist must be a disciplined video activist. Here are some tips for looking after your kit.

- Don't leave your camera lying around on a floor or table in case someone knocks it over.
- Keep your kit together. Don't split it up in various places.
- Carry your kit in a padded bag, not in an open rucksack or plastic carrier bag. You can keep it cheap by padding non-professional bags with foam. Traditional stills-camera bags are best but can be expensive. Make sure that the strap is strong and that there's enough room for all your accessories.
- Put an ultraviolet lens/filter over your lens to protect it from scratches. It's cheaper to replace a filter than an entire lens.
- Tape over the gaps along the tape cover on the camera in dusty situations. Don't use electrical tape, duck tape or Sellotape as these leave a sticky mess after you remove them. Professional 'camera' tape (normally white) is good and fairly cheap.
- Always discharge your batteries (if nickel cadmium, which some still are) before recharging, otherwise they will lose capacity over time. The new lithium batteries can be recharged without discharging. You should always turn off after use and carry a spare battery in case you run out. Remove the small 'calculator'

batteries from clip mics after use and store them in a safe place to avoid draining charge away.

- Have a rain jacket for your camera in case of downpours, or have a mate hold an umbrella over you when you video. At least carry a plastic bag with you. Watertight containers that people use in kayaks can also be useful for total water protection for long journeys.
- Label your equipment so that you won't confuse it with other people's.
- Don't view your tapes too much. After repeated playback they tend to disintegrate. If you want to preserve the quality of your footage, transfer it to another tape (BetacamSP if you can find one, otherwise SVHS or VHS) and view and edit the footage on that.
- If you plan to lend out your equipment (which isn't advisable unless you really trust the person involved), do an inventory of what you have before you hand it over.

POWERING UP IN DIFFICULT PLACES

If you find that you're having to shoot in out of the way places like the Amazonian jungle or the top of a tree, you must make specific technical preparations. There are no easy answers for this type of shooting so I can give only a brief guide. You should get advice from someone who has shot in this kind of situation before. The biggest difficulty you'll probably face is in obtaining power. A few people have found creative solutions to the logistical problems of this.

- Australian Dean Jeffries used solar panels while videoing in the Ecuadorian jungle. These charged up a 12-volt car battery, which in turn charged up sealed lithium batteries via a converter to transform the current to a camcorder-friendly 6 volts. He bought the batteries and converter from a model aeroplane shop.
- Gary Kaganoff needed five weeks' worth of batteries while making his wildlife video in the Tarkine Wilderness in Tasmania. Before his trek he made drops of food, two weeks apart, as well as vast quantities of AA batteries, which he could use with a converter for his camcorder.

- At the 1995 Glastonbury Festival, **under**_currents_ worked with Techno Tribe to use wind power to project the latest video magazine for over two hours in a very atmospheric night-time screening.
- For shooting in National Forest areas in Oregon, Tim Lewis uses a power inverter, connected via a cigarette plug to a car at one end and a camcorder charger at the other.

Getting Started

The central philosophy behind grassroots video activism is that anyone – with access to equipment and training – can make good use of a camcorder. Furthermore, there is a great need for video work, and there are many issues, campaigns and community events that are desperate for coverage. It is easier than most people think, and it is possible to have a tremendous impact.

Some people become intimidated by the technology. Others feel awkward poking a camera lens into people's faces. Some even question the role that a camcorder can play in a campaign or community work. Nevertheless, more and more activists have begun picking up camcorders to help bring about change in their communities.

Here are some examples of how novice video activists have used their cameras.

- Hazel borrowed a camera from a friend and went down with a camcorder to the No M11 Link Road Campaign in East London. She rang up the local TV channel and managed to sell the footage to the evening news.
- Carla taught herself how to use the camera that someone had left at the forest blockade in Warner Creek, Oregon. When the Forest Service Law Enforcement arrived to clear the road she was ready to capture the whole thing on camera and to make sure that the 'freddies' (as the federal police are affectionately called) didn't get violent or out of control.
- Paolo from Milan learnt to use a camera at film school. He began using his camera in campaign work to track the activities of a

toxic waste incinerator. The footage he gathered was used by the campaign to motivate others to become involved.
- Ceri and Geoff were trained how to use a camcorder in a workshop. They videoed their crazy anti-road road trip (which culminated in their donating their car to 'carhenge') and edited it on a simple VHS to VHS edit suite. The video feature, *To Pollok with Love*, proved a great success with campaigners, was chosen for the French Environmental Video Festival in Paris, and clips were shown on MTV Europe and BBC Television.

THE PSYCHOLOGY OF VIDEOING IN PUBLIC

In my experience, the biggest problems that people have when using a camcorder are psychological. The technical details are relatively easy to master. More difficult is tackling issues such as identity, privacy and confidence. There are no easy answers to these problems. The best piece of advice is that the more you take your camcorder out into the public, and the more you challenge your own fears, the easier it will get.

Confidence
Many activists lack confidence when they first pick up a camera. It may be the first time they have had a specific role to play, or they may feel the pressure from a group to 'get it right'. To combat this, practise away from a campaign situation, somewhere calm, so that you can ensure that you feel confident about the technical side of things. After that, set yourself small goals, so that you can see successes build up. Don't be too ambitious at first. Don't assume that you'll get footage onto national television or capture some outrageous corporate slip-up at your first attempt. Try to cover an event competently and then show it to a few people at home. Perhaps, you could video another activity, select the best bits for transferring to a VCR (see Chapter 9, p. 162–3) and then show it back to the whole group as a whole. From there you can build up to even more challenging tasks.

Identity
One of the biggest issues that activists face when picking up a camcorder is that of identity. What am I? Am I a video maker or an activist? There are, of course, plenty of situations where this question has serious consequences. For instance, do you obey a police officer who asks

everyone to leave a site because of trespass? What do you say to journalists when they ask who you are? Do you join in when an activist calls out for more people to climb onto the bulldozer?

Here's a classic example of this kind of situation. A woman was sitting in a tree to protect it from being cut down to make way for a road through Solsbury Hill in Bath. A security guard decided to dislodge her and began shaking the tree. Fortunately, there was a video activist nearby who was in a perfect position to record the entire incident. Images of a security guard's physical abuse of a protester would have been extremely useful to the campaign. But the video activist lost sight of her role and began shouting and screaming at the guard involved. The camera footage was extremely shaky and failed to capture the protester as she fell out of the tree. The video activist's involvement was completely unnecessary as there were plenty of other people around to provide support to the protester. After the event, lawyers and television journalists wanted footage to back the story up, but it wasn't good enough to use.

Most experienced video activists will say that the best answer is to decide what you're going to be for the day and stick with it. If you're going to use a camcorder, you should remain a video activist throughout an action or event. If you're going to be an activist, leave the camcorder at home. Of course, your motivations are the same, but tactics for the day will be different.

Close encounters

A common observation made by novice video activists is that they feel uncomfortable about getting up close to people and sticking a camera in their face. Some say there's an issue of privacy at stake. Others simply feel nervous at being in someone else's space. There are a few ways to make things easier. One is to make the group you're working with feel that they own the videoing process. To do this you can announce your intentions at a pre-event meeting, explain how your video work will support the campaign objectives, and ask if anyone objects to your videoing at the event. Similarly, at the event itself, it always helps to ask people if they mind you taping them before you do so. Sometimes, though, you won't want to ask permission, either because you don't want to miss the action or because the person you want to tape (a government official, for example) is too important for you to risk giving him or her the chance to say 'no'. At the end of the day the problem is unavoidable: you really must get close to record good sound and images. The uneasy feeling does diminish over time.

Gender

In some countries, like the UK and Australia, there are far more men using camcorders in campaign work than women. This can in turn deter more women from becoming video activists. The inequality can be put down to a variety of factors: video equipment can be expensive and it is often the men who control the group finances; video work can confer high status on the operator within a group and therefore men tend to be keen to take on this type of work; historically, professional camera operators have tended to be male and so they provide the role models; and, in society generally, women are conditioned to leave the 'high technology' to men. However, there is a large and growing number of female video activists. They often find that they can gain easier access than men to community and campaign groups, especially to those intimidated by and cautious about the media. At the same time, in order to counter the imbalance that does exist, some people have begun running training workshops specifically for women (see Chapter 12, p. 215).

Loneliness

Deciding to play the video activist role can be quite strange, and even lonely at times. Though you will have made contacts with the group before an event, when it takes place you'll be by yourself. It is important for you to prepare yourself for this experience. Many video activists have reported a feeling of alienation: they can't express their opinions on the issues, nor can they get involved in any situation of conflict that might be happening in front of them, nor can they bond with the other parties involved like the police or the media. One good way of reducing this sense of isolation is to agree a time when you can meet up with the whole or part of the group after an event. This will help you feel part of something. Another way is to team up with a buddy. Again, the more your work is owned by the whole group the more you'll feel part of a crew. Make sure you let people know *why* you're videoing before you go out, and involve them in working out the main objectives of the project.

Selection

Some people who start videoing find it difficult to decide what to focus their attention on. A lot may be going on around them; there may be too many points of conflict to witness all at once, things may start in one place at one moment and then suddenly stop only to start

somewhere else the next. 'What shall I video? I can't video everything!' they cry. Of course things get easier with practice, but a good rule of thumb is that, if you're videoing something interesting, stick with it. If there are two people being arrested by police, it's better to video one properly than two badly. Again, work out the shots you need to make the story clear. For example, if it's a banner being dropped from an office, you need to capture the moment when the banner is being unfurled. If you miss this, and simply video the banner after it has been dropped, you've missed the essential moment. Another tip is to step away from a situation so that you get a wide shot. Having a buddy to be your eyes and ears can help if something really does happen that you can't miss.

Boredom

Boredom can be a big problem of video activism. You may go out with activists ten times and nothing much may happen. Of course you get the satisfaction that the camcorder may have prevented an incident, yet it can still be disillusioning.

In the UK the Hunt Saboteurs have made use of camcorders for years as a witness to their efforts to stop the killing of foxes and deer as sport (see Chapter 5, p. 67). And yet, despite all the times they have successfully used video, people still complain about having to take the camera out rather than doing the action themselves. To overcome this, some groups pass the camera around, so that saboteurs can take turns in becoming video activists.

If you have a rotating video activist role, however, it is important that everyone involved is properly trained and is committed to video. Limiting the pool of video activists to two or three is probably best. Another way of tackling the boredom problem is to think about making a campaign video and start structuring your videoing around that (see Chapters 8 and 9).

Despair

Videoing situations of conflict can be very tough on your nerves. There may be many times when you have to hold your camera still as it records the horrors before it when your gut reaction may be to run away. Similarly, videoing in a conflict situation where you yourself might be a target can be exhausting. It is important to spend time after the event dealing with these issues. Talk it through with someone you can trust to be supportive. Share the experience with other video

activists to see how they have dealt with that kind of situation. Look after yourself, otherwise you won't be able to face going out again, and the next abuse will go uncovered.

GETTING GOOD IMAGES

The easiest way to get good footage is to keep everything simple. Most action will speak for itself. Your main aim is to capture an event as clearly as possible. If you really want to include strange camera angles, digital effects or jerky camera movements, do so rarely. Audiences will have a low tolerance for such gimmicks and will switch off.

Most novice video activists are used to watching programmes on television and therefore often make the mistake of trying to produce a finished edited video while they are actually shooting out in the field. This is known as 'in-camera editing', and is extremely difficult to do. Novice video activists tend to take short shots, pan and zoom a great deal, and cut in and out of music, with unwatchable results. It is much better to separate the shooting or production phase from the editing or post-production phase. With this in mind, the aim of a video activist is to gather as much material as possible – within the scope of the project's general aims – giving the editor as much choice as possible later on in the edit suite.

Basic principles

Setting up
As the first part of a tape has an unsteady signal, record 30 seconds of blank on the tape (if you're at the beginning) before you begin recording an event. Check again that all the gadgets are working. In particular, make sure that the microphone is working properly by checking the sound quality through the headphones.

Best position
Domestic camcorders are great given their price, but they are still not as good as broadcast cameras. So you need to make every effort to reduce their limitations and make the best of the kit you have. One area where this is particularly important is distance. Camcorders don't operate well for long-distance shots. They can't cope with too much

Photos 4.1–4.4 *clockwise from top left* How to hold a camera: 1. Arms braced underneath; 2. Elbow supported by other arm; 3. Tilting up; 4. Resting the camera on the ground (photos: Paul O'Connor)

contrast in the image, their microphones pick up only nearby sound, and when you're zoomed in for a close-up the image is shaky. The answer to all these problems is to keep the lens constantly zoomed out (wide open) and get right up close to the action. The best distance is two to five metres from whatever is going on. Of course, if you want a general set-up shot, go back as far as you need to get it, but then return to the close-up for the best action shots.

Keeping it steady

A key to good video work is getting stable images. Use both hands to hold the camera steady – one in the strap; the other supporting the camera from underneath. Brace your elbows into your chest, and push the viewfinder (I mean it) into your eye (see Photos 4.1–4.4 for various ways to hold the camcorder). You can use tripods but, as I explained in Chapter 3, they are often unsuitable for community and campaign events as they are so bulky. They also lead to inert videoing and creative complacency. Tripods are useful, though, for static situations like interviews and shots of wildlife and scenery. One trick is to balance the camera on or against something, such as a table, a door frame or the ground (the last gives good street-level effects, especially for dancing and marching).

Composing

Be aware of framing. Don't cut off heads! If you have a main subject don't give it/him/her too much sky space (see Figures 4.1 and 4.2) . Always video people at eye level, unless you're after a particular effect – for example, to make people look pompous or godlike you can shoot from below. Stick to the 'rule of thirds': split the screen into three vertical columns and three rows and place the subject's main features along these lines. For instance, when interviewing someone, place the eyes level with the top horizontal line, and align the nose with one of the vertical lines. Place a right-facing subject on the left side of screen and a left-facing subject on the right side of screen – this gives the subject 'looking space' and it will seem more 'comfortable' to the audience. Note that camcorder viewfinders show slightly more than television screens, so don't frame anything too tight.

Don't pan and zoom

One of the newcomer's biggest mistakes is to pan and zoom too much. Panning is when you physically move the camera from left to right

or vice versa. Zooming is when you gradually change the lens setting from telephoto (close-up) to wide angle, or vice versa. Both movements are very difficult to pull off without making the viewer feel sick, particularly on unstable camcorders when you aren't using a tripod. Zooms are also electric and so use up the battery. It is tempting to use zoom and pan, partly because we see them on television and partly because it seems boring to shoot still shots all the time. If you look closely next time you watch television, however, you'll see that there aren't many pans and zooms; this is an illusion produced by cutting between wide and close-up shots of the same subject. So these are the shots you should take, and then you should let the editor do the cutting between the images. If you want to introduce motion, move your body *not* the camera lens. Move about, try different angles,

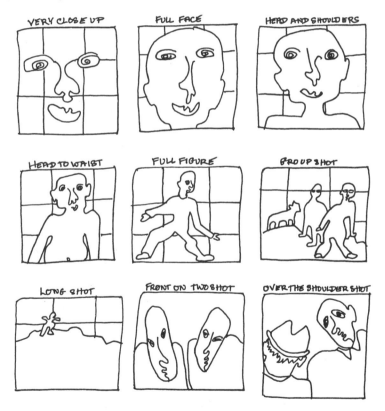

Figure 4.1 Different composition shots

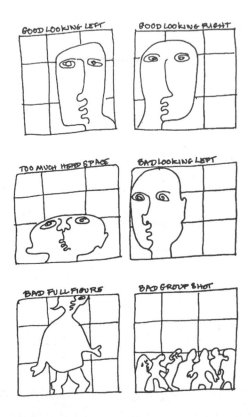

Figure 4.2 The rule of thirds

distances, tilts. There is one situation where pan can be used to good effect – the group shot. Try it, but practise before you shoot and keep it slow and steady.

Cutaway shots

These are general descriptive shots that can be used in the editing process to give the flavour of a scene. For example, at a rally they may include a close-up of words on placards, a wide shot of the whole group, or a shot of the police standing near by. Cutaways are particularly useful as 'wallpaper' images to paste over music or to cover the gap when you cut two pieces of an interview together. The secret of taking good cutaway shots is to treat the camcorder as if it were a stills camera.

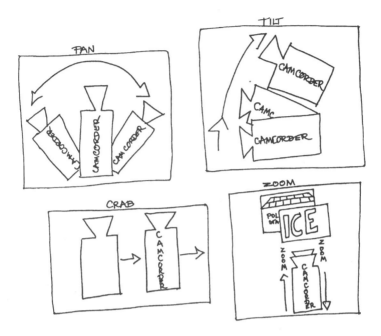

Figure 4.3 Four different camcorder movements

Let the action do the moving, not the camera. Spend some time composing the shot (don't forget to switch to standby), and then record for at least 20 seconds. Count it down; it will feel like an eternity. Sometimes this can be frustrating, but it makes for better viewing. The editor will cut everything down later for sharper, shorter shots.

Recording high-activity footage

In situations of action – like an energetic arrest – just let the camera roll. Don't bother switching off and on because you may miss a key piece of the action. This type of 'in yer face', confrontational action rarely lasts that long, so don't worry about your batteries. Leave the settings on automatic unless you feel very confident about the manual functions. If you're in a crowd, lift the camera high up to get a better view. Keep recording even if you're being dragged away. During the occupation of the Shell AGM in 1995, Roddy Mansfield took some extremely evocative footage this way. We see the action taking place in the background between a pair of legs, receding, as the camera operator is being dragged away. If people are being arrested or removed,

encourage them to speak to the camera, as this can be a powerful sequence to use later on. Walking backwards can be a good way of capturing moving scenes such as marches. (See the profile on pp. 87–8.)

Short play (SP) and long play (LP)

Long play runs the tape at half the speed. This means that you can use less tape, but the quality is inferior. The only reason for using LP is to save money. It is far better to use less tape by being disciplined, as there are few uses for LP footage given its poor quality.

Automatic/manual focus

Most camcorders now have a choice between manual focus and autofocus. There are two typical problems with using autofocus. First, if the subject you want to focus on (say a woman) is positioned behind another large object (say a bush) then the camera – to your great annoyance – will focus on the bush rather than the woman. Second, if an object (say a bus) moves between the camera and the subject (say a policeman), then the camera will try and focus on the bus, and the policeman will blur in and out of focus. This is nauseating for the viewer. Finally, autofocus works even worse in low light. The answer to all these problems is to use manual focus. It's very easy, and just takes practice to develop speed and agility.

- Switch camera to standby.
- Zoom in (close-up) on the main subject of the shot.
- Let the camera focus automatically on subject.
- Press the button that holds focus (sometimes called 'hold', other times called 'focus').
- Zoom out (wide shot) to compose the shot as you want it.
- Begin recording when you're ready.

You'll find that, at whatever zoom, the image will remain in focus. This would not be the case if you focused while being zoomed out, and then zoomed in to compose the shot. You might leave the camera on autofocus if there is so much going on that you don't have time to focus or if you don't feel confident about using the manual focus. But ninety-nine times out of a hundred you can set a focus and just keep the same distance from the action if it is busy. You'll also find that, if you retain

the same distance between you (the camera) and the subject (the action), then no matter how much movement goes on within the action, so long as the action doesn't get nearer or further from the camera, it will stay in focus.

Note that focusing is much simpler if you have a focus ring on your camera. You simply switch to manual focus and then pull the ring till the image is in focus. As with manual sound, manufacturers are producing fewer cameras with focus rings.

Features you should know about, but will rarely use

Exposure

The exposure function controls the size of the lens aperture, which in turn controls the exposure – the amount of light that enters the camera. For the most part, autoexposure is very good on today's cameras. But there are a few occasions when you will want to switch to manual. The first is when the camera is underexposing the subject, either because the background is bright or because the subject is dark (with a human subject this may be because of skin colour, or shadow – from a hat, for example). A good example of this occurs when you try to video from inside a car on a bright day. If you take a steady shot of the driver, say, against the background of the window, the face will be dark, and if the camera is moving about the image will flow from dark to light, depending on whether the background is window or car interior. Again the effect is nauseating. If you don't have a manual exposure feature, you can deal with this by changing position or by getting a close-up shot so that back-light is not a problem. If you do have the facility, you can switch to manual exposure and set accordingly. This will hold the exposure if you move the camcorder to a different background.

Manual exposure is also useful when you want to underexpose the subject. The most common example is in a clandestine interview, when you want the subject to be in silhouette. All you do is place the individual in front of the window, and then set the exposure to reduce the light coming into the camera. Be careful though: some camcorder viewfinders underestimate the light coming in, so check the image on a good television screen to make sure that the person's anonymity is assured.

White balance

This is a function that adjusts the camcorder to the type of light that enters the lens. It does this because light varies according to its source. For example, tungsten light emitted by household bulbs is different from sunlight. You'll know that the white balance is set wrong if an image looks too red or too blue. This would happen if you hit the manual white balance by mistake. I would recommend leaving white balance on automatic. You'll have enough on your hands without having to worry about this function. If you're intent on setting white balance manually, place a piece of white card or paper in front of the lens reflecting the main source of light and then press the appropriate button on the machine to set the balance.

Digital effects, time and date

Many domestic camcorders have a range of digital effects, titles, and date and time features. In general, these are more of a hindrance than a help to the video activist. They tend to get pushed on at the wrong moments, producing nasty patterns over important footage or the date burnt into some beautiful scenic shot. The two most important things to know about these features is how to recognise them and how to turn them off. If you're committed to having the date on your images for reference purposes (most viewers hate it, and television stations loathe it), then just flash on and off at the start of the day's shooting, and don't touch it after that.

The ten most common mistakes when shooting video

1 Running out of batteries.
2 Videoing when you don't mean to (e.g. shots of walking feet) and not videoing when you do (i.e. leaving camera on standby).
3 Too much zoom and pan.
4 Videoing from a distance with zoom close-up, so that the image is wobbly.
5 Composing the shot with too much sky/space above the subject.
6 Accidentally switching on a digital effect.
7 Missing the action because you're videoing something else at the time.
8 Recording with the date on.

9 Switching off the camera too quickly after the action has stopped.
10 Failing to think about how the footage will be distributed.

GETTING GOOD SOUND

Most novice video activists pay far too little attention to sound. One of the most noticeable differences between 'amateur' and 'professional' footage is in the sound quality. This is partly because camcorder manufacturers provide less control of sound than of video (see the discussion on manual sound in Chapter 3, pp. 38–9), so you have to make a great effort to keep the quality up.

Interviews

Taking interviews can be one of the most enjoyable aspects of videoing. Before you start, work out what you want the person to talk about. Make sure that you're up close with your mic and away from background noise like road traffic. Use headphones to check that the sound is working; it is easy to lose an entire interview because the battery has run out in the microphone. Check that you're in a position to hold the camera steady comfortably. Ask open-ended questions (ones that the person can't answer 'yes' or 'no' to), such as 'Why are you here?' rather than 'Are you here today to stop the sale of Hawks to Indonesia?' Encourage the person to include your question in his or her answer – this allows the editor to cut you out of the piece and just have the answer (for example, 'Why are you here today?' 'I am here today because ...' rather than just 'Because ...').

Decide where you want the person to talk to. People feel more natural (and will seem more authentic to the audience) if they can talk *to* someone. So either have someone asking the questions, and get them to stand up close to the side of the camera, or ask the questions yourself and, once you've set the shot up, look up from the camera to maintain eye contact with them, checking the composure of the shot now and again. Don't move the camera from the subject's face while he or she is talking. If the person refers to something, video it later. The editor can always cut the image and place it over the sound of the person talking.

Many camcorder novices find themselves videoing hours and hours of speeches. Don't! They are boring. It is almost always better to do an interview with someone. The sound quality will be far higher and you'll be able to ask more focused questions. People tend to ramble far more when they're on a platform than if they're speaking to camera. Occasionally, however, you may be able to video a particularly fiery and passionate speaker in an atmospheric situation. This can work well, but make sure that you video shots of the crowd's reactions.

A key task for the video activist is to select interviewees carefully. The mainstream media overwhelmingly tend to give voice to the white middle-class section of society. As a video activist, therefore, you should strive to find interviewees to redress the traditional biases of the media. You must search out the 'woman who doesn't like being interviewed' in the group, and 'the old guy who gets a bit angry at times'. Don't limit yourself to the person who usually gets to give the soundbites to the local news. If you do this, you'll widen the skills gap within the group, and may miss the more authentic and passionate voices.

Don't forget to write down people's names in case you want to caption them later or need more information about what they said.

Capturing live sound

Live sound – also known as atmospheric or 'atmos' sound – includes music, chanting, clapping, and background sounds like marching feet. This kind of sound can add great pathos and atmosphere to an event. Make sure you tape at least one minute of high quality ambient sound whenever you're out videoing. If you're recording music, tape the whole piece or, if it is very long, at least two minutes, and make sure the sound quality is good. Don't forget that an editor can separate the sound and image later on, so different images from the event can be laid over the soundtrack you record. Get right up close and concentrate on the sound rather than the images. Think of your camcorder in these situations as a bit of radio equipment. Don't move the mic at all (so, if the mic is attached to the camera, this means don't move the camera) or the quality of the sound will change. Of course, you'll need a few shots of people singing and/or playing instruments that are 'in sync' (like the sound and image of a match being lit). But you can take cutaway shots of singing and/or playing after you've recorded the main soundtrack. The editor can put the two together later.

Recording sound for use in radio

Most domestic camcorders have the capacity to record sound that is good enough quality for use on radio. But few people think of this as an option for distributing their material. This is a mistake, because it is possible, with a little effort, to pass your video sound to radio journalists as 'actuality' (sound taken on location) for use in one of their features. This is particularly true if you've videoed an event in a unique way, or if you've been to a remote and distant location.

There are certain things to think about when recording for radio. First, of course, the quality must be good. As with recording interviews or live sound the trick to this is position, location and equipment. Radio producers are looking for atmospheric sound that illustrates and gives authenticity to the story being covered. But avoid anything that makes it hard to edit, such as music or repetitive knocking, if you want to have this as background to speech. For example, record chanting at a demo as a separate track and conduct the interview away from the crowd.

Always record a minute's stretch of plain atmos sound. It allows radio journalists to smooth over edits and record their own commentary, and even ask questions, as if they were there. Make sure that you also record as many sonic effects as possible – for example, if you're covering logging, you would want to record the chainsaws at work, trees falling, logs being dragged out of the forest and, of course, 'Timber!'

Remember that, unlike television, where poor sound can be made understandable by the images that go with it, radio relies on sound alone to make sense of what is going on. Make sure that everything is explained clearly so that it is accessible to a listening audience. Ask whoever you're interviewing to describe what is going on around them in colourful language that evokes the scene.

For example, if the subject of your recording was an opencast mining site, you might record residents singing a campaign song in the pub, the close-up sound of bulldozers at work, the rumble of rocks being moved, and residents walking to the edge of the site and describing the scene: 'We are walking up to the edge of the huge hole that makes up the opencast site. Enormous clouds of brown dust are billowing up from the bulldozers. A hundred yards away, children are playing in the yard of the village primary school. It's incredible. The diggers are at it twenty-four hours a day. I can hardly hear myself think it's so loud. It's horrible to live here. Something has got to be done.'

under_currents_ has managed to get sound from video footage onto the radio on a number of occasions. In fact, the example above comes from real life. In 1995, George Marshall shot some footage of residents from Sharlston, Yorkshire, campaigning to stop an opencast mine in the village. He then provided the material to Oliver Tickell, who edited it into a short feature for Radio 4's _Costing the Earth_, and later made a longer feature for the BBC World Service.

Ten tips for recording sound

1 Get up close.
2 Use an external mic.
3 Check the sound with headphones before you start, as well as during shooting.
4 Keep away from loud background noise.
5 Record interviews in front of people, not to the side or behind, to get a good sound level.
6 Do not talk, laugh, grunt or cough when your subject is speaking.
7 Ask someone who knows what the event is all about to describe the scene and explain why he or she is there.
8 Record music and atmospheric noises separately for at least one minute.
9 Think about gathering sound for radio.
10 Try to use the correct cables rather than adapters, which are easily jolted out of place.

TEACH YOURSELF TO VIDEO IN FOUR EASY STEPS

Before you take your camcorder on the first 'serious' day out, it is worth practising at home so you become at ease with your gear and more focused on what you're looking for. Everyone finds that it takes a while to feel comfortable when out shooting in public. There are many basic technical operations you need to master and there are many variables that could go wrong: running out of batteries, rain, end of a tape, darkness. By practising you can iron out any problems you may have and build up confidence for the 'big day'.

When you get your camcorder, go through the following steps:

1 Get familiar with the equipment. Try all the buttons. Know how to turn them on and off. Learn what the viewfinder symbols represent. Practise ejecting batteries and tapes. Practise holding the camera steady for a minute. Try different ways of holding the camera. Master the standby/record function. Charge the batteries.

2 Take the camera around your home. Think which shots best capture the essence of the place. Try taking some interviews with any nearby friends and family. Perhaps ask them what they think of your new camcorder toy. Practise taking long (20 seconds or more) and steady cutaway shots. Experiment with wide and close-up shots. See if you can hold an image as steady when zoomed in as when zoomed out. Practise composing using the zoom before you start recording. See how the sound quality is different if you tape close up and at a distance and, if you have one, compare internal and external mics. When you've finished, hook the camera up to a TV monitor and watch what you've shot. Ask for a friend's opinion.

3 Make a one-minute documentary about a local issue. Decide what that issue will be. Write down the main elements of the video. For example, if the documentary was about traffic-calming in a nearby street, you might want to get shots of congestion, a couple of interviews with local residents, and an illustration of traffic-calming already in existence elsewhere.

4 Go out and record the shots that you've written down. Try to limit the amount of tape you use – for example, ten minutes. Then come home and view the footage you've shot (preferably on a TV monitor). Take notes of the best shots as you go along. List the shots in the order that you want to use them in your video on a piece of paper. Finally, record from your camcorder to a VCR the shots that you want in sequence (see Chapter 9 for technical details on editing). Finally, show your first video feature to a friend to see what he or she thinks of it.

YOUR FIRST DAY OF SERIOUS VIDEOING

It's always hectic before you start videoing. Take a few minutes, therefore, to prepare yourself before the main action starts. Before you even turn on the camera, decide what your main aims are. Write down what you need to do to achieve them. For instance, if the task

is to make a video report in Iraqi Kurdistan about a newly built school to send home to the Save the Children Fund (SCF) head office, you might ask yourself the following:

Q: What key action should I video that would capture the essence of the event?

A: The opening of a village project or the kids learning in the newly built school.

Q: Where and when do I have to be to do this?

A: Near the ribbon, in the classroom.

Q: What shots do I need to set up or establish the 'story' for the viewer?

A: Wide shot of the village, shot of the Range Rover with its SCF sticker, close-up of the school sign.

Q: Who will best capture the atmosphere of the event, and when am I going to speak to them?

A: The head teacher, one of the students, the SCF project manager. Tomorrow afternoon.

Q: What restrictions might there be?

A: I can't video the oil refinery or the armed guards looking after us, and there's no nearby electricity so I need to take plenty of batteries.

Before you start videoing, check the following:

- You have plenty of tapes (two hours at least) and your batteries are fully charged. (Many people fail to capture that key event because they run out of battery juice.)
- Your gear is working properly. Give yourself enough time to borrow or buy replacements in case of problems.
- The microphone batteries are switched on.
- You're carrying all your gear with you, since you don't know what you'll need.
- You have some form of press card or ID if you think it will help, contact numbers for media and sympathetic lawyers, a press release of the action if available, pen and paper and sticky labels for the shot tapes, and a contact address.
- You have talked to the organisers of the event to find out what is planned, where the main action will be and how you can be of most help to them.

GETTING BETTER

It goes without saying that the more you have a go at videoing the better you'll get. Whenever you video, hook the camcorder up to a television (always better than through the viewfinder), and take a look at what you've done. Show the footage to friends, ask them if they like what you've shot, and how you could improve it.

The other great way to improve your shooting is to begin editing your material. For example, most people can only get their heads round the need for cutaway shots after spending hours unsuccessfully searching for a shot to paste over a cut linking two different sections of speech from some particularly verbose interviewee. We shall look more closely at editing in Chapter 9.

Witness Video – Legal Work

Camcorders can play a powerful role as 'witness' to an instance of abuse or injustice. The best known example is the 1992 video footage of the Los Angeles Police Department's beating of Rodney King, which was used to prosecute the officers involved. But people have used camcorders to prevent injustices as far back as the early 1970s, when video was first introduced. Since then, numerous groups, including indigenous movements, trade unions and wildlife protection organisations, have used video for witness purposes.

Many campaigners' first use of a camcorder is for witness video. The skill level doesn't have to be high and the equipment doesn't have to be expensive; the most important element is content rather than quality. Even if the footage is a bit wobbly or the exposure isn't quite right, lawyers can use video images of a person being assaulted. So witness video acts as good training for video activists who want to go on to other things, such as making community videos or selling to TV.

TYPES OF WITNESS VIDEO

Witness video can function in three ways: as a *pacifier* to calm things down in situations of conflict; as *defence* against false arrest or violent assault at demonstrations; and as *offence* when gathering evidence of some illegal or immoral activity.

Video as pacifier

Camcorders are used at demonstrations to calm things down. I've often heard a security guard or policemen tell his mate to 'take it easy,

they've got a video' during an anxious moment when it looked as though things might boil over. Some activists even use broken camcorders (available from camera shops for almost nothing) – if that's all they can get their hands on – simply to deter violence and attacks. Of course, if something terrible does happen it would be a shame it hasn't been captured on video for future use.

Occasionally, a camcorder can heat things up. Activists may 'perform' for the camcorder, or the authorities concerned may become fearful of the camera and target the person using it for removal. Similarly, the video activist may become involved in an event that then increases tensions. Ostensibly for these reasons, but normally as a tactical ploy, some people in authority may refuse access to a camcorder – for example, at a meeting where activists are negotiating with a board of directors. For the most part, however, camcorders pacify rather than excite.

Clayquot Sound

One group that has made regular use of camcorders at protests is the Friends of Clayquot Sound in Vancouver Island, Canada. Throughout the summer of 1993, over a thousand people were arrested in an attempt to stop the logging of Clayquot Sound, one of the last remnants of old-growth forest in British Columbia. To ensure that people were protected, the Friends of Clayquot Sound arranged the presence of a dedicated person whose sole purpose was to video every arrest as it took place. Police officers were careful during arrests because the cameras were around, and the video tape was stored in case protesters wanted to use the footage to defend themselves in court later on.

Anti-racist groups

Others using video as pacifier are anti-racist groups like the Newham Monitoring Project and the Anti-Nazi League in the UK. Police harassment often takes places at rallies and during marches, and video is used to calm things down during these events.

Street Watch

The Coalition for Homelessness is an advocacy group based in San Francisco dedicated to defending the rights of people living on the streets. In 1993 they set up their 'Street Watch' programme; which

made use of video camcorders to document abuses by police against homeless people. Over 100 people have been trained to use their three 8mm camcorders. At any one time there are 20 people available to shoot footage.

Street Watch works in a number of ways. Sometimes there happens to be a video around when homeless people are illegally asked to move on or are being generally harassed by police. At other times Street Watch videographers are requested to take testimony from homeless people after they've been physically assaulted. This type of footage is used as part of policy work, for example at Police Commissions, to provide evidence of abuse.

One day, for example, vendors of *Street Sheet*, a monthly paper written by and about homeless people, were harassed and arrested for loitering at a shopping plaza. Video activists were sent down to document what was going on, and soon the harassment stopped. At other times, Street Watch has organised three-day video vigils with the intention of documenting any harassment during that period. This type of work has proved successful in reducing abuses both at the time of recording and after the cameras have left.

Finally, Street Watch has been successful in supplying footage to television stations. They sell the footage at $100 per minute. They have even had documentary programmes approaching them for archive footage.

Other homeless groups around the country have set up similar Street Watch programmes, including New York and Austin, Texas. The National Coalition for Homelessness intends to set up a countrywide video initiative, where they can gather material from many different sources and compile a national archive of documented abuse and examples of successful use of video to reduce this.

Video as defence

Camcorders are also used at demonstrations to gather evidence to help sue the police for false arrests and violence against protesters. Again and again, video evidence has been the crucial factor in getting wrongly accused protesters off the hook, while helping others to sue the police and security guards for assault.

Hunt Saboteurs

Among the most successful groups to use video as defence have been the Hunt Saboteur groups in the UK. As early as 1985, they were taking camcorders out on every action to protect themselves against the hunters, their stewards and the police. In March 1993, during the Sussex Chillingford Hunt fox-hunt, a steward drove his off-road vehicle into a protester. The protester had a smashed pelvis and a broken collar bone. Luckily, Paul Davis was there with his video camera and he managed to get the whole incident on tape. The hunt steward was found guilty of assault and sentenced to six months in prison. Over the last five years the Hunt Saboteurs Association in the UK has won over £500,000 from the police in compensation for false arrests and assault, much of this on the basis of strong video evidence.

Aid Watch

In April 1995, Aid Watch, in Sydney, organised a disruption of a government-sponsored development aid conference, protesting about the types of project being supported in Asia. During the protest, Kel Drummet was arrested for assaulting a security guard. Luckily Mandy Smith was present with a camcorder, and footage shown in court made it clear that it was Kel Drummet who had been attacked by the security guard. Drummet was found not guilty.

Swords into Ploughshares

In one spectacular case, activists were able to introduce an edited video into the court procedure by leaving a video testimony at the scene of the action. In January 1996, three women from the group Swords into Ploughshares entered British Aerospace's Warton base in Lancashire. Once inside they located a Hawk aircraft destined for use by the Indonesian government to suppress the independence movement in East Timor. They smashed the plane with household hammers, causing £2 million worth of damage. They carried with them a previously made video tape detailing the background to their action and including testimony from each one as to her reasons for taking part. The entire tape was played during the trial, to great effect. People thought they saw tears in the eyes of some of the jurors. It was commonly held that the video tape evidence played a large part in the subsequent acquittal of the activists (Photo 5.1).

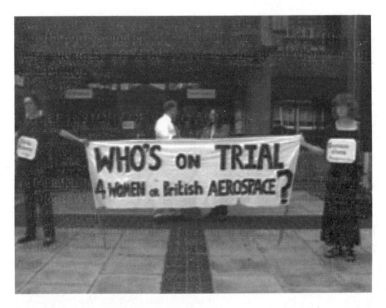

**Photo 5.1 Swords into Ploughshares protesters outside Liverpool court,
1996 (video grab: under***currents*)

Video as offence

Another use of witness video is to gather evidence of some wrongdoing
away from demonstrations and protests. This is a proactive role, with
an individual or crew going to the 'scene of the crime' to collect footage
as part of a wider campaign. This might be evidence of the illegal use
of an incinerator, destruction of wildlife, dumping of waste, cruel
treatment of animals, even police corruption. In many of these cases,
videoing will be covert (see pp. 83–5 below.)

Weavers Down
This type of video activism has been well used by groups monitoring
the destruction of wildlife in the UK. For example, in 1993, London
Kosaido (subsidiary of a Japanese printing multinational) began
clearing land on Weavers Down in Hampshire to make way for a golf
course. In the process they killed endangered species, including slow-
worms and sand lizards. Footage shot of the aftermath of their clearance
work was used by the local campaigners, the Bramshaw Commoners

Association, to prosecute London Kosaido (who were fined £6,000) and bring a halt to the construction of the golf course.

Deeside Aluminium

In another UK case, Del Drury, a resident of Pentre Maelor near Wrexham in Wales, took video footage of the Deeside Aluminium factory in their village. The footage showed that the factory emitted black toxic smoke (Photo 5.2). The video was sent to Her Majesty's Inspectorate of Pollution and used by them to prosecute the owners of the factory. The owners were fined £20,000 and forced to install pollution-control equipment (see pp. 195–6 below).

Photo 5.2 Video evidence of Deeside Aluminium factory, Wrexham, 1995 (video grab: Del Drury)

Endangered species

One of the most successful uses of video as offence has been by endangered species activists. Sam Labudde in San Francisco started using video in the late 1980s, when he captured footage of dolphins being caught in the driftnets of tuna fishermen. By the 1990s, Sam had refined his video use to an extremely effective strategy. He set out

to put a halt to the export of tiger bones and other tiger products. The tiger is an endangered species and protected under international law – in particular, the Conference on the Illegal Trade in Endangered Species (CITES). Sam and his team collected undercover footage of illegal exports in Taiwan and China. He showed the footage to US State, Commerce and Internal departments and passed it on to television stations to gain public support. The US government threatened Taiwan with trade sanctions after approval by CITES. China was let off the hook as it was such a major trading partner. Sam was forced to collect footage of the illegal trade two more times as the United States gave Taiwan time to clean up its act. Each time Taiwan demanded that the US prove its case again. Finally, sanctions were imposed in 1994, and soon enough both China and Taiwan had enacted laws banning the export of the endangered species and had vastly reduced the trade. Sam says that the video footage was central to the US policy initiative: 'We do the tough job that the mainstream media just won't do.'

The Witness Project

by Sukanya Pillay

Witness works to stop human rights abuses around the world by putting video cameras into the hands of activists. Witness exposes human rights violations when people in power deny they ever happened. Witness footage brings justice to bear for the victims of human rights atrocities, to reveal the truth about massacres, murders, torture and arbitrary executions.

Set up in 1992 – with the support of Peter Gabriel and the Reebok Foundation – Witness is a project of the Lawyers' Committee for Human Rights, based in New York, USA. In 1993, Witness began handing out hundreds of camcorders to activists and encouraged them to use them locally. One of our main successes has been activists submitting their Witness footage to International Tribunals, Courts and Truth Commissions. This has proved to be a way of marking past wrongs and preventing future violations.

In 1995, Witness set up its archive, to make footage readily available to broadcast television and human rights organisations. More recently, Witness has started a programme of camcorder training for human rights activists who already have access to video resources at the local level. Witness provides support to activists in Asia, Africa, Europe, and South and Central America.

Here are some examples of how Witness worked in 1996:

Northern Ireland: Witness activists from the Committee on the Administration of Justice (CAJ) worked to promote peace in the Province. With their video cameras, they doggedly followed the marchers and videotaped non-violent protesters being dragged, kicked, beaten and bloodied by security forces. The footage has been added to their print and video archive documenting abuses in Northern Ireland and may be submitted to the UN Committee Against Torture.

Honduras: Street children are being picked up by security forces and thrown into jail with adult prisoners. Some of these children are raped, others murdered, by these adults. Casa Alianza, an NGO working to protect children, has taken its Witness video camera into these illegal jails to videotape evidence that the children's human rights are being denied. Casa Alianza has sent the footage to the InterAmerican Commission on Human Rights to hold Honduras accountable for the violations being committed. The footage – along with material from Burma and Northern Ireland – has been broadcast on German television news, ARD.

Nigeria: In Lagos, Nigeria's capital, government soldiers maintain a terrifying order. One Witness activist smuggled a video camera into the country to show the world the abuses carried out by the government against its own people. He recorded soldiers harassing market vendors, turning over their stalls, burning their goods, and using whips to force women vendors into vans. The video tape was smuggled out of the country and back to New York. It was passed to the US Public Broadcasting Service, who used it for their Globalvision's *Rights and Wrongs*, as part of a feature on human rights abuses in Nigeria.

WORKING WITH THE LEGAL SYSTEM

Using video to provide legal support at demonstrations and actions can have a tremendous effect. At first the process may seem intimidating, but it is quite simple once you get the hang of it. There is often some confusion within groups about whether you can submit video evidence in court. The answer is yes, in principle, you can – if you work to the requirements of the legal system and prepare properly.

The exact details will vary, however, from country to country and town to town. I have based most of my advice on experience within the UK (as this is what I know best), but from my travels to other countries, and from talking to video activists working there, I understand that the general situation is similar. Before you embark on the legal use of video, however, talk to a lawyer in your country to find out about local specifics.

Work with the campaign

If you offer to video an event to provide support to a campaign or community group, you must follow it through. You'll have to find the time, six months or so after the event, to fill in the usual boring legal statements and make video copies. If you think that other commitments may stop you from doing this, don't offer your help in the first place. Give the group the opportunity to make other arrangements. Promising to help and not delivering your promise in full is dishonest, and can be damaging to the group. Similarly, the onus is on you, the video activist, to let a campaign group know that you've got useful material. If you don't, they may not know about it.

Deciding whether it will help

Video evidence is not always helpful. In some cases showing video at a trial would make things worse for the people involved. This is technically described as the 'prejudicial effect outweighing the probative value'. In one case a man was accused of assaulting a police officer at a Reclaim the Streets action in London. At the start of the video tape he is seen drunk and disorderly shouting at the police. Later on we see the police attack the protesters and the video activist being pushed to the ground. Because of the negative image of the first part of the tape, it was decided not to show the material but to call the video activist to give evidence. The case was won. The lesson to be learnt is always to talk to a lawyer before you submit video evidence.

The process

The process will probably start with the campaign group or its lawyers approaching you for footage. This may be some months after an

incident took place in the case of defensive work. After having spoken to you, the lawyers will want to see your footage and, if it's useful, take a statement from you. This can take a few hours. Then, if the lawyers are still interested, they'll want copies of the video. They should have a budget for video costs. So charge them for research, transfer, tape and any other expenses you may have.

The lawyers will ask you to present the original tape in court as evidence. If you have shot your footage on Hi8 or SVHS, they almost certainly won't have a player to watch your footage from. In this case transfer the entire tape onto a VHS tape (it must be the whole thing otherwise you cannot claim that it is an exact copy of the master) and offer the lawyers the original for use in court. If the opposing legal team insists, you may have to appear in court to be cross-examined.

Label your tapes

Many people send their video footage to a campaign group and forget to label the tape properly. This renders the tape useless. There have been several cases of lawyers being unable to use video evidence to get a person acquitted because they didn't know who shot the video, where it was shot, or on what date.

Figure 5.1 Labelling a video tape

Make the video admissible

To include video evidence in a case it must be made 'admissible'. To do this you must:

- show that the tape is *relevant* to the case, i.e. that the video was shot at the same time and place as the event in question;
- produce the *original, unedited* tape – for example, if the video was shot on Hi8 and then copied to VHS for viewing, the original Hi8 must be presented to make the evidence admissible;
- produce a statement (in the UK called a 'section 9', see box) from the *person who shot the tape* that he or she was the one to do so and that they have not edited or tampered with the material;
- establish a *chain of people* who handled or copied the original tape, and produce a statement from them asserting that they didn't tamper with or edit it.

Example of witness statement in the UK – 'section 9' statement

STATEMENT OF WITNESS
(C.J.Act, 1967, S.9, M.C Act, 1980, s.102; M.C. Rules, 1981, r.70)
STATEMENT OF:
AGE OF WITNESS (d.o.b):
OCCUPATION OF WITNESS:
ADDRESS & TEL NO.:
This statement, consisting of __ page(s) each signed by me, is true to the best of my knowledge and belief and I make it knowing that, if it is tendered in evidence, I shall be liable to prosecution if I have wilfully stated in it anything which I know to be false or do not believe to be true.

Dated the __ day of __ 19__

Signed Signature witnessed by

APPEARING IN COURT

You may have to appear in court to be cross-examined about the evidence. This is particularly likely if the opposing legal team thinks the video evidence is crucial to the success of the case.

Being cross-examined in court can be a nerve-racking exercise, especially when the action videoed is fast-moving and confusing. The lawyers will push you to interpret what is happening, and to give yes or no answers.

Don't feel pressured into answering if you don't feel you know what is going on. Let the footage speak for itself as much as you can. The lawyer will probably try to undermine your authority as an 'objective' video-maker and the authority of the footage as a valid representation of what took place. If you sound confident when asked, then it is up to the lawyer to persuade the court otherwise. The court will have no reason not to believe you.

If there is a campaign group involved, then you have to decide whether you want to associate yourself with them. One tactic is to distance yourself (see the case study below) which may add weight to your evidence. If you feel uncomfortable about doing this, think hard about how you're going to demonstrate the 'objectivity' of your video.

Don't be surprised if the lawyers you work with are unaccustomed to using video evidence in court. Part of your role will be to educate them. It is quite common for the clerk, magistrate and lawyer to meet during a court hearing to discuss how to work the video machine. But given the large numbers of successful uses of video evidence in court, it is worth the effort of becoming a legal pioneer!

Oxford baton-charge

On 1 August 1994, I heard that people were heading down to the Oxford city-centre police station in a show of solidarity with five others who had been arrested earlier in the day for squatting a building. I took along my camcorder not knowing what was going to take place.

About forty people gathered inside the station lobby and began chanting 'Let them free, let them free!' All of sudden, police arrived and began pushing people out. Then, for no apparent reason, they let off a fire extinguisher into the protesters' faces and, once they were out in the road, baton-charged them down the high street. Eight people were arrested and charged with 'affray'.

Over the following six months I worked with the defendants' lawyers to prepare the video evidence (Photo 5.3). I made a written statement and was then called to be cross-examined. This was a

Photo 5.3 Video evidence of police baton-charging in Oxford, 1994 (video grab: under*currents*)

terrifying experience. The prosecution lawyer's aim seemed to be to undermine my status as objective journalist. It went something like this:

Prosecution: Why were you videoing that day?

TH: I am an independent video-maker. My intention was to shoot the event and sell the footage to TV news.

Prosecution: Is it not true that you shot this footage which was favourable to the protesters and left out all the bits that favoured the police?

TH: No that is not true. As you can see from the footage, there are times that I shot the protesters being animated and vigorous, at one stage even slapping the windows of the police station, all of which I might have left out if I had wanted to be biased.

Prosecutor: Where did you hear about the protest?

TH: I heard about it the same way that any journalist would hear about a party-political press conference

or other event. I was sent a press release letting me know what was going on. Yes, I have contacts with the group, that is how I got the story, but I am not one of them.

According to the lawyers concerned, the video evidence played a major role in getting the accused acquitted of all charges.

ENDURANCE

Unlike shooting for community screenings, television or VHS distribution, quality is not as central as content for witness video. The most important thing is to video the moment of injustice, even if it's only ten seconds long: for example, the shot when the policeman lays into the protester. It doesn't matter if it's shaky, or the sound is muffled, or there's dirt on the lens, as long as you've got the shot. Of course, if you also intend to use the material for television broadcast or campaign videos then you must pay more attention to quality.

For most people, shooting witness video means having to turn up at every action to make sure that there's a camera about just in case something happens. It involves checking that there are plenty of tapes and batteries left, and always working whatever the conditions. In such situations the most important technical aspects become the length of shooting time and durability of equipment.

Cameras can take a real beating in conflict situations. Here's a typical example of why it is important to have a durable camera. During one of the forest blockades in New South Wales a protester jumped onto a bulldozer as it was coming up a forest track. Another protester, who was providing witness cover to the action, was standing near by. Suddenly the bulldozer took a swing at the video activist, whose only means of escape was to fall backwards into a ditch. In the process she dropped the camera right in the bulldozer's path. The camera was caked in three inches of mud when it was later dug up. When it was washed the video activist was able to get the tape out and the footage was great. A quick trip to the video repair shop and the camcorder was back in use the following week ready for the next action.

ISSUES OF SECURITY

Videoing for witness can often be difficult and dangerous. There are some basic precautions you can take to reduce your risk. As a result of taking such measures, very few people are arrested, attacked or abused, despite the large number of times that camcorders are used. These suggestions apply to any situation where there may be danger.

Get a buddy

Whenever you video have someone close by who can look after you. The buddy can shield you from walking into things (if you're videoing while moving) and from abuse from people around you. The same person can let you know if you're missing some important action or if you're about to record something you shouldn't be videoing.

Don't incriminate

One of the biggest risks in using video cameras is that you'll accidentally record activists carrying out an illegal activity and that footage could get into the hands of the police. Fortunately, this has happened on only a few occasions. For example, a video activist was present when a group of anti-car activists gained entry to the 1995 London Motor Show and threw red paint over Audi's latest model. When security guards arrived, everyone had left except the video activist, and she was was immediately arrested. The police used her footage as part of their investigation. Luckily no one was ever charged. (For an example with a worse outcome see p. 101).

Some activists have become so concerned about being videoed – because of fear of accidental incrimination as well as of police surveillance techniques (see section on countervideoing, p. 83 below) – that they are agressive and abusive to video activists. During the Brixton riot in 1995, **under***current*'s Paul O'Connor was beaten up on three separate occasions (so badly that he was vomiting blood), simply because he was holding a camcorder.

There are rare instances where people choose to be videoed doing something illegal because they feel that they should be accountable for their actions. In 1995, for example, Emma Westwood scratched

'Down with Campsfield' into the main gates of the Campsfield Refugee Detention Centre outside Oxford, where asylum seekers are held for up to two years without trial. I asked her if I should video it; she said yes, so I did. She was immediately arrested and admitted her 'crime' in court. I used the powerful footage in a campaign video to show activists taking a stand against the injustices of Campsfield.

You should therefore always ask activists before you video them. If in doubt, turn the camera away and video something that won't incriminate anyone.

Arrests

Video activists get arrested if the police view them as taking part in illegal activity. The most common instance of this is when a video activist is trespassing on private or government property. Occasionally, a video activist may be arrested cynically to stop the material getting out. In most situations, it is possible to avoid being arrested by making a clear separation between you and anyone likely to be targeted by the police. The most useful thing is to have some form of media identification, either an official press card, a business card or, if nothing else, a letter from a professional video company saying that you are a *bona fide* news gatherer (Figure 5.2). It can help to take a few moments to get chummy with a policeman and make it clear that you are an independent video activist before anything exciting happens.

Figure 5.2 Example of a press card

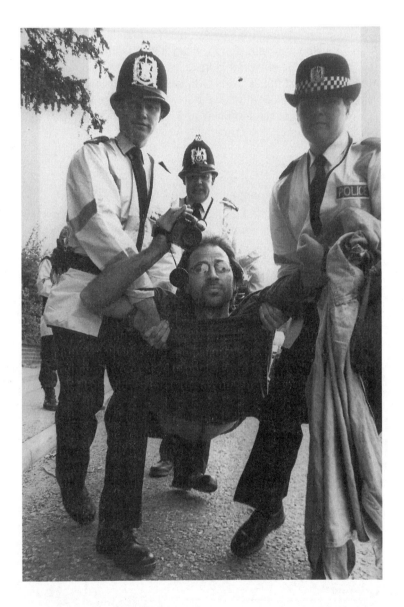

Photo 5.4 Activist arrested during a sit-down blockade, Farnborogh Air Show, 1996 (photo: Adrian Short)

If you do get arrested, keep up your video role. It will help to get you and your footage out quickly. You may feel that you're letting your mates down, but remember that the most important thing is to get the material out safe and sound, for use by the lawyers, television or other campaign purpose. In the UK, it is illegal for the police to take your camera and tape from you unless they are seizing it as potential evidence as part of a criminal investigation. But it may happen anyway, so get your lawyer onto it immediately if it does. The legal situation regarding journalists varies from country to country, so it is worth checking with a national media union to find out what the law is before going into action. Remember, people with cameras can be the targets of police and protesters. Camcorders don't give you immunity from abuse, assault or arrest (Photo 5.4).

A day trip to Clakamas County Jail

In May 1996 I met up with video activist Tim Lewis and travelled to Enola Hill, a Native American sacred site that was about to be logged. We joined up with forty protesters as they marched towards the forest gate. Without warning, and to confuse the law enforcement, the group entered the forest from a road that skirted the edge of the forest rather than the offical entrance. I hadn't really prepared for this situation and didn't know what to do. I knew that I was trespassing if I crossed into the forest but I wanted to video the protesters in action. As there were no police officers nearby, I decided to follow everyone else.

The protesters walked further into the forest towards the sound of chainsaws in operation. They saw a logger and yelled as he felled a 400-year-old tree. They approached him, forcing him to stop further work for fear of hurting them. Then two law enforcement officers came into view. The protesters sat down and linked arms. Tim and I kept our cameras rolling as the protesters started singing 'We are the old people, we are the young people, we are the new people, stronger than before.'

Suddenly, the officers walked up to Tim and me to grab our cameras. I tried to reason with them: 'I am media. Here is my press card. I am willing to leave the area.' They refused to listen, however, and put plastic handcuffs on my wrists. Meanwhile Tim, displaying much more presence of mind, bent down, ejected his tape and

tossed it to someone, who ran the tape out of the forest to protect the evidence. I wasn't quick enough, and they took both my camera and the tape. Later, they bussed us all to Clakamas County Jail.

It was only then that I realised how unprepared I was. I hadn't thought through the consequences of being arrested. The court date wouldn't be for a couple of weeks, which meant that I wouldn't be able to leave Oregon when I'd intended, and would have to delay my flight home. I didn't even know if the three criminal offences I was charged with were serious enough to have me deported or end up with me being refused re-entry next time I wanted to come to the United States.

They let us out at the end of the day, but, to our great annoyance, they kept our cameras for evidence, even though Tim's camera didn't even have a tape in it. We worked with the lawyer who was providing free advice to the environmentalists. He was representing over a hundred people, however, so he couldn't give us much of his time. After many phone calls we managed to get the cameras released after a week and a half. Two weeks later, after much negotiation with the district attorney, I went to court and pleaded guilty to only one charge: Criminal Trespass (violation). This is at the same level as a parking violation. It cost me a fine of $200.

The main lesson I learnt was that you need to know what your intentions are if you're going into a situation with even the remotest chance of arrest. And then, if you are willing to be arrested – which you may have to be if you want to get the most important footage – you need to prepare yourself properly. I had not. Next time I would.

Getting tapes out

One of the hardest things can be getting tapes safely out of a place. Don't underestimate this problem, especially if there are people anxious to stop the tapes getting out. Before you video, work out a plan.

- In 1992, Amanda and Akil captured world-exclusive footage on camcorder of the Turkish air force bombing Kurdish villages in Iraq. At the border with Turkey, they gave the tapes to an American colonel. The tapes were waiting for them behind a bar

across the border. The footage was broadcast on news stations around the world.

- In 1995, Sue Lloyd Roberts and Oliver Tickell managed to get the first footage of the Bakun dam being built in Malaysia. The dam is destined to flood huge areas of rainforest and displace thousands of indigenous people. At the airport, Sue and Oliver were stopped by police and had their video tapes confiscated. Luckily they had hidden the originals in Madonna and Michael Jackson audio tape boxes!
- During 1993–5, Australian video activist Dean Jeffries covered forest protests around New South Wales. He often worked in areas that had been closed by the police. To safeguard the tapes out he would stash them in the ground for future collection.

Storing tapes

Some video activists are still at risk even after they have finished videoing. For them it is wise to make copies of their tapes to reduce the risk of originals being seized in a raid, or even lost accidentally. In the UK the police can seize footage if it can act as evidence in a criminal case. This has happened a few times after riots, where police have demanded that video activists hand over their tapes to identify people. The solution has been to send the masters overseas. This protects the video-makers and the tapes. Even if you don't think you are at risk of being raided it is worth making VHS copies from camcorder to domestic VHS player of your most important footage and storing the tapes in separate places in case of accident, loss or damage.

VIDEOING COVERTLY

Over the last few years, covert videoing has brought about some remarkable results. People in authority have been caught handing out bribes; other people have been discovered illegally participating in badger-baiting; others have been found to be exploiting their workers – all with the help of camcorders.

One group using video in this way is Global Witness. Set up in the early 1990s, Global Witness is a small London-based non-governmental organisation (NGO) that uses camcorders to gather evidence of action

that results in human rights abuses and the destruction of the environment. Their first campaign targeted Cambodia, where the Khmer Rouge and Cambodian government were illegally logging vast areas of forest to finance their armed struggle. Through extensive undercover video work, Global Witness captured the logging trade on video, and the corrupt dealings that were going on behind it. They took the footage to Western governments and were able to get the issue on the agenda at a crucial international aid-donor's meeting. Further pressure was added when the footage was broadcast by BBC World Television.

Covert methods

If you plan to video covertly, tape over the red light on your camcorder that lets people know you're videoing. Black electrical tape is good for this. Similarly, turn off the 'beep' function that comes on when you start recording. People talk more openly when they don't think they are on camera, so you may need to employ other means to disguise the fact that you're videoing. For example, you can try lowering the camera below eye level and videoing from the hip. If it's only the sound you need (and this will be more often than you think), you can even point the camera to the ground or put it under a coat.

In the bag

Buy a cheap shoulder bag, preferably the same colour as the camera lens, cut a hole in one end, tape the frayed edges over to the inside the bag so they don't fall over the lens. Tape the camera into position with duck or camera tape (foam can be good to hold it there as well), make sure you can see the viewfinder easily from above, with the zip open, to make sure all is working OK. If you have one, put an external clip microphone through another hole or under your shirt. Then practise a lot! One of the most difficult parts of covert videoing is getting the image horizontal, so have a go and play it back to see if you've got it right. Also, test how near to the subject you need to be to achieve good sound quality.

Pinhole cameras

There is much hype about the tiny concealed cameras known as 'pinhole' cameras. Of course these are impressive, but most people can't

afford them as they start at £150 a day for hire. The alternative, low-tech methods described above have produced as many startling results as the more sophisticated up-market equipment. If you have the money, however, and the necessary technical expertise, it is a great option. What you need is a small camera lens (you can now get them the size of two matchstick heads with exceptional wide-angle lens quality), which then connects to a small Hi8 recorder the size of a personal stereo. Attached to this is a clip mic and a battery (usually large). Then you need the whole kit in some kind of vehicle (a jacket, an animal carrier, a hat etc.). You can normally get a complete kit with jacket from a specialist shop. But the equipment is not easy to use, so you'll need to practise a lot. Don't forget to account for practice time when you're working out how many days you need to hire the kit for.

COUNTERVIDEOING

Of course, activists are not the only ones who have realised the potential of the camcorder. It is not an uncommon sight to see police, security and construction workers, as well as the media, all using their camcorders at a protest in a kind of video standoff (Photo 5.5).

Photo 5.5 Police with audio tape, camcorder and loud hailer at the Newbury bypass protest site, 1996 (photo: Paul O'Connor)

This has serious implications for the activist, since not only are the 'opposition' becoming more video literate, and therefore more careful, but also video activists are increasingly given a hard time by other protesters who suspect their political allegiances. Often police and security crews dress in civilian clothes, so it is difficult to distinguish them from the reporters and protesters.

Footage shot by police in the UK is now filed and later used to prove participation in demonstrations. For instance, the only people to be arrested after the 'Battle for Wanstonia' in East London (as part of the No M11 Link Road Campaign) were people who had participated in an anti-fascist demonstration six months before. Police used video footage from the two demonstrations to link the people together.

This type of surveillance work can lead to some surprising benefits for campaign groups. Police are often the only ones to get the best close-up footage of the action that is going on. Such footage can end up in court as part of police evidence, and it has been known for some cheeky video activists to use this footage later in their campaign videos.

Ten tips for witness video

1 Carry a lawyer's number with you and check out specific legal situation of each event beforehand.
2 Identify yourself as media as early as possible to the police authorities.
3 Work out a plan to get your tapes out and away from an event in case of trouble.
4 Never video anything that may incriminate other people.
5 Include footage of police officers that shows their police identity numbers and makes it clear where they are standing.
6 Don't switch your camera on and off or you may be accused of being selective.
7 Use cheap equipment (in case it gets broken and you need to replace it) and cheap tapes.
8 Stock up enough batteries to ensure that you can video the entire event.
9 Label your tape with your name and address, and the place where and date when the footage was shot.

10 Identify the time and place both for your future reference and for
 the courts – take shots of a newspaper, a street sign – and, if
 possible, find witnesses who can verify that it was you who took
 the footage.

Videoing a riot

by Roddy Mansfield

In April 1997 I filmed a march to Trafalgar Square in London, by
sacked Liverpool dock workers and Reclaim the Streets activists.
Although the march had started peacefully, by 6 p.m. the police had
given the order to clear the square and a number of police baton
charges followed. Heads were beaten. People were knocked to the
ground. Bottles, placards and flares were thrown.
 Although it was tempting to run for my life, especially when the
police were charging towards us on horseback, I realised how
important it was to get footage of what was going on. I kept the
camera running.
 One of the most difficult things I found was to decide what to video
given that so much was going on around me. I made a mental list
and tried to stick to it. It included shots of police being violent and
abusive (both physically and verbally), shots of police charges,
shots of protesters being calm, non-violent and in good humour,
images to portray the protesters as diverse and not just a bunch of
frightening-looking hooligans, and reactions from protesters about
what they thought of the situation.
 I also had a problem about where to stand. I realised that I
needed to be in different places for different shots. By getting into
the thick of the action I was able to film the baton charges close up.
This was important so that I could highlight the individual officers
who had lost control. However, I also shot general views from an
elevated position further away, for example, standing on a waste
bin, or the steps of a building. This meant that I was able to capture
the whole picture of police in riot gear charging on one side while
hundreds of people were partying on the other. My job was made
a bit easier because I was in touch with other video activists at the
demonstration, and we signalled to each other to cover different
aspects of what was going on.

I also took a friend along with me to take completed tapes out of the area. On more than one occasion I thought I was going to be arrested. Since my tape contained evidence of police misdemeanours, I would probably have never seen it again. Also, this was an occasion when I didn't contact television news until after I had edited the footage, as I knew that broadcast stations routinely pass all such footage over to the police.

When I'm in this kind of situation, I only really feel frightened when I take my eye away from the viewfinder. But once I start using my camcorder and I see that the little red light is on, I know I'm committing it all to tape, and that the footage I'm collecting could be useful to someone's struggle for justice.

If I find myself in similar circumstances in the future, I will take the risks again and be right in the thick of the action, because I know what an important role a camcorder can play in a riot situation.

Supplying Footage to Television News

One of the most exciting kicks for a video activist is getting footage onto television. Video activists can supply footage for a story that might otherwise have been missed, and, for a story that *is* covered, can provide additional material that gives a grassroots perspective.

Getting camcorder footage on television is a new development. Until recently, makers of news and current affairs programmes were unwilling to use non-professional footage on the grounds that the so-called 'non-broadcast' formats – domestic Hi8 and VHS tapes – were of too poor a quality to use, or that the footage was not 'objective' but was political and biased. Furthermore, they would refuse to take footage from a non-union member.

In the 1980s, a number of factors changed all this: cheap high quality camcorders became available, the journalists' closed shop was broken by anti-union governments, television stations sought to cut the costs of news gathering, and the footage being sent in was just too good to pass up. How could a television station refuse exclusive footage of a plane crashing, an earthquake in progress, or a politician in an embarrassing situation?

By the 1990s, groups struggling for social change had realised that they had a chance of getting their issue onto local and even national television by shooting the story themselves. It was horror footage that paved the way: footage shot by Thai students of the military crackdown of pro-democracy rallies; footage shot by the Ogoni in Nigeria of brutal massacres and property destruction by police; footage of hunt saboteurs in the UK being beaten up by hunt stewards.

As the years progressed, and the newsrooms became more accustomed to these political stringers, video activists were able to supply increasingly substantial stories. No longer did there have to be violence or bloodshed. Television stations were now prepared to take footage about overseas development projects, marches and rallies.

This was revolutionary for small groups who had always found it hard to get journalists to come to their events and who certainly didn't have the resources to hire a professional video crew. Now all they had to do was to think of some clever stunt, hire a camcorder for the day, video it and get it to the local news station. More often than not, their footage would end up being broadcast to millions of people, and the video activist would even get paid for it.

WHY SUPPLY FOOTAGE TO TELEVISION NEWS?

Over the last forty years, there has been a great debate among social science academics about the impact of television. At first, researchers claimed that the effect was like a bullet shot by the television producers, via the TV, into the viewer's head. In the 1960s, this simplistic view was thrown out by those who argued that programmes had little or no effect on the viewer. They said that, given the quantity of programmes being broadcast and the complexity of the brain processes, you could not prove that programmes lead to changes in behaviour. The debate was rekindled when researchers looked at the effect that pornography and violence have on children, and the issues became one of great moral significance.

Today it is commonly held that television has some political impact, but that the process is complicated and indirect given the enormous informational bombardment most people experience every day. After all, you only have to look at the vast resources that corporations put into advertising, or the efforts that politicians make to get their message onto the news, to realise that television must have some effect.

The debate about the impact of television has been reflected within campaign groups themselves. In the 1970s, a split emerged in the environmental movement when radical activists argued that television was overrated as a campaign tool and that mainstream groups gave it far too much weight. In fact one of the motivations for the setting up of Earth First! in the United States was that the more established groups, like Greenpeace or the Wilderness Society, put too much

weight on the mainstream media. Getting television coverage for a banner-drop or the blocking of a waste pipe for a few hours might alert people to the environmental crisis but does nothing to stop the crisis from continuing the next day. Instead, Earth First! chose to intervene at the point of destruction – lying in front of a bulldozer, getting between a tree and a chainsaw, blockading an entrance to a mine for a matter of months rather than hours.

During the 1990s, the debate moved on once again. As video activists became increasingly successful at placing their footage with television stations, some began to question how effective this strategy was. They argued that trying to pass activist footage to television can be a drain on a group's sparse resources: the equipment is expensive, it takes a lot of energy to video and then to sell footage, and the end results might not be sympathetic to the group.

With these thoughts in mind, some video activists choose not to supply footage to television at all. One of these is John Jacobs from CATv (Community Access Television), who has been involved for many years in the community access video scene in Sydney, Australia. 'Small is better than big', he says. 'News journalism is a bankrupt form of social change. Footage becomes disempowered when it is on television.' He believes the solution is to organise community screenings and to use material as part of a social programme: 'That is the way to have an impact.'

Pros and cons

In 1996, environmental activists at a workshop in Eugene, Oregon, debated the pros and cons of selling footage to television news. They came up with the following list of positive outcomes:

- The broadcast may help to recruit people to the campaign.
- The campaign group can use the tapes for other purposes later.
- The group can earn money by selling the footage.
- The broadcast may influence decision-makers positively.
- The group can learn about how the medium works.
- The group can learn skills from TV professionals.
- The broadcast may attract other media attention.
- The group's morale will be lifted.
- Public awareness will be raised.

And the group also came up with the following list of negative outcomes:

- The footage may be used to incriminate activists.
- The TV station may lose the tapes.
- The group may waste time and resources in selling and chasing up.
- The footage may influence decision-makers negatively (bad spin).
- The group may be shut out of the production process.
- The campaign may become more 'commercial' in its approach.
- Once it's covered on TV, the event or issue may become an 'old' story more quickly.
- The group's morale will sink if the TV station doesn't use the footage.
- The audience may be the wrong one for the campaign.

Sometimes it may be good *not* to give footage to television. Here's an example. In 1995, Copenhagen-based media group TV Stop received an anonymous phone call: 'Be outside the prison gates, tomorrow morning, 6 a.m. Don't be late!' The team turned up as instructed, set up their gear and waited. Suddenly, they heard an explosion. Cameras on! At that moment a gang of prisoners broke through the prison's walls and escaped. TV Stop videoed the entire thing and sold the footage around the world. But the escapees turned out to include rapists and murderers. What started as an intriguing story turned into a nightmare. TV Stop was racked for months with internal fighting between those who thought it was immoral to publicise, let alone make money out of, this type of event and those who felt that the end justified the means, and were happy to sell this story if it meant they had the money to fund their other, more ideologically sound activities.

As with many of the tactics covered in this book, it is important to realise that working with television is only one option, a single powerful string that should be used wisely in a multi-strand video campaign. As San Francisco video activist Sam Labudde says, 'Facts alone do not bring about policy change; you need to get public support for your campaign. Television is best for this. You need both evidence and exposure to bring about political accountability and shifts in policy.'

Video activists who are committed to bringing about change rather than promoting their careers must work out exactly why they want

to supply footage to the mainstream media. Is it strategically useful for the campaign being supported? Are there better ways to distribute the footage? How can you keep the news interested in the material after they get tired of seeing the same sort of protest footage without having them force the agenda of the group and escalating the types of actions being organised?

Nevertheless, there's no denying that, if you do decide that it would be useful to sell to television, it can be a lot of fun.

WHAT IS TELEVISION NEWS LOOKING FOR?

A video activist can sell footage of a story to a television station if the station wants to cover the story but doesn't yet have footage for it. Putting it another way, to get material onto television the video activist must offer unique footage.

There are a number of reasons why video activists are able get unique footage. Video activists should be aware of all of these, so that they know what opportunities exist for them.

It's too risky!

People assume that the reason a television news station doesn't send a crew to an event is because they've decided that it isn't newsworthy. This may be true for some cases, but the more usual reason is that the station has decided that the event is riskier than another story taking place on the same day. The story may be considered 'too risky' for a number of reasons:

- It isn't as 'reliable' as other stories (for instance a protest compared to a news conference).
- It involves legal or physical dangers.
- It takes place at a remote location and will cost too much money to cover.
- It isn't fixed to a specific time and covering it to ensure getting the 'moment' will take too long.

This can be a great opportunity for video activists, who are likely to have far less to lose than news editors. They aren't paying for an

expensive crew, they don't have to fill a news slot and can therefore afford to cover stories that don't take off as expected, and they won't be wasting their time as they can use their footage for other things besides television news (i.e. for witness and campaign videos, see Chapters 5, 8 and 9).

Gary Kaganoff

In December 1995, the Tarkine Tigers – a group of Australian environmental activists campaigning to stop a a road being constructed through the Tarkine, one of the country's largest untouched forest areas in Tasmania – asked video activist Gary Kaganoff to take images of the destruction. The government had erected a media exclusion zone around the construction site, so access wasn't easy. First Gary flew over the new road in a helicopter to capture the extent of the destruction. He then had to walk for nine hours through thick bush to get to the construction site. There he managed to video the workers without being seen. Then he hitched for three hours to a nearby town and, with help from a local engineer, managed to create a device that would link the camcorder to a local telecommunication tower and wire the footage via Hobart, the capital of Tasmania, up to Sydney. The footage arrived in time at ABC, and was used on the evening's national news. Not bad for a day's work.

Tim Lewis

In the United States, forest protests are also often situated in remote areas far away from local television stations or their stringers. Video activists like Tim Lewis from Cascadia Uncut have therefore had great success in getting footage shown on local television. Within an eight-month period he sold over 12 stories. 'Anyone can do this. You just have to establish a rapport with the news journalists, act like an independent shooter, and be there when it happens. They like you, you're saving them money.' When producers from CBS's *60 Minutes* programme rang local organisers for footage, they were put in touch with Tim. *60 Minutes* used a minute of Tim's footage and paid him over $1,000, which helped him to continue to provide video support to activists. Following the *60 Minutes* programme, CNN contacted Tim for footage as well.

Being 'in the know'

In some cases the news crew doesn't turn up simply because they haven't been invited. This is frequently the case when campaigners don't want to inform television stations about the time and place of an event in case they pass the information on to the police.

Criminal Justice Bill

On 4 November 1994, six people climbed up onto the roof of the Houses of Parliament in London and dropped a banner to protest the widely criticised Criminal Justice Bill that was being passed that day (Photo 6.1). They let video activist Paul O'Connor know in advance. He was the only person to be there when the activists began their climb. Paul managed to sell the footage to all the national television stations in the country.

Photo 6.1 Anti-Criminal Justice Bill protest on the roof of the Houses of Parliament, London, 1994 (video grab: under*currents*)

Millieudefensie

In 1995, Dutch environmental pressure group Millieudefensie organised an occupation of the main runway of Amsterdam's Schipol airport

Photo 6.2 Activists occupying a runway at Schipol Airport, Amsterdam, 1995 (video grab: *Stoom*)

(Photo 6.2). The group was protesting against the expansion of the airport, which would increase air traffic, producing more greenhouse gases and noise pollution. They couldn't tell the local media about their action in case it led to their action being thwarted, so they took along their own camcorders. After informing air traffic control of their intentions, 50 activists sat down on the main runway. They chained their arms together with tubing. The protest delayed landing for over an hour. Gerbrand Oudenaarden videoed the entire episode, making use of a forged press card, and later sold the footage to all the national television stations, who used it as the centrepiece for major features. Without the footage the campaign would have been lucky to have had a 15-second slot on television.

In the right place at the right time

Sometimes it is simply chance that allows the video activist to be at the scene rather than the news crew. This is the kind of aeroplane crash

camcorder footage that television stations love. They can justify it easily, saying that there was no way that they could have known to be there at the right time, and so are happy to use such footage. However, it is still up to the person or people who gets the footage to do something with it. This is where the activism comes in.

Aguas Blancas massacre
On 28 June 1995, a truckload of peasants on their way to a meeting to organise for better land rights was ambushed by police in Aguas Blancas, Gurrero, Mexico, and 17 were slaughtered. The government blamed terrorist groups for the massacre. A judicial observer happened to be near by and captured the scene on video tape. The footage, which showed police planting weapons and shooting the peasants in the head, was sent anonymously to Mexico's largest television company, Televisa. Amnesty International passed the material on to television stations around the world, including TV Globo in Brazil and TVE in Spain. Its broadcast sent shockwaves round Mexico, and put pressure on the Mexican government to investigate. There have been at least four investigations into the incident, which have led to measures designed to clean up the corrupt regional police force, and the resignation of the Governor of Gurrero, Rubén Figueroa.

Attack on Palestinians
On 10 October 1996, an amateur Palestinian cameraman captured two Israeli border policemen kicking and punching six Palestinian workers. The footage appeared on national television, resulted in the two policemen being sacked, and forced Prime Minister Benjamin Netanyahu to condemn the attack as 'immoral and criminal'.

Brazil
During a two-week period in early March 1997, Brazilian police were videoed attacking, beating and shooting at 15 law-abiding citizens in a Sao Paulo shantytown. The 90 minutes of videotape shot by an independent cameraman were sent to national television station Rede Globo. The images broadcast clearly show an officer hitting one of the men – Mr Sanchez, an accountant – 39 times in eight minutes. As a result of the video, ten policemen have been indicted. 'The moment it was shown on television, this crude deed, it changed people', said Luiz Antonio Guimareas, Attorney General for the state of Sao Paulo, to a *Herald Tribune* reporter. 'It was no longer a piece of paper, an article

in a newspaper. There were real victims. It showed if it can happen to them, it can happen to anyone.'

Groups can prepare for freak episodes by making sure that the equipment is around in case anything sensational does happen.

The Ogoni

By 1993, the Ogoni people of the Nigerian Delta had equipped themselves with video gear and had started training in anticipation of future problems. Serious problems did happen that summer. Over a thousand people were brutally murdered by a government-supported militia. The Ogoni were the only video team present. The video images contained shocking scenes of burnt corpses, limbs hacked off with machetes and houses burned to the ground (Photo 6.3). The footage was smuggled out of the country and was shown by CNN, and by Dutch and UK television. According to Jane Bennet Powell, a journalist from UK's Channel 4 News, if they hadn't had the footage shot by the Ogoni, 'it is unlikely we would have been able to cover the story'.

Photo 6.3 Video evidence of the Ogoni massacre, Nigeria, 1993 (video grab: MOSOP)

Missed it!

There are situations when a television crew *does* turn up at an event and a video activist can *still* provide footage to the news station by offering a unique perspective that the media professionals can't get. This is often possible because the video activists are prepared to dive into the middle of the action and can therefore get the most dramatic footage. At other times, the video activist manages to get the images because the television station has turned up too late for the action or gone home too early. In such situations, video activists play an important role in providing the campaigners' point of view. Such subtle differences make a profound impact on a viewing audience. Here are a couple of examples.

The Battle of Wanstonia

On 13 January 1994, over 1,000 bailiffs and police arrived at a group of terraced houses in Wanstead, East London. The houses had been squatted by 300 protesters in an effort to delay the construction of the M11 Link Road through the area. This clash was later known as the 'Battle of Wanstonia'. In one of the houses, Becky and Patsy (the original tenant of the house) barricaded themselves into a room reinforced with concrete, corrugated iron and wooden timbers. They were 'locked on' with a cable tied to a wrist and the other end hooked onto a washing machine filled with concrete. Video activist Zoë Broughton was there too, with domestic camcorder, car battery and portable light. Fifteen hours later, bailiffs started to smash through the wall, and pieces of concrete and wood flew through the air as the wall was breached. Zoë's footage of this was sold to ITV's national television news. Their 'professional' crew had been rounded up into a 'press pen' across the road, and had only been able to get footage from the police perspective, from a safe distance, away from the unpleasantness inside the buildings.

Rickety Bridge

In June 1996, anti-road protesters in Newbury were evicted from their tree-houses at Rickety Bridge. Local television station Meridian was there to cover the eviction, but the crew wasn't prepared to climb the trees to get the protesters' point of view. 'They don't want to be seen as partial to the protesters and they're scared of the financial risks of sending their crews up the trees', says Kevin Jarvis who did shoot

footage from the trees. 'But they want the footage because it's the most dramatic you can get as you're right in the middle of the action.' Kevin sold his footage to Meridian and used the money to fund the production of a documentary that tells the story as he would like it to be told.

PROBLEMS AND ISSUES

To sell or not to sell

All video activists who pass footage to television companies face a dilemma. Should they or should they not ask for money? If they don't ask, will the television people treat the footage less seriously, and see the video activist as an amateur? And if one person fails to ask for money, will this reduce the chances of others being paid by that television company? A video activist who does ask for payment risks being rejected by the television news station and getting into trouble with the other campaigners for prioritising money over coverage. Of course, the money can be very useful, for buying more tapes, maintaining the camera or supporting a campaign. Some experienced video activists say it's worth calling a television producer's bluff: if a television company really wants the footage it will be willing to pay a small amount for it. Others say that it's worth trying to obtain payment, but they don't push the issue. I always ask for money. Yes, I have suffered a few painful rejections, but for the most part I have been paid and this has been extremely useful in my work.

Sensationalising

Many groups find getting television coverage more and more difficult as time goes on. They feel they must become increasingly sensational in their activities, alter their objectives to meet television's needs, and lose the empowerment they gain from following their own agenda. Having a video activist in a group can add to the pressure to act up for the cameras. All the problems faced by activists when confronted by a television crew apply to a video activist if they aren't careful – soundbite fever, sensationalism, focus on violence, and so on. On the other hand, someone with media savvy can be a valuable resource for a group designing its media strategy.

Incrimination

On occasion police use footage broadcast on television as evidence to prosecute criminal activities (see Chapter 5, pp. 78–9). This was the case with a student video activist in Melbourne, Australia. On 15 August 1995, students from La Trobe University occupied an administrative building to protest against new rules that would forbid the use of student money to finance political causes. In the course of the demonstration a student kicked down a door. Another student videoed the whole event, including the smashing of the door, and passed the unedited tape to local news, thinking this would 'help the cause'. The police saw the footage and used it to arrest and then prosecute the individual concerned.

UK police have a track record of seizing tapes to assist their prosecution work. For instance, after both the Poll Tax riot in 1989 and the Hyde Park demonstration against the Criminal Justice Bill in 1994, police seized footage from people videoing at the event. Later, they demanded that all television stations hand over any footage (some of it shot by video activists) of the events. The seized footage was used successfully in court to prosecute activists.

To prevent this kind of 'own goal' from taking place, some video activists transfer the non-incriminating parts of the footage onto a better quality BetacamSP sub-master and it is this that they send to television stations. According to Paula Seager, who runs the Audio Visual Section at Amnesty International, this is a much better practice anyway because 'television companies are more likely to use footage if it arrives on their doorstep on a Beta tape'. While many groups don't have access to such high quality equipment, it may be possible to persuade a local video facilities house to provide free or subsidised access to such gear on occasion.

Disappointment

Providing footage to television news can be extremely demoralising. Journalists are a hard-bitten lot and they can be rude and insensitive. They may demand instant action and immediate results, and then fail to respond to phone calls when you try to get hold of them. Worse still, after you've jumped through all their hoops, they may still say 'Sorry, we didn't use it.' So prepare yourself for a rocky ride. It may help to have a friend or colleague you can talk to during the process, someone to provide a little perspective. Just remember, television news is a fickle world. So much depends upon luck – the mood of the journalist

you speak to, the other news of the day – that even if you are rejected once, the next time they may say 'Yes, we'll use it, it's great!' So keep trying.

In-fighting

In grassroots groups, one of the most frustrating problems for the video activist can be the grief they get from other activists when they start selling footage to television. They can be accused of financially benefiting from the work of other people (who invariably are not being paid), of 'selling out', or even of taking the easy option of not being an activist themselves. The way that experienced video activist Zoë Broughton solves this problem is by discussing her role as much as possible before any action takes place. 'Any committed video activist is going to want to support the group they are working for, so a meeting of agendas shouldn't be hard', she says. 'For example, you can explain that no one is going to make money being a video activist, that any money made by selling footage goes to paying for tapes and camera repairs, which allows you to shoot more actions, so that there will be more television coverage and so on.'

TACTICS FOR SUPPLYING NEWS FOOTAGE

Video activists have had great success in selling video footage to television stations around the world. They have been able to place their stories on local, national and international news. More and more people are attempting this type of 'tactical television', but many people fail along the way.

There are some tactics you can adopt that will increase your chance of success. First, think about why television may be interested in your material. What needs of theirs are you meeting? Remember that over the past five years it has become easier to sell camcorder footage to the news. This is mainly the result of an improvement in the quality of camcorders; the format becoming more familiar to news and current affairs programmes, which now have the equipment to handle it; and the shrinking budgets of news stations – 'amateur footage' bought for £100 per story is cheaper than sending a news crew out at £800 per day. So be confident; you're helping them to meet their needs.

In spite of that, it isn't always easy to sell a story. News editors and documentary-makers still prefer BetacamSP and continue to be

prejudiced against Hi8 and SVHS (the best quality non-professional formats). They see it as a non-broadcast standard, likely to have bleeding colours, drop-out (occasional horizontal black lines), poor contrast and bad sound quality. Of course this can be true, but when used correctly Hi8 and SVHS are perfectly usable for broadcast television. In fact, many stations are using these formats themselves for 'difficult' situations, like foreign shoots, secret videoing and 'access' television (when the public makes videos for television).

A key tip is to make sure you ring the station in time for their editorial meetings. These normally take place late in the evening for breakfast news, early in the morning for lunch-time news and early afternoon for evening news. So to maximise your chances of getting your footage onto television, call as soon as possible, preferably before midday, to let them know what you have. (For contact numbers, see pp. 230–1 of the Resources section.)

When to go for it

Before you can sell some footage you have to get some. This requires four things: a potentially interesting 'story'; high quality equipment (see Chapter 3); the skills to get good images and sound with it (see Chapter 4); and uniqueness. This last is generally a matter of luck – if you turn up at an action thinking you've scooped the rest of the pack, you may well find that two local and one national documentary crews are already set up for the big event – and that the news isn't too busy that day.

What makes a good 'story'? This is difficult to put your finger on because it is completely subjective. It depends far less than most people think on what is actually going on ('news') and far more on what news editors and their staff think is worth covering ('newsworthy'). Typically, however, it will:

- have happened today;
- be a new story, or a new angle on an old story;
- have wide implications;
- be relevant to the audience (which is why there are so few overseas stories and so many stories involving people we know about already – like politicians);

- have visual impact or drama (for example, a large number of people at a rally or someone chaining herself to a bulldozer);
- be entertaining and humorous, or tug at the heart strings (some news programmes like to include a funny or human interest item at the end).

If one or more of these applies to a story it's worth giving it a try. Here are a few examples of what has worked in the past:

- Anti-Gulf-War group organises 'vomit-in' (using red, white and blue food colouring) at President Bush ceremony in Portland, Oregon, in January 1991.
- In March 1994, on the first day of road construction at Solsbury Hill, Bath, protesters stop work by chaining themselves to bulldozers.
- Undercover footage shot in April 1995 shows that puppy breeding farms keep animals in appalling conditions.
- In May 1996, a musician dresses up as an eight-foot alien and prowls the streets at night. Police arrive on the scene to find out what is going on. His stunt turns out to be a protest, to highlight the intrusive city-centre CCTV cameras positioned outside his home, which swivel around and point into his window.
- In Sheffield, in November 1996, churches, mosques, tenancy associations and schools join together to organise the launch of a new coalition to tackle local community issues. The launch is attended by over a thousand people.

Of course, these news values will vary from station to station, region to region, country to country. One way of finding out what will work in your area is to watch the news over the course of a week, making notes about the kind of stories they cover. And if you offer footage to a newsroom and get turned down, ask them why they didn't like it and what would have made a difference. Don't forget that just because they have said 'no' once it doesn't mean they will do so again. It takes time to educate news editors and journalists about the virtues of video activism, so don't be disheartened; they will understand soon enough.

Preparing to video an action
Before you set off, make sure you have:

- all your equipment (camcorder, tape, microphone, etc.);

- a press card;
- the telephone numbers of TV news stations (see pp. 230–1 of Resources);
- a press release to send to TV news stations;
- if possible, a mobile phone.

Have a look in your television guide or newspaper to find out what time the local and national stations go on air. Write them down along with telephone numbers and journalist contacts as you acquire them. And remember that the better your relationship with a journalist the more likely you will be to sell your footage.

What to video

There is quite a difference between videoing for television news and witness video (see Chapter 5). Unlike witness, where you have to video everything over a long period of time to make sure you don't miss out on anything, shooting for television is all about discipline and quality. Because television news programmes or documentaries are unlikely to use more than 30 seconds of your footage, you need to capture the *essence* of the action – normally, the most exciting moments – in a few shots. For example, if the essence of an anti-McDonalds action is a litter drop, and you fail to video the moment they dump the litter on the steps of the McDonalds headquarters, you aren't going to be able to sell your footage to television. Similarly, television stations love arrests, so make sure you cover these well and try to get in close enough to get good sound and facial expressions.

Television stations rarely use interviews from video activists – either the sound quality isn't good enough or they have a crew that turns up later to cover the action. Nevertheless, they do occasionally use them, so make sure you record at least one person explaining why they are there and what they think of what has taken place during the action (the response of the police, the success of the action, etc.). Again, television likes explanatory shots, such as placards with succinct slogans, chanting and wide group shots (to show how many people are involved).

THE SALE

Once you've got your high quality video of a unique and newsworthy story, everything rests on how you sell it and who you sell it to.

Deciding who to sell it to

There are a lot of different television outlets these days, each with its own broadcast remit, editorial policy, and traditions of taking video activist materials. You should take all these factors into account when choosing who to call and in formulating your pitch. For instance, a commercial station is more likely to want sensational footage of arrests and a public service station may be more interested in interviews and banner slogans.

As your aim is to get the footage seen by as many people as possible you may as well try and sell the footage to as many broadcasters as possible. Of course, with experience you'll learn that some broadcasters will never be interested in a certain kind of story.

However, don't underestimate the power of local and regional television. For example, BBC Newsroom South East has a reach of over 10 million people in the UK. Such channels are normally desperate for footage so you have much more chance of getting your material shown here than by national news programmes. They are also more likely to take repeat stories from the same issue or campaign over a number of weeks or months.

News stations will almost always say that they want to view the footage before they use it. This creates a difficulty when two different stations want to look at it. The solution is to give it to the station that has the first news broadcast or that you feel is most interested. Stations have agreements with each other about swapping footage, so you can tell the other station to get your footage through a microwave or satellite feed from the first station. They will sort out the technical details.

If you have interest from national as well as local television, then you should give priority to the national stations, which have a wider audience and pay more money. They are usually pretty scrupulous, especially if you get the name of the person you're speaking to, and go through the points of the 'deal' (see below).

The pitch – calling the newsdesk

So now you're ready to pick up the phone (mobile phones, though expensive, are great for this, especially as journalists often want to call you back). Here's how you do it. Call the main number of the station (see Resources, pp. 230–1) and ask for the newsdesk. If it's the BBC

you'll have to say which newsdesk: 1 o'clock, 6 o'clock, etc. When you get through, say that you're an independent video-maker and that you have some footage for the next news broadcast, then ask who you should talk to. You probably won't get the right person straight away but will be transferred one or more times, so don't give your best effort until you know you've got the right person.

The conversation may go something like this:

Video activist: Hello, my name is Jill Parsons and I've got some really exciting footage for your next news broadcast.

Journalist: What is it about?

VA: Well, I've just come back from a rally outside the Houses of Parliament where the Lesbian Avengers handcuffed themselves to each other to pressure the government to lower the age of consent. There were over thirty people. I have some great close-ups of banners and people chanting. There were two arrests.

The journalist might then tell you she isn't interested in the story because (a) they have plenty of stories (b) they've already covered the story or (c) it's just not that interesting. But if she is interested the conversation will typically continue like this:

Journalist: Well that sounds interesting. What did you shoot on?

VA: I've got a really nice Hi8 camcorder. The picture quality is excellent as it was all outside. I got great sound too, lots of chanting and a couple of good interviews.

She might get a bit hesitant at this stage and say that she doesn't usually take footage from the public, but almost all television stations do nowadays and this is just part of the bargaining process. The journalist you're talking to might not have taken camcorder footage before, but someone else in their newsroom will almost certainly have done. If she's going to be difficult, there's nothing you can do about it except say that all the broadcast stations take Hi8 now, and that people are selling Hi8 to local television stations all the time. Point out that the BBC and CNN have handed out Hi8 camcorders to many of their overseas correspondents.

The journalist may also question your news-gathering objectivity:

Journalist:	So, how did you come to hear about the action? Are you involved in the campaign?
VA:	I am an independent video journalist who shoots different things going on and then passes the footage on to the news. I heard about the event through a press release.

Once you've got her interested in your footage, and before you send the tape, it's time to secure the deal.

The deal

Make sure that you go through on the phone each of the main areas of an agreement before you send in the tape. Don't give away more than you have to. If you don't ask about the issues then the television station will presume the agreement in their favour.

The main areas of concern include:

- Money – Decide *before* you talk to the television station whether you're willing to give the footage away for free. If you're not, decide the minimum payment you're willing to accept per minute, with a minimum of one minute in case they use less than that. Then you need to agree a price with the person you speak to at the television station before you send the tape in. Also agree how to invoice them. For up-to-date information on standard rates contact your local television union (for example, Bectu in the UK). A guide for the UK is £100–£150 per minute for local news, £200–£300 for national news, and £500 for international news. (These figures were accurate at the time of writing but are likely to change.)
- Programme – You need to define which programme the footage is for. If a news programme passes the footage to a current affairs programme you should be paid twice.
- Territories – You need to limit where you are permitting them to broadcast the footage, otherwise they could pass footage to other regions or countries. If a local television station wants to pass the footage on to national television because it's so good, then they should contact you for your permission. If they don't

ask for permission, because there isn't enough time, make sure that you're paid by each of the stations.

- Frequency of use – You need to establish the number of times they will use your footage. One or two times is the norm when selling to television documentaries (see Chapter 7, p. 123), but not for news, as they may have frequent bulletins throughout the day.
- Timing – You need to limit when they can use the footage. For example, if it is news, you might say they can use the footage as many times as they want on the day of the sale, but then they will have to pay extra for future transmissions.
- Exclusivity – Some stations will ask for exclusive use of your footage (in other words they are the only ones allowed to broadcast it). They may offer you more money for this privilege, but as an activist you'll want to get your footage out as widely as possible, so resist the temptation of the extra money. Insist that you are licensing them for non-exclusive use only (i.e. you can give the footage to other broadcasters as well).
- Strap – This is the 'Protester's footage' or 'Amateur footage' caption that television news often places at the bottom of screen, superimposed upon the video footage. Some people say this is quite good as it shows that non-professionals can get their footage onto television. But I feel that it undermines the 'objective' power of the images; people might see it as an indication of bias. So I always try and get a guarantee from the station that they won't put a strap on our footage. This isn't a key problem – it's up to you to decide what you want. But if you don't want a strap, argue that you are a freelance independent video-maker and that the words 'amateur' and 'protester' do not apply to you.
- Credit – News won't give credits.
- Copyright – Don't hand over your copyright to your footage. There is no reason to. You may be asked to waive your 'moral rights' as the author of the material. This enables the programme-makers to use your material as they wish. Waiving these rights is pretty much industry standard these days, so don't worry too much about it. The safest way to protect against misuse of your material is (a) to limit the use through territory, frequency and programme (see above), (b) not to give it to a broadcaster who you know won't be sympathetic to your campaign, and (c) to make sure you don't hand over any material that could be used to cast the campaign in a bad light.

A typical deal with a local news station in the UK might be:

- £100 per minute used, within a minimum of £100;
- BBC1 News only;
- for broadcast in South-East region of the UK only;
- for use that day only, as many times as they like;
- non-exclusive use;
- retaining copyright;
- no credit;
- no strap.

Make sure that you establish how and when the journalist will send you back your tape and take down the name of the person you've been talking to for future chase-ups. It has been known for people to lose out on money or never get their tapes back because they don't know who they spoke to. In one case, a tape was returned to a video activist a year after it was 'lost' by a television company.

If a second station is interested in your footage, the quickest and safest method of getting the material to them (if a courier would take too long) may be for the first station to send the material by microwave or satellite link to the second station. Most television stations have agreements to do this with one another. Quality can be lost in such transfers, however, so get the news to take the images straight from your master tape whenever possible. But again, there's a risk of losing track of tapes that are being couriered from one station to another if you don't keep a note of the names of all the journalists involved.

Finally, it has been known for the police to try to get hold of master tapes held by television stations. If your footage is sensitive, make sure that they know they cannot pass it on without your permission. Of course, the police can can record the broadcast, but the master tape, which will include some footage that hasn't been broadcast, should be safe from their hands.

The contract

A big problem faced by many video activists is that agreements made with journalists over the phone are 'forgotten' later on. One safeguard would be to record your conversation, though this isn't always practicable, especially if you're ringing from a public phone box or mobile

phone. A sensible solution would be to send a contract. However, most news stations are too hassled and hurried to deal with contracts. Of course, it is always worth making notes but this doesn't mean the television station will agree later on.

Nevertheless, if you're planning to sell footage regularly to stations I strongly recommend that you make up a basic contract and fill in the details when you hand in a tape. Even if they don't sign it and send it back, you can at least say that you told them what your intentions were on paper. If you can, fax the contract to them after you've handed the tape over. Send a backup copy to the television station's legal department and keep another for your files.

Sample contract copy

Sarah Viewfinder
56 Camcorder Avenue
Battery Belt, CA 94603
Telephone: 415 345 6666

cc. Broadcaster's Legal Department

I Sarah Viewfinder am granting a non-exclusive license to you [Planet Central TV] (the Broadcaster) to transmit the footage I shot of [anti-nukes protest at Pentagon] as part of the program ['News at 6'] only and for [unlimited time] in the following territories:[US only]; and to be transmitted only on [March 25, 1997].

In consideration of this, the Broadcaster will pay Sarah Viewfinder the sum of [$500] for every minute used, with a minimum use of one minute, and send the check to the address above.

Signed, Sarah Viewfinder: [signature]
Signed, Broadcaster Name Position
Date

If the station breaks its agreement with you, give them hell. Be persistent and keep chasing them up – it's worth the effort. If you fail to, it won't only be you who loses out; it will reinforce bad behaviour, which will affect you and other video activists in the future.

This all might sound complex, legalistic and a bit intimidating, but once you get into the swing of it it's just common sense. It can help to practise the pitch with a friend in a role play situation. Whoever plays

the newsdesk journalist, have a go at being difficult and sceptical. This can be a lot of fun.

Delivering the tape

Before you send in the tape, make sure that you do the following.

1 Label the tape clearly with your name and address for return delivery.
2 Include a basic fact sheet about what the action was about, a press release often works well.
3 Include a rough list of contents on the tape, in order of action, preferably with approximate times.
4 Cue the tape to the first point of the sequence you think they will be most excited about.
5 Make sure that you have the name of who you're sending the tape to, and have included a letter outlining the terms of the agreement, the sell price, the return date, etc., taking a copy for your own records.
6 Package the tape well to protect it from damage. Sony Hi8 grey hard-case tape boxes are effective and look good too.

You can either drop the tape off or have the television station pick it up by courier. Delivering it yourself gives you a chance to see the inside workings of a station and make face-to-face contact with the journalist you've been negotiating with. You may even be able to have some editorial control by sitting in with them while they make their editing decisions. Couriers are great for saving time, and the television station might be more likely to use your footage if it has invested some money in you already. The choice is yours.

You aren't there yet! Even if you've made the deal and the cassette is on its way, you still haven't clinched it. The quality might not be good enough; other stories may come in and squeeze yours out. Make sure you watch the news (and make a video copy) as it is embarrassing if you chase the station for money when they never actually used the material (this has happened a number of times to me). But if your footage doesn't make it, don't give up. Try again; television stations are always hungry for footage.

Peter Vaughn

On 14 March 1995, 15 forest preservation activists gathered to stop the logging in Mumbulla State Forest, southern New South Wales, Australia. They managed to stop a logging truck, but the driver radioed for support. An hour later, 20 vigilantes arrived. They burned the protesters' banners and threatened them with violence. The whole thing was recorded by video activist Peter Vaughn, who had climbed onto a truck to prevent the vigilantes from taking and smashing his camera.

The footage is very powerful, with the tension rising as the standoff continues. 'So you are threatening us?' asks one of the protesters. 'We're just asking you to leave', a burly logger replies. The vigilantes go off in a group to discuss what to do. Then they walk towards the protesters and try to get Peter off the truck with long poles, but he has picked up a piece of wood to defend himself with. One of the loggers suddenly punches a protester in the face. Others follow his lead and assault the other environmentalists.

Photo 6.4 ABC TV News coverage using Peter Vaughn's footage (video grab: ABC News)

Peter captured all this on his video camera and then drove 300 miles to get the footage to ABC TV in Sidney. He gave it to Alan Tate, ABC's environmental correspondent, who went to interview Cole Dorber, the spokesman of the Forest Products Association – a pro-timber lobby group. Dorber said 'If we have to fight, if we have to physically confront those people who have opposed us for so long, then so be it, maybe the time has come ... and I have to say to the people in the industry, if you are going to do this, use your common sense and make sure no one is filming you at the time.' This must be one of the worst spins in history (Photo 6.4).

The story grew throughout the week with numerous reports in the media. Finally, during a question in parliament, Prime Minister Paul Keating denounced Dorbor's words. Dorbor was then forced to apologise on national television. As a result of the fiasco, BORAL, one of the biggest wood-chipping companies in the country, pulled out of the Forestry Products Association, taking 25 per cent of the financial contributions with them. This all took place at a time when the forestry industry was trying to portray the environmentalists as violent extremists. Peter's footage changed this perception for ever. Now the loggers were viewed as the thugs.

Television Beyond the News

In Chapter 6 we looked at the process of supplying unedited footage to television news. This approach works for a great number of people. It is a quick and easy way of getting a group's message on television. It requires almost no resources and anyone can do it. The main problem with this approach, however, is that video activists have very little editorial control over how the footage is used. Another drawback is that the news is likely to use only a small amount of material, perhaps as little as 15 seconds. So, as they become more experienced, video activists tend to want to try out more sophisticated methods of working with television, methods that will give them more control over the final programme.

This chapter is no more than an introduction to a few of the main issues involved. It touches on some of the 'advanced' ways of supplying footage to television – important for those with limited experience who want to get more involved – but a detailed examination of the more complex and sophisticated aspects of television work is beyond the scope of this book.

OTHER WAYS OF SUPPLYING FOOTAGE TO TELEVISION

Besides supplying raw footage to the news, there are three main ways in which video activists can provide material to television. The method will depend on the resources at hand, the skills of the people involved, and the subject matter of the issue featured.

Video news releases

When a group edits its own news feature and supplies it to news stations for free, this is referred to as a video news release (VNR). It is the most resource-intensive route. To make a VNR a group must shoot or gather in high quality material normally shot on BetacamSP equipment, edit it on a broadcast-standard edit suite, provide a television-quality script and possibly even a narration, and then make a number of BetacamSP copies and send them off to news stations. The great advantage of this method is the editorial control it gives a group. They can decide the angle, perspective and opinion on a story, while giving the impression of journalistic objectivity by using traditional news broadcast techniques. The obvious disadvantage is the expense (note that television channels do not pay for VNRs), and the skills and equipment needed. And news editors can feel uncomfortable about accepting VNRs from pressure groups, as was the case with Greenpeace's high profile campaign to stop the sinking of a Shell oil rig in the North Sea in 1995. This route tends to be the domain of large non-governmental organisations and pressure groups such as WWF, Save the Children Fund and Amnesty International.

Archive for documentary use

Unlike the other two methods, the archive route normally relies on a television documentary producer approaching a group for material rather than the other way around. For this reason it needs a stable base and a reasonably high profile. Campaign-related archives vary considerably, from the single video activist who is known to have unique footage about a particular issue and supplies original master tapes, to an organisation that is known for being diverse and reliable and that supplies timecoded VHS viewing copies and, if needed, broadcast-quality sub-masters. The advantages of running an archive are that it can be quite lucrative, television stations may use considerable amounts of footage and credit may be given.

Documentaries

Making your own documentary feature provides the ultimate in editorial control. Having won the approval and the budget from the television station, video activists can go out and make the programmes they want. Their programmes will be seen by millions of viewers and can have an enormous impact. The video activist will also be extremely well paid along the way. Of course, the main hurdle is winning the

support of the television station, and many people spend their lives writing one proposal after another in the hope of winning a 'commission'.

I shall now examine each of these methods in more detail.

PRODUCING A VIDEO NEWS RELEASE

Supplying VNRs to newsdesks has become very popular in the past few years as a cost-effective means of getting a group's point of view onto the news in a large chunk of airtime. VNRs are far cheaper than advertising and have the more persuasive gloss of objective journalism.

VNRs vary from group to group, with some opting for short, easy-to-edit one- to two-minute pieces based mainly upon a strong bit of footage, to more ambitious seven- to ten-minute pieces that include a number of different interviews and atmospheric sequences and are highly polished. The expense will therefore vary enormously. A six-minute feature shot by a professional sound and camera crew on BetacamSP and involving overseas travel will cost around £20,000. A short piece shot on camcorder by an NGO worker can be made at home for under £5,000.

When making a VNR it helps to imagine that you are a journalist working in a television newsroom. At any stage when a question arises, simply ask yourself what that journalist would say. For example, when choosing the story for your VNR, you might ask yourself the following:

- What is the story? Is it new, exclusive and interesting?
- What is the best place and time to illustrate the story?
- Are the images unique?
- How does it tie in to other stories going on at the same time in the news?
- Is the piece biased or politically motivated?

Remember that you are on journalists' territory here, so you need to be able to strike a balance by saving them effort without threatening their professional integrity.

The essential ingredients of any VNR are the following:

- background information containing the essential facts behind the story, stated as objectively as possible, and including relevant contacts information;
- A BetacamSP tape containing: an 'A' Roll, made up of ready-to-air edited feature, including interviews, narration, action shots and cutaways; and a 'B' Roll, made up of a selection of the best shots, soundbites and atmospheric sound from which the news station can make its own feature;
- a script that goes with the 'A' Roll, which includes the names and titles of those interviewed, and place names;
- any translations necessary for the 'B' Roll not included in the script.

It is often useful to talk to a news channel before investing in a VNR to gauge their interest and see what their requirements are. It may also help to talk to other NGOs who have made VNRs in the past. It is well worth making an extra effort for your first VNR. If you have a track record of producing reliable, 'objective', good quality features, then the news channel is more likely to use your work in the future.

VNR backlash

Newsrooms have been criticised for using edited features made by groups like Greenpeace on the grounds of bias. This came to a head during the 1995 Greenpeace campaign to stop the sinking of the Shell 'Brent Spar' oil rig in the North Sea (Photo 7.1).

According to David Lloyds, Channel 4's Commissioning Editor of News and Current Affairs programmes: 'On Brent Spar we were bounced. This matters – we all took great pains to represent Shell's side of the argument. By the time the broadcasters tried to intervene on the scientific analysis, the story had long since been spun far into Greenpeace's direction. ... The pictures provided to us showed plucky helicopters riding into the fusillade of water canons. Try writing analytical science into that' (from 'Greenpeace used us, TV editors say', *Guardian*, 28 August 1995). He proposed a new set of ground rules giving 'health warnings' about footage provided by pressure groups, and suggested that broadcasters ban all VNRs, except where their journalistic qualities could not be had by other means.

Photo 7.1 Greenpeace videoing the occupation of Brent Spa oil rig from a boat, 1995 (photo: Greenpeace)

Partly for this reason, VNRs are less fashionable than they used to be. It is now more common for Greenpeace to send newsdesks a clip-reel, containing the best shots cut together in chronological order, than to make a VNR. Clip-reels are more likely to be used as they give journalists more room to impose their own editorial line.

Other groups are choosing clip-reels over VNRs because they are cheaper and easier to make. They don't require narrators, for example, which can be expensive, although some celebrities give their narrating services to campaigns for free. It's also difficult to get the right tone in a VNR, to meet the strict journalistic criteria necessary to win airtime while making sure the group's message is put across clearly. Many groups have had their fingers burnt when making VNRs. They make them too propagandist, too promotional, then they have them rejected and decide that the whole thing was a waste of money.

There is nevertheless a place for VNRs. They are especially valuable for targeting small markets where the editorial line would be in jeopardy if left up to the broadcasters.

Tips for making good VNRs

1 Analyse news to learn what kind of stories they are looking for.
2 Run operation like a professional news outfit.
3 Shoot and edit almost exclusively on BetacamSP.
4 Choose your story very carefully.
5 Think like a broadcast journalist.
6 Promote the story in the week before release to get newsrooms excited about it, but never exaggerate the quality of your material.
7 Provide unique images.
8 Pick a time and place (a news peg) to enhance the news value of the piece (e.g. a VNR about toxic reindeer sent to TV stations at Christmas).
9 Develop a good working relationship with journalists so that they have trust in your integrity.
10 Make sure to do the job properly because you'll have only one stab at it.
11 Don't put too much in the script.
12 Be prepared to compromise so that story can get into the news.

Greenpeace Communications

Greenpeace has its own dedicated media organisation, Greenpeace Communications. Until recently this was based in London; it is now based in Amsterdam. 'Comms', as it is known, provides media support to Greenpeace national offices around the world. One of their greatest successes over the years has been supplying television stations with footage that they have shot themselves.

In 1995, Greenpeace sent its ships to Muraroa to stop France testing nuclear bombs on the Pacific island. Professional camera operators took pictures from *Rainbow Warrior* and *MV Greenpeace*. These were then sent through an Inmarsat telephone to the Comms head office in London. Even though the quality of the images was not that good, they still used the material, editing it on a BetacamSP edit suite. Within 20 minutes of the material arriving in London, a broadcast tape would be delivered to international news services, Reuters, APTV, CNN, BBC World and WTN.

According to their news editor David Brown, broadcasters were clamouring for the images. He estimates that over 100 broadcasters used the images, with over 500 having access to the pictures. This generated enormous public interest in the issue, as well as in Greenpeace. One of the reasons for the success was the uniqueness of the footage. However, once the French confiscated the equipment later in the campaign, their publicity machine was seriously wounded.

Greenpeace Comms also produces video news releases – highly polished edited features that include a news story, narration and script as well as background footage. Greenpeace uses VNRs to put an issue on the news agenda with a particular editorial spin. For example, in 1992, Greenpeace wanted to let people know about the dangers of organochlorines (extremely toxic chemicals that are poisoning our food chains). They produced a VNR to coincide with a report. To provide a visual element, they travelled to the Arctic and showed how polar bears had high organochlorine content. Once it was edited to a journalist-quality script, the VNR was passed to news stations around the world. Most of them used it verbatim.

According to Tony Marriner, who was one of the first to shoot for Greenpeace in the 1970s, VNRs are as 'successful as they are good'. There are many groups who produce VNRs that he feels are too propagandist. Even Greenpeace 'shouts too much about making

these news features'. It got Greenpeace into trouble in 1995 when broadcasters were criticised for taking too much material from Greenpeace. 'VNRs should be invisible,' says Tony. 'When they are working well, you shouldn't know who they come from.'

ARCHIVE SALES TO TELEVISION

In Chapter 6 we concentrated on selling to the news on the day an event takes place. An archive can multiply the use and impact of footage by getting it shown more than once and to different audiences. Contact is usually made when programme-makers approach a campaigning group for material, and the group puts them in touch with the video activist who has been working with them. Make sure, therefore, that the group you're working with knows what footage you have, and that they can get hold of you easily.

Another way to supply video to documentary-makers is to become known for a certain type of footage. For example, in the 1990s **under***currents* became known as a good source for dramatic road protest footage taken from the protestors' point of view, and we were approached with requests for footage by over 100 television stations, from Japan to Canada to Finland.

Selling footage to documentary producers is slightly different from selling to news, because the programmes are likely to be more opinionated and have a stronger editorial line. There have been cases where video activist footage sold to documentary programmes has been used to politically damage the campaign involved. You need to be clear that the programme will benefit the group that you are working with. What is the programme about? Will it support or undermine the campaign? Would it be best to give the producer the whole tape or edited sequences to make sure that they use the most beneficial sections? Does the campaign know about the programme? Do they want you to support it? As a safety measure, always ask the producers to send you a letter outlining what the programme is about and how they are likely to use your footage.

Often a documentary company will ask for a viewing tape before they want the master. This is a low quality copy of your footage often on a VHS cassette with 'burnt-in timecodes' (a counter number of hours, minutes and seconds appearing on the screen) to help locate the footage the programme maker wants. It's acceptable to charge for

sending viewing tapes since programme-makers frequently don't use the footage they're sent. In the UK you can charge £50 to £100 for such 'research' costs (to cover tape, copying, post and your time). This also guarantees against a programme wasting your time.

Make sure that the documentary company sends you a copy of the final programme so you can check how much footage they've used and how they've used it. And, of course, make sure you get the tape back. They should need it for only a day or two to make a transfer to BetacamSP tape. Insist that they bike it back or send it by registered post immediately.

The main areas of concern when concluding a deal with a documentary company are similar to those we have already examined for selling to news.

- Money – This depends on territories and frequency. Ask your national television union for the latest broadcast rates for footage use. For national coverage, one or two times only, you can expect: £300 in the UK, $500 in the US and A$200 in Australia. For international rights you can expect to be paid at least £500.
- Territories – Many documentary-makers now seek wordwide rights so that they can sell their programme abroad. Make sure you establish what they are seeking. If they want more than national rights charge at least double the country rate.
- Frequency – A standard frequency would be once or twice only within each territory. If you are supplying footage for a title sequence, multiply the normal rate by half the total number of episodes it will be used in. But basically you are going to have to negotiate. There are no set rules. Ask for more than you expect and more often than not you will get it.
- Copyright – The rights situation for documentaries is similar to that for television news (see Chapter 6, p. 108). Agree a price for specific rights to be licensed *before* you give them any tapes. Make sure they confirm this in writing to you.
- Contract – In this situation you have plenty of time to get a contract, so do so, with both sides signing it (see Chapter 6, pp. 110–11).
- Exclusivity – As with news, some documentary-makers will ask for exclusive use of your footage. Again, insist that you are licensing them for non-exclusive use only.

• Credit – Try to get the producer to confirm an 'end-of-programme on-screen credit' for your footage. Better still, if the programme depends on your footage to make it work, ask for an 'on-screen credit over the clip' as it is being broadcast.

Tips for running a television archive

1 Catalogue tapes and give each a separate number.
2 Make high quality backup copies of the best tapes.
3 Label your tapes fully and clearly (name, address, summary of contents) – printed stickers are useful.
4 Inform relevant campaign groups and television companies about your archive.
5 If you are storing other people's material, agree a deal before a sale takes place.
6 Charge television companies a 'research fee' irrespective of use.
7 Before sending material get a written description of programme and confirmation of the deal.
8 Always send tapes by registered mail.
9 Check the 'going rate' for archive sales by calling television companies for their price list.
10 Double check how much of your material they use by looking at copy of final programme.

The under*currents* Camcorder Action Network Archive

In September 1992 I heard a helicopter fly over our office in North London. On a whim I dropped what I was doing – probably drafting yet another proposal for a television documentary – grabbed my camcorder and ran outside. I followed the noise of the helicopter blades and traced it to a lane a few hundreds yards away. A man had got stuck in a factory lift and was being rescued by emergency services. I videoed the action and rang the local television stations. Both used the footage, calling it a 'miraculous escape story'.

We realised that there was a huge opportunity to get untold community action stories onto television, and began to supply camcorder footage regularly to television. Later on, we decided to set up a television archive that would compliment our on-the-day

sales. This enabled current affairs and documentary-makers to access the material as well. We invited video activists to store their footage with us, and offered to act as agents on their behalf.

The Archive has proved enormously successful. At the time of writing we have sold over 100 stories to over 40 television channels around the world. The Archive is now the largest and most comprehensive archive of protest and community action in Britain in the 1990s. Video activists are attracted to store their footage with us because of the successes we've had in the past in placing campaign stories onto television and because they want to support **under**currents with profits from any sale that takes place. Television companies come to us because they know that they can rely on us for unique and high quality material and that we are reasonable and efficient to work with.

Perhaps most exciting of all, the National Film and Television Archive, one of the key recepticles of contemporary UK culture, is now working with us to catalogue and integrate the **under**currents archive into the main national archive. Tree sitters and anti-nuclear protestors are part of history – it's official!

Our next hope is to set up a computer-based database and to use the Web and other opportunities to market the service. In this way we hope to get even more alternative footage onto television and seen by an even wider audience.

BECOMING A PROFESSIONAL DOCUMENTARY-MAKER

After video activists have supplied a fair number of stories to television, they often begin asking themselves, could I do this for a living? The idea is attractive as it offers video activists a source of income while satisfying their need to make a difference. But, as with freelance photography, it is hard to make enough money to earn a decent living. There are three major drawbacks:

- Events that elicit the kind of footage that television is looking for are not that common.
- After a while television gets bored with images of activists organising stunts or being dragged around by police.

- The constant search for sensational television-friendly material may lead video activists away from the campaign they have been supporting.

Some people can make a living this way. They are known as 'stringers'. But I don't know of anyone who has been a stringer and kept to his or her political aspirations.

Another option – one that's even more attractive than selling raw footage – is to try to make edited features for television news and documentaries. The appeal of this is undeniable. It gives video activists far more editorial control. There are plenty of resources. Highly skilled camera operators and editors work on the project. There is a big audience. Broadcast executives provide their experience and support. Video activists can be paid enough to allow them to do non-paid 'charitable' work later on.

There are now many such 'broadcast activists' in the UK. Many learnt their craft through the Film and Video Workshops that were set up and financially supported by Channel 4 in the early 1980s. The aim was to support community programme-making. People from the Workshops spent years training others how to make videos, producing their own local documentaries and, from time to time, making issue-based films for television. Since the demise of the Workshops in the 1990s (mainly due to the drying up of Channel 4 funds), a number of these people moved into full-time television work, skipping from one proposal to the next. Many of the most powerful programmes of the last decade have come out of this group of people (see the profile on pp. 129–30).

There is no formula for getting an idea turned into a broadcast documentary, but there are a few guidelines for getting the process started. The first thing to do is to carry out the research. Your main advantage will be that you have contacts and access to a group and the issues they are working on that no one else has. You must exploit this advantage to the full. So spend as much time as you can working with the people involved to develop a good broadcast proposal. As with all video activism, the key will be to work to the group's agenda. This will not only be more politically effective but is also likely to produce a greater chance of winning a broadcast commission, since a group that is participating in and commited to the project will ensure that the research is of a high quality.

Once you have carried out the research you need to write a proposal. This should summarise the main elements of the programme, and be written on one side of a sheet of A4 paper. Do not send the proposal to more than one commissioning editor within the same company at the same time. You should propose a programme that will be intriguing, polished, relevant, legally sound, well researched and balanced.

- Intriguing – You must capture the commissioning editor's imagination. To do this you must propose either an entirely new subject or a novel approach to dealing with an old one.
- Polished – You must sell not only an idea but the way you are going to make the idea work. Explain how the programme will look, details of what and who will be in it, its style and music, etc.
- Relevant – Commissioning editors are increasingly looking for large audience programmes, so you must show how your programme will appeal to a wide number of people.
- Legally sound – If you are dealing with a controversial subject, make it clear that you are aware of the legal implications. For example, suggest ways to make sure it is not libellous.
- Well researched – Commissioning editors get hundreds of proposals every week appearing on their desks. You must do adequate research before you send your idea in or they won't believe you know what you're talking about.
- Balanced – Television works under strict codes of fairness. Most editors will not let you give voice to just one side of an argument. Show how you will present both sides of the story.

A typical process may go something like this:

- Research an issue.
- Develop a proposal.
- Send the proposal to a broadcast company (perhaps through an established production company).
- Get feedback from the broadcast company.
- If it's good, rewrite and submit the proposal for development money.
- If you get development money, develop the proposal further.
- If you get a commission, make the programme.

Common problems

Competition

It is becoming increasingly tough to win commissions. There are now hundreds of independent companies jostling for very few programme opportunities. Don't give up your day job expecting to make your first broadcast documentary.

Editorial freedom

According to those who have tried it, making activist features for television can be very difficult. The problem is treading the tightrope between the activist and broadcast worlds. On the one hand the video activist wants to make a feature that will have an impact. And on the other hand he or she needs to persuade the broadcaster to support the project. This conflict runs like a fault line through the entire process. The legal department cuts out a sequence that the campaign wants in. The commissioning editor wants an investigative piece and the video activist wants an empowerment video.

Harassment

Be aware that once the programme is made there can be even more problems for the video activist. The need to be seen as objective may mean that you cannot participate any more in political events. The broadcast company may label you as a campaigning video-maker and be reluctant to ask you to make more videos. The impact of your video may be so great – because of the size of the audience – that it can lead to increased harassment from state and corporate authorities. Even worse, the campaign group that you work with might turn against you and accuse you of being a 'sell-out'. Being a professional video-maker can be a lonely business.

In fact, most video activists who try it stumble at the professional video hurdle. The combined pressures are just too great. They either fail to win a commission or, if they are commissioned, their final product is watered-down and politically insignificant. In neither case are they supporting a campaign or a community that's working to bring about change, and they may in fact end up taking away scarce resources from those struggles. Very few people are able to retain their social agenda and integrity and make powerful documentaries for television.

What often happens is video activists become half-involved in the world of video journalism. They are approached for footage by a producer who is making a video. They are courted with attractive-sounding assurances, but end up supplying their best material to the producer, who uses it as the core of the video, and then are cut out of the production process. As far as the television producer is concerned, it is much easier and cheaper to maker videos like this than to employ the activist as a full member of a production team.

If you want to be a video activist television producer think carefully about your strategy. The journey down this path is not an easy one.

Tips for the video activist television producer

1 Ask the campaigners if they want a programme and explain the limits of television to them.
2 Don't mention the campaign group to the broadcaster.
3 Appear to be objective to the broadcaster.
4 Ensure quality control (i.e. don't interview people who talk rubbish).
5 Make sure the research is watertight.
6 Let the campaign group know that you agree with their case and want to support their cause.
7 Feed the research you've gained during production into the campaign.
8 Re-cut a broadcast video and/or give copies of the broadcast video to the campaign.
9 Pay campaigners and community groups for their time spent on the programme.
10 Check in with the campaign groups as the production process goes along.

Oxford Film and Video-Makers

Oxford Film and Video-Makers (OFVM) was set up in 1987, inspired by the Channel 4 Film and Video Workshops. Their aim was to make film – and especially the new video technology – accessible to the local community. They adopted the workshop method of 'integrated

practice', where people learnt how to use the equipment through the production of a programme.

Thousands of people have been trained by people from the workshop, and over 100 videos have been made for and about local community and campaign groups. Recently OVFM won a large grant from the National Lottery, and for years they have received funding from the Arts Council and Oxford County and City Councils.

Perhaps one of the most impressive aspects of OFVM's work has been the large number of video activists who have started with them and gone on to make broadcast productions. Interestingly, the vast majority of these have been rooted in community campaigns. Glen and Kay Ellis have made several films about oil corporations oppressing indigenous people in Nigeria; Richard Herring and Stuart Tanner produced a *Dispatches* programme about the illegal extraction of mahogany from Indian land in Brazil; Gemunu de Silva produced *Animal Acts*, a documentary about the animal rights movement in England; while Mary Anne Sweeney made a film about prostitute unions in Brazil and another about a group of Anglo-Asian women fighting their own union in Birmingham. All of these were broadcast on national television, and all producers maintained contacts with campaign groups throughout the production process.

According to Richard Herring, 'Our approach is 'bottom-up' – we start in the community – not 'top-down' like most programme-makers. This is what makes our programmes distinctive and therefore attractive to the broadcast company commissioning editors.'

8

Producing a Campaign Video

After using video for witness (see Chapter 4), making a campaign video to raise awareness is the next most common video activist project. For a campaign video, unlike witness video, the raw material has to be edited to make it effective for a particular audience. This is a crucial difference, as editing can take a lot of time.

In almost every community you will find someone who collects video material of local events, spends their nights logging tapes, and edits them into some kind of sensible order. Some people can even make a living doing this by making promotional and educational videos for non-profit and campaign organisations.

However, some video activists get so caught up in the excitement of the production process that they lose track of the purpose behind all their effort. As a result the campaign video does not get finished or, perhaps worse, their target audience doesn't like it. As with the other methods described in this book, making a campaign video is just another tactic. It may be more appropriate to use video in another way – like selling to television (Chapters 6 and 7) or using the Web (Chapter 11) perhaps.

So, before you attempt to make a campaign video, ask yourself these questions:

- Why am I making this video?
- Who will benefit from it?
- Who will see it?
- How will it effect change?
- Is there an easier way of doing this than making a campaign video?
- Where will it be distributed?

If you can't answer these questions easily, think again and reconsider whether you should make a campaign video at all. If you can answer these questions, then you are ready to go ahead with the project.

TYPES OF CAMPAIGN VIDEO

Of course there are a thousand and one different ways of making a campaign video, and the choice depends on the audience and the campaign. The most common types, which we shall look at in turn, are educational videos, empowerment videos and fundraising videos.

Educational videos

The aim of the educational video is to raise awareness of a certain problem or issue. Television documentary-makers have honed this to a fine art, using great skill to persuade people of a certain point of view.

Video is extremely good at showing you a problem and letting you (in theory) make up your own mind. However, it is not very good with arguments. Certainly, the written word is better for running through theoretical discussions. Educational video-makers therefore tend to use video to provoke an emotional response, rather than to teach in-depth knowledge.

An educational video should:

- show you evidence of a problem;
- explain why the problem exists;
- include 'experts' confirming it as a problem;
- include affected people saying how it impacts on their lives.

An example of this type of programme taken from television is the series *Animal Detectives*, first broadcast by Carlton Television in the UK in 1995, which followed the work of agents from the Environmental Investigation Agency (EIA) to expose the worldwide trade in wild animals, using hidden cameras and microphones. One episode looked at the fast-growing and illegal international trade in bear parts, particular gall bladders, used in traditional Chinese medicine. It highlighted the existence of commercial bear farms sanctioned by the Chinese government. The government claimed that these farms

conserve Asiatic Black bears, because their bile is 'milked' from them while they're alive, but captive-bred stocks are supplemented with animals taken from the wild. Some particularly shocking footage showed bears in tiny cages, unable to lie down because of the metal catheters implanted into their gall bladders, which caused swelling and infection. This video, subsequently shown in several other countries, exposed these horrors for the first time, and encouraged both conservation and animal welfare groups and governments worldwide to pressurise China to change its official policy of 'using wildlife resources' in this way. By April 1997, the Chinese government had made some changes to improve the bears' welfare, but was still deciding whether the farms should be phased out.

Educational videos are extremely common in the video activist world. Such features are used by groups to inform others about their problems and to try to recruit people to their cause.

In 1995, the Native Forest Council in Eugene, Oregon, made an educational video *Born in Fire*. The group wanted it to act as an introduction to Warner Creek – a roadless wilderness area that was going to be clear-cut under the new 'Salvage Logging Rider' legislation. They worked with a local production company and produced a very effective 15-minute documentary. The video was sent around the country to members of Congress, the media and environmental groups, to mobilise people against the destruction. In August 1996 President Clinton's Administration paid the timber company *not* to log the area. Warner Creek was saved.

Of course, once an educational video is made, it needs to be distributed to have an impact. The most common ways to do this are:

- at screenings (see Chapter 10);
- by mail order – through advertising or leaflet drops in magazines (see Chapter 11, p. 201);
- on community broadcast television stations (see Chapter 11, pp. 189–91).

Empowerment videos

Empowerment videos are aimed at getting people active on an issue, rather than simply raising awareness (Photo 8.1). They can be an extremely effective means of community organising. They should:

Born in Fire videoscript

Video	Audio
Beautiful shots of forests, waterfalls, wildlife, etc.	Soft eerie music. Voice-over: 'The beautiful landscape of the Pacific North-West ...'
Shots of salvage logging using helicopters dissolve to shots of chainsaws and massive felled trees, devastated landscape.	Voice-over: 'Wild fires are a natural part of the environment ... They have become an excuse to allow timber companies to enter protected lands.'
More shots of beautiful forests, mist, etc.	Voice-over: 'We now stand at a crossroads ... We can either allow the continued liquidation of our forests or we can take a stand and let fire take its rightful place in the ecosystem ...'
Ex-logger being interviewed	'I've worked in the industry for fifteen years and have never seen anything like this. They are taking green trees out of the forest. It's not right.'
Shots of burnt trees.	Voice-over: 'Five years ago an arsonist set fire to this forest; 206 acres were destroyed.'
Campaigner being interviewed	'We have to make sure that arsonists are not rewarded with timber sales.'
Biologist being interviewed, as he scrapes away top level layer of bark	'If you look here, you see that the tree is still living underneath.'

- give a no-compromise view of the problem;
- show people doing something about the problem (with some success);
- be fun and positive;
- show what life is or would be like without the problem.

One of the most successful programmes to be made about the UK anti-roads movement was *You've Got to be Choking*, made by Jamie Hartzell for **Under***currents*. This 35-minute feature charted the campaign to stop the M11 Link Road being built through Wanstead in East London. The video included material shot by more then ten people, spanned two years, and was the first to cover an entire campaign. Not only did it win a number of prizes at international film festivals, but it became known as 'the' documentary on the anti-roads movement and was seen around the world.

You've Got to be Choking went like this:

Sequence 1: Sound bites from key campaigners about why they were involved over images of Wanstead and general shots of sitting on bulldozers.

Sequence 2: Images of early days of direct action and discussion by key campaigners about why they use it.

Sequence 3: Activists squat houses in the path of the road to delay building, bailiffs arrive to evict them, discussion about the responsiveness of the police.

Sequence 4: The threatened felling of the chestnut tree on the green, the community responds by setting up camp around the tree, police evict tree dwellers and knock down the tree.

Sequence 5: Campaign moves to three houses due for demolition. Press conference where evicted tenant tells media she is now squatting her own house. Setting up of defences in houses, close-ups of people 'locking-on', sealing themselves in concrete bunker, waiting during the night. Interviews with people about how they feel.

Sequence 6: Eviction from houses, police arrive, bailiffs smash windows, people dragged out. Intercut of general shots with women in concrete bunker, on phone telling people how they feel. Sequence ends with bailiffs breaking into bunker, threatening protesters with violence to get them out and dragging camera-woman away.

Sequence 7: Song sung by women about being strong, final interviews with key campaigners about how campaign will go on, caption saying campaign is continuing with final shot of people invading construction site as an example.

Another example of an empowerment video is that made by George Marshall, Glen Ellis and Jason Torrance in 1992. Their *Rainforest*

Empowerment Video was crude but effective. Along with its sister *The Direct Action Video* it sold hundreds of copies and was seen by community and action groups around the world. With a shoestring budget of under £50 and using a basic two-machine edit suite, they compiled archive footage into six minutes of pure energy.

The *Rainforest Empowerment Video* went like this:

Sequence 1: Beautiful image of rainforests and their enigmatic wildlife, soft pan-pipes.

Sequence 2: Shocking images of rainforest destruction, with heavy, doom-ridden music.

Sequence 3: Exciting and thrilling shots of activists stopping rainforest destruction, hi-energy techno beat.

Caption informing the audience where they could get more information.

The most common ways to distribute empowerment videos are:

- at screenings;
- by mail order – through advertising or leaflet drops in magazines.

Fundraising videos

An interesting use of video is as a fundraising tool. These kinds of videos have their own peculiar requirements. They must evoke sympathy for a cause and outline the need for financial support while maintaining respect and admiration for the group or organisation involved.

Fundraising videos often include:

- shocking images of the issue at stake;
- testimony from the people affected, saying how they need help;
- shots of the group at work on the issue, looking efficient;
- interviews with the public saying how good the group is;
- a finale, where the need for financial support is stated (voice-over, piece to camera or caption).

An interesting use of videos for fundraising was made by Oxfam in 1995. They sent over 2,000 free video tapes (a mail-drop) to new members who requested further information about their work. The video was 20 minutes long and gave illustrations of Oxfam's successful

work in low-income countries. Besides having an educational value, the video was intended to encourage donors to renew their covenants when they ran out.

But including video in a fundraising strategy can backfire. Aid Watch in Sydney, Australia, collected camcorder footage of failed government development projects overseas and edited a short promotional video with the material. They then sent it off to donors along with grant applications. 'Only a few of the donors would accept the video as part of the application', said Aid Watch coordinator Lee Ryanan. 'They either didn't have the right equipment to watch them or didn't think it appropriate. I got the feeling that many of them thought "This cost a lot of money to make" (even though it didn't), "so they obviously don't need our money".'

The most common ways to distribute fund-raising videos are:

- at screenings;
- by a general mail-drop;
- as a complement to a grant proposal.

THE PROCESS

The making of a campaign video can be broken down into a number of stages. They are:

1 Preparation and research ('pre-production');
2 Shooting ('production');
3 Editing ('post-production');
4 Distribution ('transmission/broadcast/screening').

It is worth keeping these in mind to help you budget time and money, and to chart your progress as you go along. Each stage requires its own set of skills. In broadcast television, each is done by different sets of people: Stage 1 by a director and researcher; Stage 2 by a camera and sound operator, director and production assistant; Stage 3 by the director and editor(s); and Stage 4 by the transmission technicians. A video activist is probably going to have to do most, if not all, of these tasks. This is both the joy and the anguish of this type of work.

In the rest of this chapter I shall look at the first two stages. I shall look at editing in Chapter 8 and distribution in Chapters 10 and 11.

PREPARATION AND RESEARCH

The main reason that television programmes seem so professional and polished is not, as people suppose, because they have access to more sophisticated technology. It is because they have invested so much at the front end of the process, even before a programme gets the go-ahead from the 'authorities'. First, it goes through an initial research phase when a director hunts around for stories and comes up with an idea. Then the programme goes through a development phase, during which a researcher gathers in the information to make sure a director's crazy idea could work in practice. Then, if the programme gets the green light, it goes through yet another research phase when the crew is arranged, the locations and interviews are set up, the equipment is hired, and so on. This is all called 'pre-production'.

One of the biggest mistakes that video activists make is not to put enough effort into this research and preparation stage. In this instance, it is worth following the television producer's example.

Preparation

To save time when making a campaign video, and to make it most effective, prepare everything in advance. First, meet with the campaigners who are going to use the video. Ask them what they need most and how they intend to use it. If it's to raise funds it will be different from a recruitment video. If it's to get the local school kids involved it will be different from an in-depth educational video for researchers. It may also help if you show the group a video made in the style you are aiming at and gauge reactions.

Cooperation

When you are making a video for a group, it is best to get things straight as soon as possible. Sadly, I know of many instances of people making videos for a group and then coming to blows with them at some stage because there hadn't been enough talking at an early stage. One useful method is to make a written agreement between you and the group. This might include:

- what the video is for;
- how long it will be;
- who is to make the video;
- any financial transactions that might take place and when;
- when the video is meant to be finished by;

- who owns the video once it's complete;
- how the group intends to use the video;
- what rights the group has to change the content of the video;
- where the video will be distributed.

You should see this more as a letter of understanding and less as a legal agreement. Some groups might be put off by this level of planning and communication. If this is so, I suggest you seriously question whether you should make a campaign video for them. Perhaps you could help in another way.

Structure and content

Once you've established the group's need, sit down and work out the best way to meet this. Is it to get interviews with the people concerned? Is it to follow one person's story? Is it best to use archive material or to shoot new footage? What would be the best music to use?

Campaign video to slow traffic in high street

Video	Audio
Shots of heavy traffic	Spluttering car exhausts
Interview with residents on why they don't like traffic	'It's horrible! My kids all have asthma ...' 'We wish someone would do something...'
No-cars action day sequence: shots of mums with kids and signs in road, traffic ground to a halt, close-up of handing leaflets out to drivers.	Music: Talking Heads, 'Road to nowhere'.
Nearby village where they have managed to reduce car volume. Shots of empty streets	Natural sound
Interview with locals	'It was hard work to get the council to change their mind, but we won in the end, now look how nice it is!'
Camera crew trying to get interview with council members, turned away at main gates	'No, you can't come in here.'
More interviews with locals	'It's time for action!'
Montage of images of empty streets again	Song: 'Here we go, here we go, here we go!'

Have a first try at a structure for your video. Write down the most important sections and what shots you will need to make these work. Try to separate what you need for sound and what you need for images.

Schedule

Many people don't realise how long it takes and how much effort is required to make a campaign video. For the record, let me say this: if you are going to do it well (which you should if you want to have an impact), *it's going to take a long time and it's going to take a lot of effort.*

To make things easier, make yourself a production schedule, and write down the date next to the action you are going to take. If one thing is going to take longer than another thing – say trying to get hold of a copy of a programme from a television station – schedule it early in the process. A useful rule of thumb is to work out the scheduled time and add 50 per cent. In the event you may well take even longer than this!

Schedule for making a ten-minute campaign video

Activity	Number of days
Interaction and negotiations with group about their needs	2
Research	2
Shoot	5
Preparations for edit (transfers, music, finding edit suite)	1
Log	2
Structure and paper edit	2
Edit	14
Screening to group for comment	1
Fine-cut and final edit	3
Final screening to group	1
Follow up	1
Total	34

Research

Video activists should spend a great deal of time on research before they start recording. It will not only lend credibility to the project (it can be very embarrassing if you get your facts wrong in a video, and difficult to change later on) but will also generate surprising and useful information. Become an expert on the subject you are working on, talk to as many different people as possible, challenge any

assumption that the group makes. If people get troubled by your enthusiasm, you can explain that you are role-playing as if you were an unconvinced member of your audience.

Video archive

Making use of material shot by other people can be incredibly useful. It will be essential, of course, if the event that's the focus of your campaign video has already taken place, but it can also save you having to make a trip to a far-off location. To find the material, start by talking to the group you are working with or other groups campaigning on similar issues. They are the ones most likely to know who has made videos about their subject in the past. Once you have traced your archive material, you will need to get permission to use it from the people who shot it. You can often do this simply by explaining that you are making a non-commercial educational video. It may be that the only copy that you have seen is a poor VHS version, in which case you should try to get a master copy to work with. If they send it to you in a format you can't edit from, you must go to a video facilities house to make a transfer.

Budget

Work this out before you go into production. If you own your own camcorder then making a campaign video need not cost much at all. If you don't, then hiring equipment should cost under £200. The main costs are going to be tape supplies, travel (if any) and hiring an edit suite. If you are making the video for a group, try to get them to cover the costs. This will make them take the project more seriously and encourage them to get more involved. If they have no funds, ask them to approach local organisations who might loan their edit equipment for nothing or at a subsidised rate.

Budget for low-cost ten-minute video

Item	Cost
Tape (3 x Hi8)	£30
Travel	£35
Phone	£15
Transfers (e.g. Hi8 to SVHS)	£20
Hire of edit suite (20 days)	£600
Duplication (50)	£150
Total	£850

SHOOTING

This is the stage when you will be shooting new material for your video. Make sure that you are ready on the day. It may help to write down a detailed schedule for each day's shooting with what you hope to have recorded by the end of the day. Take extra care to double-check on appointments before you travel miles to meet someone. It may sound obvious, but I've seen many examples of people wasting time (and money if they've hired equipment) by not making sure. You can use another professional trick – the 'call sheet'. This is written by the director on the day of the shoot and handed out to everyone in the crew to let them know what is going to happen. It is a useful discipline, and can help to make sure that you get everything done in the limited time you have.

Equipment
This will depend on what the video is for and how big your budget is. However, there is no reason why you can't make a campaign video on a basic camcorder. There is rarely a need for high-level professional gear. You may want to pay special attention to sound, however, as good audio quality can have a big impact on a campaign video – especially if it includes many interviews. So make sure you have a good external microphone (clip/lapel mic or omni mic on a long lead). It also may be worth using a tripod to make sure these interviews are visually stable, but don't go overboard and make everything as steady as a rock, or the video will be deathly boring.

Subjects
The worst kinds of campaign video are made up of endless 'experts' talking, intercut with general scene-setting shots. If you want to have an impact you have to capture reality in action – what goes on when the camera is not around. An interview is not reality in action, since it would not have happened without the camera. But a group of residents angry at the lack of books at school being turned away from the town hall, a police officer manhandling a protester, or a van illegally dumping rubbish at the local tip – these are examples of reality in action; this is the kind of footage that moves people, by showing life as it is. There is no mediation, no interpretation, no analysis. It shocks, angers, excites and depresses, and these are the emotions you want to evoke. Use this as the foundation for your

**Photo 8.1 Corrie Cheyne videoing Reclaim the Streets action, London, 1995
(photo: Gary Essex)**

feature and build the story upon it. Work out what images and sequences you need to support this core footage. In the case of the residents being turned away it might be testimony from them recalling how they felt or a shot of a classroom where ten kids are having to share one book.

The sting

If you want to encourage people to do something as the result of the video, you need to steer them in the right direction. What shot or image would do this? In the traffic-calming example on p. 139, it would be showing how another group managed to persuade the council to take action. In the example of excessive use of force by the police, it might be showing how someone used video evidence to prosecute the police in the courts. If the purpose of the video is to raise funds, then you might want to show the financial need that exists and how money has been well spent so far.

Partnership

Making a campaign video by yourself can be a lonely and at times frustrating experience. Even with cooperation from a group, it is worth making it with another person. Not only can that person help practically – for instance, operating the camera while you ask questions – but it can be very useful to have someone to bounce ideas off as you go. Before you start, however, be sure to talk openly about the role each of you is going to take and how you will make decisions. It may also be worth working out who 'owns' the video once it has been made. This kind of discussion may save a great deal of argument later on.

The shoot

As I pointed out at the beginning of this chapter, the main difference between shooting for a campaign video and for witness or television is that you are going to edit the video. This means that you want to give yourself as many choices as possible later on. So feel free, for example, to ask an interviewee to repeat his or her answer until you are both happy with it. Try taking a shot from two, three or even four angles. Record background sound separately from images, so you can have a 'clean' audio track for laying over images. Take as many cutaway shots as possible. For instance, if you're interviewing someone by a river, take a close-up and wide shot of the river, any animal life that you see, any signs nearby ('Polluted water – Do not swim'), a shot

of the subject at the river taking a water sample, and so on. In general, record far more associated images and sound than you think you will use. You will probably find them invaluable in the edit suite.

Making my first campaign video

by Catherine Wheeler

It all began in the Campaign Against Arms Trade (CAAT) office as they were planning their latest action. Someone spoke those seven fateful words: 'Wouldn't it be good to video this?'

The plea was overheard and relayed to me. I volunteered to video the demonstration.

I'd never actually picked up a camera before in my life, but there I was five days later at the demonstration, armed with my friend's mum's camcorder, a dodgy microphone and some serious 'attitude'. It was raining hard and freezing cold, but I think I caught the video bug that day.

A group of activists went to the British Aerospace Annual General Meeting at the Marriott Hotel in London, and staged a die-in. They lay on the ground and covered themselves in fake blood to represent the people killed in East Timor by the planes that British Aerospace was supplying to the Indonesian government. At the same time there was a banner-drop, someone was dressed as the Grim Reaper, and the sound of aircraft and people screaming was blaring from an amplifier.

The stunt worked, it proved a point and it was fun, but unlike most stunts, which soon become yesterday's news, this one was transformed into an active campaigning tool for CAAT.

I started videoing more CAAT actions and, after a year, decided to make a campaign video about CAAT activists, told in their own words.

It sounded easy enough, but I soon realised what I had let myself in for. I had a year's worth of CAAT actions and interviews that had to be condensed into ten minutes. But through the efficient management of video material – putting it all into a logical order, deciding what was relevant, and ruthlessly discarding unwanted material – the task was achieved. The guiding principle behind my decisions was that CAAT had identified students as their target

audience and the aim of the video was to get them to join the campaign.

Another problem was lack of finance – as a novice video activists I had seriously underestimated how much video-making costs. To economise, I edited most of the footage on domestic video recorders.

The fun bit came when the video was near completion and I knew it was really going to happen. I got some friends to help me out with the music, then took it to the on-line edit at **under**_currents_ for its final polish.

The film is now shown nationally by CAAT in schools and universities. Making it was hard work, but there's nothing like the buzz of finishing a video. Would I do it all again? Too right!

Editing a Campaign Video

Editing is an extremely powerful tool for video activists. This is the stage in which they can have most control over the video experience. There are no uncertainties, simply the material, the equipment and the editor. The rest is creativity.

Editing is an activity that involves taking a large number of decisions. Which shots should be used? What sequence should they be in? Which graphics should be used? What kind of music? How long should it be? Who should do the voice-over? What quality of equipment will be used? These questions can be extremely difficult if made on simply aesthetic and artistic grounds alone. As with all video activism, things are made much easier if there is a purpose to the project. Again, you need to assess needs, aim, audience and impact.

If the aim is to produce a five-minute empowerment piece to screen to a group the following day to excite them about the action they organised the day before, then speed is the most important criterion, and you can simply transfer the best shots from a camcorder to a VHS player. If, on the other hand, the aim is to produce an educational video that the group can use over the next two years to recruit more people to the campaign, then a professional editor should be used along with broadcast-standard editing equipment, a few weeks set aside, a budget for graphics, music and voice-over, and shots selected for their ability to bring about recruitment.

The essential tasks remains the same, however, no matter what equipment you use or what the video is for. Editing is the process of becoming familiar with your material, structuring it in a way that makes it watchable and then polishing the edges so that viewers believe they are watching a continuous sequence.

ACTIVIST EDITING

There are a number of techniques that video activists can use in editing to enhance the ultimate political impact of their work. These include the following.

Subjects

One of the most striking and persistent failures of the mainstream media in the West is that the people they use to talk on their news and documentary programmes are predominantly white, middle-aged men. There has been some progress with presenters, but not interviewees. In November 1996 **under**currents did a survey of all flagship news programmes on UK television and found that less than 20 per cent of interviewees were female and that, of these, 75 per cent were interviewed because they were the mothers, wives or girlfriends of others appearing or featured in the programme. Bias in the selection of subjects is also found among video activists. I believe that as a video activist it is your responsibility to correct this injustice and give space to the diverse voices in the community.

Content

Another failing of the mainstream media is their reluctance to include material in news and documentary programmes that would be deemed too radical, too controversial, or defamatory. This is understandable – they have careers, advertising agreements and government patronage to lose. You don't. So don't shackle yourself with the restraints of mainstream television. If something's true, put it in. If it's angry and passionate, put it in. If it's critical and finger-pointing, put it in.

Narration

Though you will have had to think about the narration, or voice-over, earlier in the production, the real choices take place in the edit suite. This is where you are likely to decide the final wording of the script and record a person reading it. However, narration can be a big problem for the video activist. Traditional documentary makes great use of third-party narration in a 'voice of god' style. This can make the programme overbearing, worthy and serious. Worse still for the activist, it gives you no idea of whose voice it is, and so gives no opportunity for passion or personal experience. To politicise a programme, a video activist can use subjective testimony (where

narrators are characters in the story and the viewer knows who they are because they appear sometimes on screen). For example, an activist in an animal rights group may provide the voice-over for a video about the group's campaign. A slightly friendlier way of doing this is for the subject of the story to tell us what is going on 'in situ', where the action is happening, a bit like a presenter. You need someone who can do this calmly, colourfully and with presence of mind. It doesn't need someone 'special', but be aware that not everyone is comfortable doing this. You might have to record ten or more takes to get it right. That's fine; it is what the professionals always do. The alternative to all this talking is to use no narration at all, but then it may be difficult to get the essential facts across (dates, places, names, etc.). To solve this you can use captions or titles, which should be clear without being intrusive.

'Underproduction'

One of the big criticisms levelled at contemporary television is that it is 'overproduced'. At its most extreme, the images are cut fast, overlaid by outlandish graphics, digitally distorted, and swept in and out of screen with wild digital effects such as tumbles and wipes. When you make your own video you can get away from all this. Let people talk a little longer. Keep those long shots. Don't worry if it's a bit wobbly; it will feel more authentic. In general, turn your weakness (few resources, little experience) to an advantage by keeping your feature simple but powerful. Remember, though, that audiences will have a low tolerance for endless shots of talking heads.

Quality versus content

Mainstream television is obsessed with quality. In traditional video-making, the editor discards any images that fail to meet the standards laid out by the technical department. In contrast, a video activist editor can include almost any standard of image so long as the content is powerful. Of course, you should keep the quality as high as possible – for instance when copying from tape to tape. The wider audience won't want to sit through a sloppily produced videotape.

Your choice of editing equipment will probably be determined as much by what you can get access to as by where the video is going to be distributed. The general rule is that the bigger the audience the better quality the video needs to be, and therefore the higher the standard of editing gear you will need.

Editing with emotion

by Kevin Doye

In late 1994 I went to a demonstration against the Criminal Justice Bill in Hyde Park, London. After standing at one side and watching a systematic and pre-planned attack on a peaceful demonstration by the police, I was shocked.

After going home and watching the coverage of the demonstration on television, I was even more shocked. The news described the event in terms that gave a different picture from the one I'd observed: 'appalling attacks on police from anarchist troublemakers'. I realised two things. The first was that editing has enormous power to manipulate footage from an event. And the second was that everything that I had seen on television and read in the newspapers throughout my life might not actually be true.

So, with those feelings inside me, and aware that I had never picked up a video camera or looked at an edit suite before in my life, I decided to do something about it. I bought a camcorder and found someone willing to trust me with their edit suite. I had believed that it took years of training to learn how to edit footage together in a way that tells a story, entertains, and encourages the viewer to find out more. It was much easier than I thought. I realised that editing video was just like putting together music compilation tapes, except the tapes I was using now were slightly bigger and had pictures.

I played around on the edit suite and arranged the pictures and sound in a way that I believed highlighted and explained the real issues. I wanted people to experience emotions and feel that they were part of the event. Bigger and bigger anti-road actions were happening across Britain, and I wanted to take the passivity and lies out of the pictures seen on television.

I quickly found that I was putting video together immediately after I got back from an action to show people what happened as soon as I could. If the action was a success, I would edit a video that highlighted the joy and the feeling of teamwork that comes from a worthwhile action. If it went badly, usually because of police violence, I would highlight that in the video. I lost my awe of the mass media. I realised that I didn't have to edit in the same way as the polished news reports I saw on television, and discovered that

the roughness made the pictures more real, and added to the impact of the completed video.

In 1995 I jointly set up Conscious Cinema in Brighton with Dillon Howitt. We raised funds for a U-Matic edit suite, blagged a room to set it in, and showed activists how to use it. Out of this was born four hour-long compilation video tapes which we then distributed to over 100 community cinemas around the country. Later in 1996 we teamed up with the SchNEWS radical street newsletter for the 'SchLIVE Tour' and played in 36 cities, festivals and protest sites.

At the end of the day, it is up to us to take back the media, highlight our version of events, put emotion and feeling back into it, and give people images that let them make up their own minds. Anyone can do it.

TIMECODE AND COUNTER NUMBERS EXPLAINED

Using timecode is a trick that video activists have stolen from the professionals. It enables editors to keep track of each and every frame they are working with. This can save enormous amounts of time and give the video activist much more control over the editing process. It's therefore worth making the effort to grasp the complexities of timecode.

People get very confused about numbers on video tape. In fact, it is fairly simple. There are two main types: 'counter numbers' and 'timecode'. The former is found in almost all domestic and professional equipment and the latter only in expensive camcorders and edit machines. A counter is a numeric display that increases and decreases according to the tape heads, independent of the particular tape in the machine. So if you stop a tape when the counter is at a particular point, then replace it with another, the counter number will stay the same. If you then fast forward the second tape, then put back the first, the counter will have moved on, even though the first tape is at the same point as before. This can be frustrating. Furthermore, counter numbers do not represent time in seconds, but use different scales that vary from machine to machine. 'Timecode', on the other hand, is a number that is actually written onto the tape, with each frame having its own unique number that relates to hours, minutes, seconds and frames. Typically the first frame of a tape will read 00.00.00.01. The second frame will read 00.00.00.02. The third, 00.00.00.03 and so on. The

beauty of timecode is that it is specific to the tape that's in the machine. So if you stop a tape at a certain timecode, then replace it with another tape, you'll get a different timecode. If you fast forward it, then put back the first tape, the timecode will return to what it was originally. This means that you can keep track of every frame.

There are three ways of generating timecode. The first is when you record the tape in a timecode-equipped camcorder or edit machine as it's recording. The second is when you 'stripe' the tape, recording the timecode over a tape that already contains video material. And the third is when you 'burn in' timecode, by making a viewing copy of a master tape with the timecode numbers in vision, normally in a small box on the top of each frame.

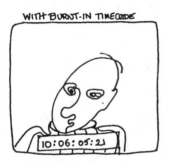 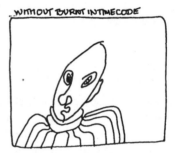

Figure 9.1 Burnt-in timecode

To make things more complicated, there are different types of timecode. SVHS, U-Matic and BetacamSP tapes run on two kinds of timecode. There is LTC (Linear Timecode), which records a different number along the edge of each frame. There is VITC (Vertical Interval Timecode), which records a number diagonally across each frame. Hi8 cameras and players use RCTC (Readable Consumer Timecode). Infuriatingly, this again has two types, 'domestic' and 'professional', the former being used by domestic equipment, the latter by professional equipment. I have never found any technical difference between them.

THE EDITING PROCESS

There are a number of stages to editing, and the more time and effort you are willing to put in the better the results will be. The basic process

is *setting up* – when you make sure the equipment is ready to operate; *preparation* – when you organise your tapes, view your material and make your first attempt at designing a structure for your video, and *editing* – where you complete the process of transferring images and sound from your source tapes to your completed edit master, ready for viewing.

Preparing for editing is almost exactly the same no matter what equipment you use. Many people make the mistake of rushing into the edit suite with their raw material and going straight into the recording process. A general rule is that time spent outside the edit suite in preparation saves you twice the time you would spend inside the edit suite.

The editing process itself can be divided into eight stages.

1 Transfer of original tapes to edit masters
2 Log
3 Structure
4 Paper edit
5 Editing, which can range from a single beginning-to-end edit to multiple edits (first edit, second edit, third edit, etc.), ending with 'rough-cut'
6 Showing rough-cut to group/client
7 Writing down all timecode in-points and out-points ('edit decision list')
8 Final edit or fine cut (adding captions and digital effects)

Most people are surprised at how much time editing takes, far more than any other stage of production. One of the most stressful things a video activist experiences is the sense that time is running out on the edit suite before the next person is due in. The best way to reduce the stress is to spend as much time as possible off the machines preparing for your edit, especially at the logging and paper edit stages. Another way is to *plan* on spending a great deal of time inside a dark, dank closet. Either way you will need to adjust your life accordingly. Be flexible, but make sure that you meet vital needs, not least getting away from the edit suite and having fun!

Transferring your material

Many people start their editing process by transferring their original
tapes (those shot on camcorder on location) to edit masters. There are
four reasons for this. First, domestic (Hi8 and VHS) tapes are fragile
and degrade with repeated playing during editing. Second, a higher
standard format holds the quality of image despite recording down
'generations'. (A generation is a common term used to describe the
transfer of one tape to another. Therefore, a shot that had been copied
to one tape and then another would be called 'second generation'.)
Third, they may be editing on a different format (say SVHS) from the
one they shot on (say Hi8). Fourth, timecode can be burnt in to the
viewing cassettes to make logging and paper edit easier.

Logging your material

Logging your material enables you to familiarise yourself with the
material and acts as a quick reference point.
 The first step is to make a log sheet (see Figure 9.2). You will need
at least three pages per tape logged. If you design a master sheet, and
make photocopies, you can keep the master for later use. Some people
find it useful to order the log sheets in a ring binder. When working
with a number of original tapes (say over four) it also helps to have a
one-page master, with a brief summary of the contents of each tape
for quick reference.
 Watch the tape and as you do so write down what you see in the
'description' column. Add the in-point – the counter number or
timecode where the recorded clip starts – in the 'in-point' column (note
that an 'out-point' column is unnecessary as you can take the counter
number or timecode where the clip ends from the 'in-point' of the next
clip). You don't have to be too detailed at this stage as you can always
go back and note more information later. A good guide is that you should
be jotting down information pretty much all the time without feeling
hurried and without the need to stop the tape to catch what you've
just missed.
 For interview sections, write down the start of key sentences as you
go. Even if you think the footage is poor, write this down. You can use
it as a marker later on. Similarly, make a note if you think the footage
is particularly good.

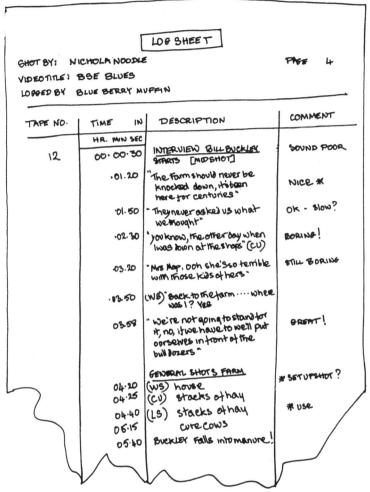

Figure 9.2 Example of a log sheet

Logging abbreviations

NG:	no good	G:	good
VG:	very good	*:	use this shot
CU:	close-up	W:	wide
BS:	bad sound	GS:	good sound
T1:	take one (if there is more than one take of the same shot)		

After you've watched the tape to the end you can go back to re-log parts that you found difficult to catch the first time. You'll almost certainly have to do this with interviews and speeches.

Structuring

Most people find structuring their video the hardest part, but this is often because they are in too much of a rush to start editing and don't give themselves enough time to work things out. It's far better to plan a structure away from the moving images and whirr of the machinery. With all the material logged on paper, it is easy to experiment with different sequences.

Before designing the structure you need to answer three questions: 'Who is the video for?', 'What is its purpose?' and 'Where will the video be shown?' You should have answered these before you even started videoing, so it shouldn't be a problem. But there will probably still be some confusion. Now is the time to work things out. Once you know the answers to the questions, making a structure should be simple.

For instance, suppose the footage is of a student protest at a mining conference. You have decided that the video is for the local student group, to inspire them to further campaigning against the proposed opening of an opencast mine, and that it's to be shown at a group meeting. Then the structure might go something like this:

1 Activists walking into hotel
2 Head to head between conference organiser and activists
3 Images of conference
4 Interview with local student explaining why the group is there
5 Shot of students delivering a petition
6 Arrival of police and violent arrests
7 Interview with student saying how the action went

If, on the other hand, the video is to be shown to the inspector of a public enquiry, with the same aim of stopping the opening of the opencast mine, then the structure might be like this:

1 Images of conference
2 Interview with asthma expert at the conference

3 Shots of mine machinery creating dust
4 Interview with environmental expert about effect on greenfield sites
5 Images of greenfield sites that will be lost
6 Interview with local student explaining why the group is there
7 Shot of students delivering a petition

Each line is known as a 'sequence'. You can have fun moving these sequences around till you have the right structure. Some people find it useful to write sequences down onto separate pieces of paper and move them around on a table to try out different orders.

Another good question to ask yourself is 'What story am I trying to tell?' This is what many beginners fail to grasp. There is always a story, in every situation, and it's this that will make your video watchable. What makes a story? It's a difficult thing to pin down. Perhaps the simplest way to see it is as a group of happenings that has a beginning, middle and end, and with some kind of interest, focus or angle that directs the viewer's attention. (Remember, though, that these happenings don't have to be presented in chronological order.)

For example, the World Bank is not a story, it is an institution. Similarly, people being angry at the World Bank (*conflict*) and the reasons for this (*issues*) don't amount to a story. Again, a press release sent out (*action*) on Hiroshima Day (*angle*) is not a story. However, if you have a group of protesters who march from their office, set up some banners and hand out leaflets, get moved on by security guards, manage to shout a couple of chants at some workers being bustled through the security lines, and succeed in securing a meeting with one of the senior policy-makers the next week, you've got yourself a story. With a story, it is easy to lay out a structure for a video.

One important decision to make is how long you want the video to be. Don't forget that people are used to watching fast-moving television programmes these days. This doesn't mean you have to pander to the three-second-attention-span culture, but it does mean that most people will switch off when faced with watching 50 minutes of people rambling on about their pet subject. A good guide is that we're all prepared to watch three or four minutes of anything, and most people can watch up to 12 minutes without losing attention, but it is difficult to make a sequence above that length that will keep the audience's attention.

Paper edit

Once you've established your structure, you can look at the details. On a fresh sheet of paper, write down the sequence of shots that you want to include, with timecode, in the order of the final video. So, for example, if you started with 200 shots in the log, and you want 20 shots in your video, then write these down in the order that you want to edit them with the timecode next to them.

I can't stress too much how important this process is. You may find that you have to go back to the footage to find new shots that you need for your structure but you missed in the log. That's fine; just remember to reset the counter to zero if you need to.

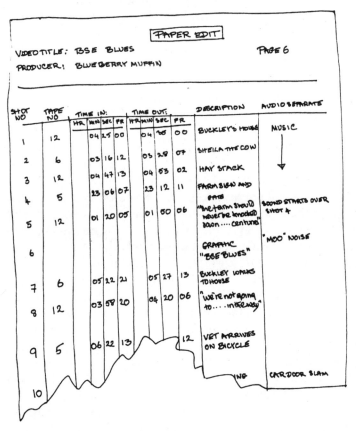

Figure 9.3 Paper edit example

Editing

At last you can get down to some actual recording. I shall assume that you're working on a two-machine edit suite (see pp. 163–6). These are the most widely accessible edit suites available after the basic Camcorder–VHS set up (see pp. 162–3).

Blacking the tape

Before you start to edit, you should record a steady (black) signal onto the whole length of the video tape to stabilise the signal. The effect is a bit like putting underlay beneath a carpet to stop it from rucking up. It greatly improves the quality of the recorded images, and allows insert editing. Some edit suites have a 'black and burst' box that will supply the right signal. If you don't have access to this, you should use a master 'black tape' that you can copy over to each new tape you record onto. The best way to make a black tape is using a 'black and burst' box, so if ever you have this facility, take the opportunity to make a black tape for future use. You can make do, however, by plugging your camcorder into a VCR with the camcorder cap on. Once you've made a black tape, keep it as a master (write warning notes all over it!) and then use it as a source when blacking your edit tapes.

First edit

Using your paper edit as a guide, record each shot from player to record machine in turn. At this stage don't worry about exact frame accuracy. If anything, add a few frames on to the end of each cut. This will make later editing easier, as you will have room to spare when you re-edit the same cut. Similarly, do not separate sound and image at first. Concentrate on getting the structure and sequences right. You can work on sound overlays (using a different sound over an image) later.

Second edit

Once the first edit is complete it will probably look a bit clumsy and be about twice as long as you want your final video to be. Don't panic! You can make changes in the next edits. Simply take the record tape (the first edit) and place it in the player machine. Put a new blacked tape in the record machine and starting editing again. You will probably have to supplement the first edit with original material not

yet used. That's only to be expected. You'll realise that you need different shots from the ones you first chose. These early edits should be used for experimentation. They are often the most creative and enjoyable stages of editing.

You will notice that there's a limited number of ways of editing your shots. According to Richard Herring, from Oxford Film and Video-Makers, there are as few as three:

1 Cutting by scene – Shots are edited in one location and one time. Commonly seen in soap operas and Hollywood movies.
2 Parallel cut – Shots are intercut between two or more locations. For example, in *Apocalypse Now*, a sequence showing the ritual killing of a bull is intercut with the killing of Kurtz.
3 Montage – Shots, typically unrelated, are cut together to create an overall impression. This is often used for dream sequences. Music videos also often use montage.

Rough-cut

When the second edit is complete, put the tape into the player and move on to the third edit. The next two to three edits will be about shortening shots, experimenting with sound overlays (music, narration and cutaway shots) and reworking the structure. Keep this process up until you feel you have made all your edit decisions. Soon you will have reached the 'rough cut', when you can't think of any more changes that need to be made.

Showing the rough-cut

Show your video as you make it to as many people as you can. Showing it to the campaign or community group featured in the video is especially important. Not only can they tell you if the video will be useful in its current form (if you've included factual errors or made some political blunder) but it also will make them feel more involved in the process and therefore more likely to help in distribution later on. It's sometimes hard to take 'constructive criticism', particularly if you've been up all night editing. Remind them what stage you're at with your editing process, so that they don't get too hung up about the technical details when you want to know what they think about the general structure. And when listening to feedback you need to strike a balance.

Each person who criticises your video is only one person with a valid opinion, but nevertheless one person's opinion may be shared by a lot of other people. Also, don't forget that different audiences will want different things. So keep asking yourself 'Who is this video for?' If different people like different parts of your video, consider it an achievement. It means that you'll end up pleasing a wider audience.

Edit decision list

Once the 'rough-cut' is finished, write down all your in-points and out-points in sequence on a piece of paper. This is your edit decision list (EDL), which is the basis for the 'final edit'. You should pay special attention to sound overlays where you have two in-points at one time (i.e. sound and vision). You can create your edit decision list either by looking at the original log sheets or by using timecode, if you have it.

Final edit or fine cut

The biggest problem that video activists have is that they are working with controversial issues that people may be unwilling to listen to. Viewers will find the smallest excuse to switch off, and a poor-quality product is guaranteed to stop them watching. The final edit is the stage where most attention has to be given to quality. Of primary concern are poor sound, flash frames (gaps between two edits that appear like a flash to the audience), sloppy cuts (for instance, a hand coming down just as the shot cuts), and out-of-focus images. One way to get higher quality is to go back to the best source tapes you have and edit your final cut from these. Another is to edit the final cut on a better format suite.

Off/on-line editing

One trick learnt from 'professionals' is to separate the editing into two stages. The first – the 'off-line' – takes place on low-quality, cheap equipment (such as VHS–VHS or U-Matic–U-Matic), allowing the editor time to make choices without expenses piling up. Then the editor takes the rough-cut to an more expensive 'on-line' suite. In the

case of a video activist this may be an SVHS suite, or if they are lucky a BetacamSP suite, or better still a non-linear suite. Here the final piece is edited onto an edit-master, sound is polished up and digital effects (like dissolves, wipes and captions) are added.

TYPES OF EDITING

There are a number of different types of editing, using different levels of equipment, which you can choose depending on your resources, target audience and skill level. The three most common types are camcorder–VCR editing; two-machine editing; and non-linear editing.

Basic camcorder-to-VCR editing

The camcorder–VCR is the most accessible form of editing available (almost anyone who can lay their hands on a camcorder can find a VHS machine to edit onto). It is extremely easy to use and is often of good enough quality for the job at hand. Surprisingly, though, few people make use of this type of editing, either thinking it too difficult to operate or of too poor a quality to be useful.

This system is particularly helpful if you want to show a short, roughly cut compilation to a group. An example may be a four-minute tape made up of 15 of the best shots taken from 40 minutes of raw material. The short tape will be much more watchable, and hence more powerful, than the longer original.

Before you start make sure that you have:

- all your original tapes;
- a blank tape to record onto;
- paper and pen for the log and paper edit;
- research materials for guidance.

You will find that with a bit of practice you will be able to add your own tricks to make it work better. Note that each camcorder and VCR has its own peculiar pre-roll time (sometimes called 'backspacing') once you've pressed the buttons, so experiment with how long it takes for the machines to play and record accordingly. Then follow these steps:

1 Power your camcorder with the mains supply adapter.
2 Switch your camcorder to playback mode (sometimes known as 'VTR').
3 Connect your camcorder to the VHS player using the line-in/line-out sockets. It's best to use the RCA (phono) leads and switch your VCR to 'AV' mode. Otherwise use the lower quality RF (aerial) lead.
4 If you can, press the display function on the camcorder to view counter numbers on the TV monitor.
5 Rewind your tape and set the counter to zero (this way you can find your shots later).
6 View your material and write down the shots you like with counter numbers – the 'log'.
7 Using the log, write down the shots you want in the order you want them – the 'paper edit'.
8 Turn off the display function on the camcorder (otherwise it will be recorded onto VHS tape).
9 With the camcorder on 'stop', record 30 seconds of black to the front of the VHS tape.
10 Find your first shot on the camcorder and press 'pause' ten seconds before the shot starts.
11 Press 'pause' and 'record' on the VHS machine.

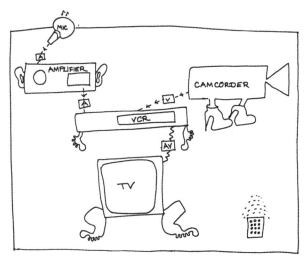

Figure 9.4 Basic camcorder–VCR edit setup with separate sound

12 Press 'play' on the camcorder and then 'record' on the VHS machine as soon as the camcorder gets to the right in-point.
13 Press 'pause' on the VHS machine when you want the shot to end.
14 Continue steps 8–13 until you've gone through all the shots on your paper edit. Once you've done this, rewind to the beginning to make sure you're happy with what you've got.

This may sound complicated, but it's actually incredibly easy. It takes about five minutes to learn and about 15 minutes to perfect.

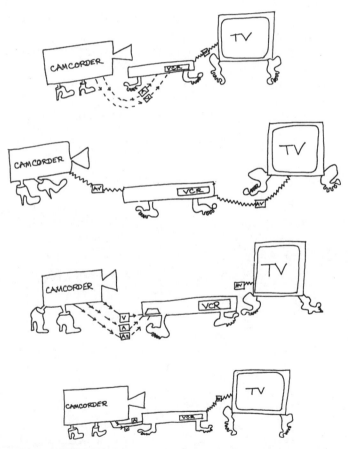

Figure 9.5 Camcorder–VCR editing options: (top to bottom) phono; RF/aerial; scart; s-video and phono

Two-machine editing

Two-machine edit suites comprise a video player, a recorder, two television monitors (which can be domestic) and an edit controller. The lowest quality two-machine edit suite is made by connecting two domestic VHS machines together with a scart lead, or pair of RCA leads. This setup can give a surprising amount of control and quality. Some domestic machines now have jog shuttles, which are the extra-fast fast-forward and rewind knobs that professional machines have. Others have 'insert edit' capability, which enables more accurate editing as well as narration and music overlay. However, these domestic machines are expensive, and for the same money you can buy a second-hand professional suite that is both more durable and of better quality.

Professional two-machine edit suites have many advantages over the camcorder–VHS set-up.

- They are almost frame accurate (to within three or four frames).
- You can preview an edit before making it, which saves wasted effort.
- They have insert editing, where sound and images are separated while editing, as opposed to assemble editing, where you record sound and image together (see camcorder–VHS editing, pp. 162–3).

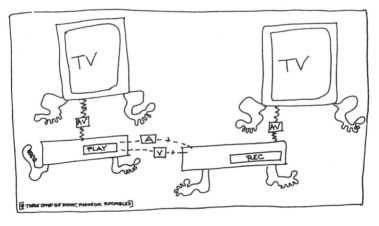

Figure 9.6 Basic VHS–VHS editing. Cables between player and recorder can be scart, phono or RF and are often connected via an edit controller.

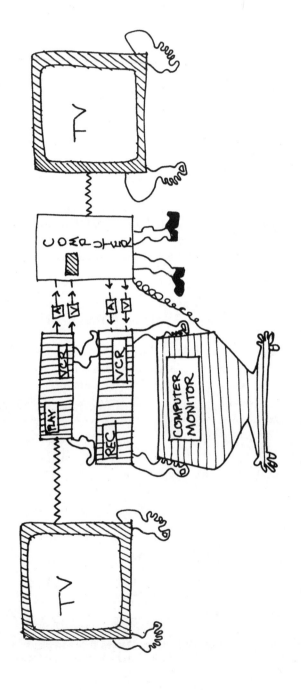

Figure 9.7 Non-linear edit suite

- You can adjust the sound levels.
- They are built to last.
- You can swap the tape from recorder to player as they are the same format.

Most community television centres and universities have at least this type of equipment, with additional titling programs, or they have PC-based edit suites ('video toasters'), which can add effects such as dissolve, title rolls and fades. So if you can't afford to rent or hire a suite yourself, make contact with these types of organisation and explain what it is you are doing, and you may find that you can use the equipment for free or on a subsidised basis.

There are several different types of two-machine edit suites. These are, in ascending order of quality:

- Domestic VHS–VHS (connected by scart or RCA leads)
- Professional VHS–VHS
- Hi8–Hi8
- U-Matic–U-Matic (low band)
- SVHS–SVHS
- U-Matic–U-Matic (high band)
- BetacamSP–BetacamSP

Note that Hi8 edit suites have a bad reputation. Some of this is justified, in that Hi8 is a more fragile format than its non-professional peers VHS or U-Matic. Hi8 is also a slow format, in that it takes more time to fast forward and rewind. Furthermore, Hi8 edit suites often cannot cue sound on a frame. This means that you can't hear the first half-second of sound after it starts playing, which is very annoying when editing interviews, for instance. However, many people overstress these failings, and given the price of such edit suites and the fact that many people shoot on Hi8 tapes (which saves having to transfer to a different format for editing), Hi8 suites are not such a bad choice.

Non-linear editing

The ultimate in editing equipment to work on is the non-linear edit suite – dedicated computer-based systems that store images and sound in their hard drives. They are called 'non-linear' as they can access material at any point in the material, rather than having to spool

through tape to find a particular shot, making editing far quicker. They have the additional advantage of being able to perform digital effects such as dissolves, fades and tumbles; they allow for sophisticated sound editing to take place; and they frequently include software to create titles. These types of suite are particularly useful for longer videos (over 20 minutes) that need stylish effects and titling, and which have to be of a higher quality.

Non-linear suites are becoming increasingly available to activists as the price is coming down. This is especially true of hard-disk capacity, which at present is what sets the price. Right now it costs around £1,000 per 5 gigabytes of memory (you need at least 8 gigabytes) and this price is falling all the time. The most common machines used by video activists are unsurprisingly placed at the low-quality, low-price end of the spectrum. One of the most popular suites is Fast's 'Video Machine'; another is the Macintosh-based 'Media100'. Both include titling and digital effects and both can vary their output from VHS to almost broadcast standard. With 8 gigabytes the computer can store up to three hours of VHS-quality and around 40 minutes of Betacam-quality material (because of different compression rates).

An increasing number of non-profit and commercial-but-progressive media groups have such equipment and make them available at

Figure 9.8 Rolls caption and still caption

subsidised rates. One way to reduce costs still further is to edit the rough-cut on a cheap machine (for instance VHS–VHS), and then move on to a non-linear edit suite to polish it up and add special effects.

Effects equipment

Effects can be used to make a video slicker, which can be important when trying to win an audience's attention. Captions can make all the difference when you're trying to get difficult information over to an audience. However, some people make the mistake of adding too many effects to a piece, and forget that the raw footage may actually be more powerful without unnecessary additions.

Captioning
A basic way to add captions is to paint or draw them on card, shoot them on camcorder, and then edit them into the video. Paper Tiger in New York designed a box containing a roll of paper with words on it that was wound past the camera for titles and credit sequences. A more sophisticated way is to use a caption generator, which is made up of a computer and titling software.

Vision mixer
A useful way to jazz up captions is to use a vision mixer. This is a device that can switch and mix the output signal from two or more visual inputs. It often also includes an electronic box of digital tricks, such as fades and dissolves. CATv in Sydney use a vision mixer to great effect in their work. They set up a cheap camera on a tripod, point it at a caption stuck to a wall, push the image through a vision mixer, and end up with startling and weird results.

Computer-generated effects
A popular and affordable new toy is the PC-based edit suite, nicknamed the 'video toaster' after a particular brand. This fairly cheap computer add-on can do two things: first it can control the edit machines (and remember the edit decision list in the process); second, it can generate still graphics, crawling and rolling captions, dissolves, wipes, freeze frames, fade-to-blacks and fade-up-from-blacks and colourisation. Note that this is not a non-linear machine since it cannot digitise material. Mission Creek Video, who provide video support to community activists in San Francisco, use an Amiga 2000.

Sound mixer

A basic sound mixer can add a lot to an editing process, enabling volume control, narration and sound fades, and providing a means for improving poor sound (by adjusting background noise levels).

PROBLEMS AND PITFALLS

The iffy factor

One of the most difficult decisions to make when editing is whether to include the shot that seems to be just about OK, but isn't great. For some reason you have an attachment to it: perhaps you enjoyed shooting it; there's someone in it you like; it's funny. But if it doesn't feel really good, get rid of it; you can always bring it back later. Most videos could benefit from less material, so start with getting rid of these iffy shots, it will make things far easier for you.

Editing ergonomics

One of the biggest complaints by editors – besides the fact they can't keep down a relationship – is backache. To avoid this, and other aches and pains, try to adopt a good posture when you're working. Make sure that you work facing straight on to the screen, not at an angle; that the top of the screen is roughly at eye level, not too high or low; that you use a chair with adequate support for your lower back, and that it's at the right height so that your feet can rest flat on the floor; and that your forearms are roughly at a right angle to your upper arms and are parallel to the surface of the desk or table.

Health and wellbeing

Get away from that jog shuttle. Take breaks, stretch, get some air. Stay clear of junk food, too much coffee, all those cigarettes. It may feel as though they're helping, but don't forget that you're going to have to do this for another couple of weeks, so pace yourself.

Everyone gets depressed when they're editing. It's an incredibly complicated, stressful and taxing occupation that involves a great deal of discipline, patience and creativity. So be easy on yourself; it's hard! It isn't a bad idea to get away for a couple of days, especially in those dark moments when you just feel stuck. You'll be surprised at how much more energy and insight you have when you get back to the chair. It's well worth scheduling such a break in all editing timetables. That way you won't feel that you're wasting money by not showing up on the day.

Deadlines and other deathly things

I have never known a genuine deadline. I am the first to push people to get a video done in time, but this is usually a display of my own anxiety rather than a real need being met. In fact, most people are too rushed when they edit. Question the reality of that deadline. Surely it is worth spending just a little more time getting right that sequence that isn't working, rather than hurrying and finding that the group you made the video for doesn't like it and isn't going to use it! It happens, sadly.

Ten common mistakes made in editing

1 You underestimate the time it will take to edit.
2 You spend too much effort getting the first rough-cuts exactly right.
3 You get confused about timecode.
4 You separate sound and image and then forget where the sound came from.
5 You don't log well and then spend hours looking for a cutaway shot.
6 You get upset when you show your feature to a friend.
7 You fail to check facts with the campaign group.
8 You use too many digital effects.
9 You don't eat properly.
10 You forget to ring home to say you will be late (again).

Ten tips for improving editing

1 Black your edit tapes.
2 Spend as much time as possible preparing edit decisions away from the edit suite.
3 Show your video to people at different stages.
4 Allow for a few days' rest time in the edit schedule to let things settle and give some perspective.
5 Transfer record tapes onto a higher quality format.
6 Use timecode.
7 Include as little interview time as possible and as much action as possible.
8 Keep narration and captions to a minimum, apart from subtitles for inaudible speech or for the deaf.

9 Use plenty of music to keep it pacey, but not too much to turn off your intended audience.
10 Work out how long your feature should be, halve it, and then aim for that.

The under*currents* edit process

At **under***currents* we have worked hard to find a process that is accessible to all yet assures the highest quality possible. The solution we have found involves shooting on Hi8 camcorders; editing rough-cut on a simple VHS–VHS deck (by video activists themselves). We then transfer the edit decisions to a non-linear suite (Fast's Video Machine) – typing in the in-point and out-point numbers – and get the best quality we can by returning to the original master source tapes for the final edit. The hi-tech equipment requires more experienced people to take on the 'editor' role, so the activist then takes on the 'director' role, telling the editor what to do. Once the shots have been reassembled, the sequences are polished, and sound overlays, captions and digital effects (like dissolves and fades) are added. This has proved a very effective process in terms of empowering people to make their own videos while making the best quality (and therefore the most compelling) videos possible.

In summary, the process goes like this:

1 Make VHS copies of source material.
2 Log source material.
3 Work out structure with main sequences.
4 Paper edit.
5 Edit rough-cut on VHS–VHS edit suite.
6 Show rough-cut to 'client' group.
7 Re-edit rough-cut.
8 Write in/out-points onto edit decision list (EDL).
9 Go back to source tapes and digitise clips onto computer hard drive.
10 Polish edit on computer and add music, sound overlays, narration, captions and effects.
11 Record programme onto a broadcast-standard BetacamSP tape.
12 Celebrate!

Campaign Screenings

Many video activists have found that the most effective way to distribute their material is to organise their own screenings. Shows can range from a post-event camcorder playback to a sophisticated multi-projector multimedia rave extravaganza.

The number and diversity of video screenings exploded in the late 1980s with the arrival of the cheap, lightweight, high quality single-beam video projector. Until that point, projectionists had to rely on more expensive and less transportable equipment. For as little as £50, a video activist can hire a projector and screen educational features to over 200 people. For the grassroots organiser, the video projector is now replacing the slide show as main tool for awareness raising.

Screenings are a very useful tool for a video activist. They are cheap, they are mobile, they can be adapted for a target audience, they are interactive and, perhaps most importantly, the content is controlled by the video activist. Screenings can also reach a large audience. Road shows have resulted in hundreds of thousands of people seeing grassroots videos that they would otherwise have missed.

Many organisers of screenings say that, because of these charac-teristics, screenings can have more impact than other forms of distribution, even television. This is because members of the audience feel involved in the experience rather than passive participants. They can interact with the campaigners and video activists who are there on the night. They can ask them questions not answered by the video. They can find out how to get involved.

Equally important, the video activist can have face-to-face contact with the viewing audience. This may be of great significance if, for example, the audience is made up of politicians or decision-makers.

Furthermore, being present at a screening can give the video-maker feedback on the effectiveness of the video itself – which parts worked well, which did not.

Transparent Films

by Heather Frise and Velcrow Ripper

In the last six years, Transparent Films have functioned as a media activist/documentary production group, based in British Columbia, Canada. The primary thrust of our media work has been towards forest campaigns (road blockades, tree sitting, demos, etc.) and, more recently, issues related to bears in British Columbia, primarily trophy hunting.

In 1991, we spent the summer living on the road blockade mounted in the Walbran Valley to stop a multinational logging company, Fletcher Challenge, from decimating an old-growth forest. We documented the daily confrontation and sent our tapes out when we could for news broadcast. But we then realised this wasn't the ideal way to bring public attention to the issue. For one, they tended to use the footage that best typecast environmentalists as either flaky hippies or threatening terrorists. So we felt it was time to put representation into our own hands, to make a video using the voices of activists on the blockade, including some interviews with environmental biologists, elders and other involved individuals. This became the first activist tape we produced: *The Road Stops Here*.

The tape became an extremely useful tool for activists around the world, becoming a focal point for benefits screenings, tours, television broadcasts, etc. After one screening in Bellingham, Washington, about 60 US activists organised a rally in solidarity with Canadian rain forest campaigners. A number of these people also came up to participate directly in the blockade. When the tape was shown to an indigenous group in Brazil, they copied the direct action techniques depicted in the film, and successfully blocked a mining company from invading their lands.

We have recently released *Bones of the Forest*, a 16mm feature video, which has been in production throughout all the other work we have been doing. It is a 'poetic essay' video, which draws from the stories of old people to explore the issues surrounding the ancient

forests in British Columbia. The video has been hugely successful, doing both the international festival circuit (where it has won awards) and smaller, grassroots tours, all the way up to the Yukon. Some of the elders of the video have, on occasion, accompanied the video to screenings. It is an evocative, moving video, and seems to be effective in awakening people to the urgency of the situation.

We have also set up, and teach at, the Gulf Islands Video and Television School on Galiano Island, British Columbia, where people come for week-long intensive production workshops. We are also interested in exploring the idea of holding media activist training at this facility.

TYPES OF SCREENING

The type of screening you choose will depend on your purpose. If the aim is to make an impact on a politician then a one-to-one meeting may be best. If the aim is to increase the numbers involved in a campaign, a nationwide road show could be very effective.

Post-action screenings

After an event has taken place, many groups like to sit down and watch what happened on video. Often the footage will not have been edited and is played straight from the camcorder onto a television set. Or, if there has been time, the video activist may have transferred the best parts from the camera onto a domestic VCR, and then shown the group the roughly edited video tape.

Walk Across Europe

In 1995, a group of peace activists embarked on a Walk Across Europe to highlight the problems of increasing nuclear proliferation both in the civil and military sectors. When they arrived in the UK, some were turned back for not having 'correct' immigration papers. The next day they took part in an action outside Aldermaston military base. Both of these events were videoed by video activist Kevin Doye. At night he roughly edited the material from his camera onto a video player and then showed it to the group the following day. This was incredibly inspiring for the group, who not only enjoyed watching themselves

on video but felt proud that their actions were worthy enough to be covered in this way.

Media Rights

The Media Rights group in Tennessee provides video support to Earth First! in their area. They decided that they wanted to be able show the campaigners what they shot after actions had taken place, but the groups they work with have no access to television equipment and are often camped deep in the wilderness a long way from power sources. So Media Rights have equipped a van with VHS players, basic editing equipment and solar panels, and now screen roughly cut-together footage right after each action.

Research screenings

Some video activists use camcorders for research purposes. They gather information on video, then show it to their group, who use it to assess their work, plan future campaigns and shape policy. Once again, footage may be played straight from the camera or be edited roughly from camera to VCR.

Save the Children Fund

Save the Children Fund train and equip their field officers with camcorders so that they can video the field projects taking place overseas. The 'video report' is used by desk officers and policy-makers back in the UK to evaluate how the project is going and to assist in deciding future efforts.

Enough is Enough

Activists from the Enough is Enough campaign, protesting against World Bank activities, used a video at the 1994 World Bank 50th Anniversary meeting in Madrid to assess the possibilities for a banner-drop at the main conference centre. The footage was shown at a pre-action meeting and was extremely useful in developing an effective strategy.

Anti-opencast protest

Residents of Brymbo, North Wales, fighting a proposed opencast mine, travelled to nearby Walsall and took video footage of a mine already in operation. They found that the developers had lied to the Walsall community and deposited toxic waste in the mine. The Brymbo

residents returned home and showed the footage to the rest of the community.

Lobby presentations

Sometimes groups make use of videos to capture a problem and then present the evidence to politicians or other decision-makers. This can be extremely successful if the footage is powerful, and speaks directly to a target audience.

Amnesty International in Bosnia

In May 1996, Amnesty International collected camcorder footage from Bosnia illustrating that large numbers of people have 'disappeared' throughout the conflict. Their political point was that the war was not over and that action was necessary to prevent further disappearances. They took the footage to the European Commission, lobbying officials to introduce policy to respond to the situation.

ASEED Europe

In 1993 activists from ASEED (Action for Solidarity, Equality, Environment and Develoment) Europe occupied the offices of the European Round Table (ERT), based in Belgium. The ERT is a lobby group made up of chief executives from Europe's leading corporations, who lobby the European Union to increase infrastructure across the continent. ASEED had previously made a video about the work of the ERT, demonstrating the damaging effects of its policies. While they were in the offices, the activists showed this video to the director and the rest of the staff. Many of the workers admitted they hadn't known what the ERT had been up to and were thankful for the educational video!

Cascadia Uncut

In 1995, Cascadia Uncut – a collective of video activists around Eugene, Oregon – produced the short video *Last Chance for the Umpqua*. This showed the renewed clear-cutting of the old-growth forests that was taking place under President Clinton's Timber Salvage Rider legislation. They made hundreds of copies of the video and distributed it through grassroots groups as well as sending targeted copies to members of Congress and to the White House. In February 1996, one

of the activists, Tim Ream, took the video on tour to over 40 cities around the country. In March 1996, as a result of these activities, along with continued blockades within the forests themselves, National Forest Service was forced to move the logging concession from the original roadless wilderness area to a less sensitive location.

Community screenings

Some groups have made screenings a regular occurrence. They find a venue, publicise the screening event, and then organise the show. Once they attract an audience, video activists start sending footage in for the next event.

VideoActive

In Melbourne, Australia, VideoActive organises a weekly show, running community videos at a hotel in the centre of the city. The hall can take up to 400 people. The audience is charged $5 at the door and is treated to two videos each night. Each of these videos is relevant to a particular group, and that group is encouraged to invite its members along. The shows also act as a forum where people from different groups get the chance to meet each other.

Exploding Cinema

Exploding Cinema inspired a wave of 'open screenings' in the UK in the early 1990s. The collective organised shows in strange locations (most famously a disused swimming pool in London) and then invited anyone who wanted to show their work to come along. The only rule was that the video-makers had to defend their own work. If members of the audience didn't like what they saw they were encouraged to make their views known and the video could be stopped. Though the features were sometimes arty, many had political content and were made by video activists. Exploding Cinema became known as one of the only distribution mechanisms for people using video to bring about change.

Artists Television Access

In San Francisco, Artists Television Access provides a venue for a variety of community video 'curators'. Some are video activists who host regular shows and collect pre-cut videos from around the country. An example is Craig Baldwin, who has hosted his Other Cinema show

every Saturday night for over four years. Others are community activists who make their own videos to support their campaign work. For example, local forest activists have run environmental theme evenings while others have run gay and lesbian video sessions.

Some groups have seen the potential of such screenings and have begun coordinating video distribution between exhibition spaces.

Conscious Cinema

Conscious Cinema in Brighton is a collective that provides training and editing space for video activists. They then compile activist features onto a one-hour video magazine every few months and send the zine out on VHS tapes to over 30 screening groups around the country. In 1996 they organised SchLive!, a multimedia road show that screened video activists features to over 100 groups.

Video Arts Foundation

The Video Arts Foundation based in San Francisco has compiled the 'AEIOU' directory of venues in the USA (and more scantly around the world) where videographers can screen their videos. Though this is not dedicated to social change videos alone, the directory does provide video activists with a useful tool for locating screening venues.

Another option is to coordinate a one-off community screening in a number of venues on the same night. This has the advantage of reaching a large audience quickly without having to maintain a resource-hungry screening project over a long period of time.

undercurrents

In November 1996, **under**currents organised over 30 screenings around the UK all on the same night, to mark the launch of the sixth issue of the video magazine. The sites ranged from commercial cinemas to community groups to people's homes. The fact that the shows happened on the same night attracted media attention and added to the 'happening' atmosphere of the event. An estimated 3,000 people watched the video in one day, an impressive number considering the lack of resources involved. This 'national launch' – the brainchild of Debora Cackler – took only three weeks to set up, and even this was on a part-time basis. Almost everyone approached said that they would like to host a local screening. The feeling was that people were eager be part of a project that enabled alternative visions to be seen.

Video projectionists

Mixing video at clubs has become extremely popular in the 1990s. Using video decks, a projector and vision mixers, a projectionist – sometimes called a 'video jockey' or 'VJ' – is able to intercut powerful but soundless images as the music pounds away. In some events as many as eight film and video projectors can be used at one time, creating an awesome effect.

A video projectionist can be paid as much as £1,000 a night to mix video at one of these events. Many of the projectionists work in the video business, either at mainstream or cable stations, and therefore have access to the equipment and technical knowledge that they need. But there is little or no political content at most of these events.

The jump to video activist work has occurred in a only few places. Where it has happened, the impact has been very exciting. For instance, in Sydney, Australia, a group of projectionists called Subvertigo mix political images and psychedelic graphics at raves and clubs. According to John Jacobs, one of the group's members, 'What is great is that you can show strong images to a crowd that's there for a different reason and is very receptive. It's like beaming underground images straight into someone's head.'

Similar video activist screenings take place at raves, clubs and free festivals in the UK. According to VJ activist Liz Thomas, 'Many clubs are now allowing projectionists to screen alternative and radical footage to the dancing crowd. This usually receives a warm reception and contributes to the process of empowerment.' Liz intercuts grassroots protest video with general archive material, such as footage found on hospital medical tapes and underwater sea programmes (see box below).

Example of video activist projection mixing between two tapes

Tape A	*Tape B*
Time lapse photography of plants growing, unfolding leaves and natures own defences – thorns. Startled animals and close-up of eyes. Close-up of tree trunk showing rings that represent the length of the tree's life.	Road construction shots, bulldozers etc., people building tree houses, people chaining themselves to chainsaws and logging equipment. Security and police evicting protesters. Montage of historical events emphasising the tree's longevity and what is has lived through.

Video festivals

The traditional way for non-professionals to get their videos seen by other video-makers is to submit their work to festivals. There has always been a large circuit of these types of event to which people can send in their short documentaries. Sometimes they have the added bonus of prize money for the favoured and commendations for the almost favoured. If people are extremely lucky, their video may be picked up by a television scout and selected for future broadcast. But this is very rare indeed.

Video activists have begun making use of these networks to gain prestige and funds for their work. It's incredible, but true, that under-resourced non-professionals are able to compete with over-resourced professionals. For instance, features made by community activists with **under**currents have won prizes in Germany, France, Bulgaria, Japan and the UK.

Of particular interest to the video activist is the thematic festival. Over the last few years an increasing number of issue-based events have emerged, such as the New York Gay and Lesbian Video Festival, the Okomedia Ecological Festival in Freiburg and the Chicago Women in Director's Chair Festival.

These festivals are attended by people interested in the issues as well as in video-making in general, so they do offer some hope of political impact. But such effect is diffuse and unreliable. And because applying to such events takes time and costs money (tape transfers, post, etc.), many video activists are reluctant to risk investing resources and being rejected. For a list of video festivals that take activist videos see pp. 231–4 of the Resources section.

On the other hand, alternative music and counterculture festivals have proved a great opportunity for showing campaign videos. Video activists have had much success in bringing along their videos and showing them to blissed-out audiences at gatherings around the world. Such efforts range from the highly polished multimedia shows put on by groups such as the Oxford Film and Video-Makers at the annual Phoenix Festival in Reading, to roughly cut-together action videos shown at the Arcadia Gathering in California.

SCREENING STRATEGIES

These strategies are designed for organising a public screening, but most of the ideas will apply to other types of show.

Choosing the material
The key to effective use of a screening is to target the material to the audience you have chosen. Decide what your purpose is. Think about what their needs are, what they are interested in, why they are coming to the screening. For instance, if you are planning to screen to a nightclub audience, don't include features that are packed with interviews as no one will be able to hear the talking over the music.

Make the screening an event
People can tire very quickly of watching depressing doom-and-gloom videos. So think about what will keep them happy and entertained as well as what will appeal to their consciences. Try to vary style as well as content to hold people's interest. Perhaps intermingle live performance artists, such as poets, jugglers or musicians, with the video to make the evening more interactive. Another way is to have an MC introduce each video to get the crowd excited. Audience feedback – laughing, clapping, heckling, etc. – should be encouraged to make the show more of an experience.

Audience gimmicks
By getting the audience involved in the screening, you can turn the process into a form of two-way communication rather than a one-way broadcast. It is this that sets communal screening above broadcast as an effective way of motivating and activating. Two devices for achieving this are the *gong* and the *clapometer*. The gong gets struck when someone has had enough of a bad video – a great leveller for self-important media people. The clapometer – which gauges audience appreciation by the loudness of the applause – gives the group a chance to judge the best and worst videos of the evening.

Scheduling
Don't show too many videos at once. Most people can't take more than an hour and a half of videos, especially if there are many short features in succession and the videos contain no narrative. If you have too much, organise another screening! A time limit on material is essential, with

ten minutes being a reasonable maximum length for any one piece. Vary the subject matter of the videos throughout the evening and make sure that you put some of your favourite ones on towards the end of the night, when people are tired, to maintain their attention.

Printed programme

A printed programme is essential to help the audience navigate its way through the bewildering array of material. It also gives you somewhere to print a manifesto, put out a clear message as to what you are about, and advertise for material for your next show. Don't forget a contact number.

Money

Good reliable equipment – especially video projectors – costs money, and doing shows without cash becomes a very time-consuming and frustrating business. You can raise money by charging an admission and selling food and drink. Funds may be available from local councils and foundations, but video activist features may be too controversial to attract support.

Video-makers' participation

Ask video-makers to introduce their work beforehand or explain it afterwards. Live commentaries or voice-overs can work really well and add an extra dimension to a piece. Audiences like to meet video-makers. The gap between viewer and producer is narrowed, which is empowering and inspiring for many people. For video-makers, being present enables them to see at first hand what works and what doesn't.

Space

Control over the screening space is essential in order to get a relaxed atmosphere where the audience can concentrate on the show. Make sure that the space is dedicated – that is, segregated off from other parts of a venue – so you don't have to compete with the juke-box or other distraction. Start off in small venues with lengthy intervals between shows and then build up to bigger venues and more frequent gigs as demand grows. You get a far better gig when the venue is full ... even if that means there are only ten people in a tiny room.

Effort

One of the main problems with screenings is the effort involved. Unlike other forms of distribution, say television or mail order, screenings

require that you're physically at the point of consumption itself to organise the show. So involve lots of people in the organising of the event, and be efficient at allocating tasks to people.

Copyright

Screening a video to a public audience involves copyright issues. Technically this type of distribution is called 'theatrical' distribution. To show the material you need to get permission from the people who hold the copyright. This will almost always be the producer/director in the case of a video activist feature. For programmes that have been broadcast, the TV station normally holds the copyright.

The Headcleaner Communications Quango

by Pops Yashimoto

The Headcleaner events are a mix of film and video screenings, live performance and a fair dose of the banal. Films, videos and verbal abuse is our motto and we stand by it. The bad and the mad and the just plain sad. We entertain them and they entertain us.

Our philosophy developed in response to a particular set of circumstances prevailing in the Midlands in 1994. Non-commercial video-makers were wanting an outlet for their creative talents and they were joined by a growing number of activist video makers who were documenting the huge social movement gathering in opposition to the Criminal Justice Bill. Meanwhile, at clubs and raves, video and slide projections were becoming a vital part of the indoor psychedelic festival scene as pioneered by Club Dog and Whirligig in London.

Ironically, in an age of digital global communication, we arrived back at the music hall and a vaudeville variety format that would not have been out of place a century ago. Videos were interspersed with magicians and deathly serious political comment; no-budget sci-fi video was followed by didgeridoo players; nude performance artists in flippers were followed by a rant about road-building, with a samba band rounding off the night. Anything goes and it usually went.

The only limits were the imagination of the performers and the all-powerful dismissive power of THE GONG. Yes a gong for those

narcissistic crap video-makers and self-obsessed poets. There were no appointed guardians of taste and decency, no moral nannies. If material was submitted in time it got screened until the restraint of the audience snapped and sub-standard or offensive material was gonged off the screen. The inevitable arguments among the audience as to the merits or otherwise of each piece brought a level of interactivity to the shows that would be anathema to the silent reverence of the traditional cinema or the sycophancy of the art-house set.

The important thing was to get the video-makers to the screenings. By encouraging dialogue of any form, the mystique and therefore the elitism of the video-maker is broken down and their material simply becomes an effective aid to communication.

With Exploding Cinema leading the way in a headlong rush toward its own implosion, screening groups sprang up in different parts of the country, notably Red Dog in London , Vision Collision in Manchester, Conscious Cinema in Brighton and the Headcleaner mob in Birmingham. With the generous help of the Vegatropolis Food Co-op at the Angle Gallery in Birmingham, the Headcleaner collective set out on its merry way to bring enlightenment to the lucky people of the Midlands.

SCREENING EQUIPMENT

The list of screening equipment that you need can shrink or expand according to your budget . However, there are certain things you need if you want a stress-free evening. The basic setup consists of the following:

1 Video recorder
2 Large TV or video projector and screen
3 Audio amplifier and speakers
4 Connecting cables and mains extensions
5 Blackout

Video recorder
The more expensive the video recorder you use the better. Machines operated by remote control are ideal, because you can operate them from the back of the audience. If you are going to amplify the sound

Figure 10.1 Advanced video projection kit

then try to get a VCR that has separate audio outputs for its two sound channels. Avoid VCRs that have only an RF (aerial) output, because these are a nightmare if you want to amplify the audio.

Televisions
If your screening is for fewer than 30 people then try to get hold of a large (26-inch or bigger) television. This will be cheaper and easier than using video projectors and PAs. Put the television at a good height (five feet off the ground) so that the heads of the people at the front don't obstruct the view of those behind them.

Video projectors
If your screening is for more that 30 people then it is time to get hold of a video projector. There are two main types of projectors: the older three-gun CRT (cathode ray tube) models and the smaller and more portable LCD (liquid crystal diode) models. The quality and cost of the two types is about the same. The CRT projectors are usually fixed-focus and so need to be placed at a set distance from the screen. They take about 45 minutes to set up. LCD projectors, on the other hand, can be zoomed and focused using a remote handset and can be placed virtually anywhere in a space (great for raves because they can be hung up out of harm's way). They take about ten minutes to set up and are much less of a bother. The LCD projectors are also far easier to transport. Commercial hire facilities are horribly expensive when it comes to video projectors. It pays to ask around community resource facilities and

activist networks for cheaper options. Models range from the very small to the very large (and expensive), so make sure you are getting one powerful enough for your needs.

Audio amplifiers and speakers
For screenings of up to 20 people, a domestic hi-fi amp and speakers is sufficient. Because there's usually a lot of dialogue, quality is very important, and domestic systems are far superior to guitar amps or combos. With audiences of more than 20 it is worth getting hold of a small PA amp and speakers: 100 watts should be large enough for crowds of up to 50 but you need something more powerful if there are going to be over 50. If you have more than one audio output it is sometimes possible to use a domestic system and put the top frequencies through this while also using a guitar amp for bass.

Cabling and connecting up your kit
The best way to avoid having problems connecting up your equipment is to set everything up on a trial run the day before the screening. There is nothing worse than trying to sort out technical problems with an audience waiting for the show to get going. Once you start getting into more complicated setups it's worth investing in a couple of assorted adapters and carrying spare BNC and phono cables. There are kits available that enable you to convert every conceivable type of audio and video connector into the desired plug. These are well worth the money.

Projector screen
A king-size sheet will suffice for a basic show. Remember pegs, tacks or pins to hang it with and try to get it as smooth as possible (take a travel iron). Proper projection screen material is more expensive but makes the image about 20 per cent brighter. If you have a proper budget or are touring or doing pay gigs then Fast-Fold screens, available from commercial hire facilities, are a godsend.

Blackout
The venue needs to be light-tight, especially in the summer months. Most video projectors will be totally useless in a daylit space. Blackout felt material borrowed from a theatre is ideal, but otherwise thick club backdrops will do or, as a last resort, black bin-liners. Video

projectors cannot deal with other light sources, so be careful when using spots and other lights in gigs.

Advanced screenings

If you are planning to screen to a larger audience or if you want to have fun mixing images, sounds and different formats, then you may want to use the following equipment in addition to the basic list given above (p. 185):

- Vocal PA (100 Watts will be enough for almost all situations)
- CD/Cassette Player
- Audio mixer
- Microphone
- 16mm and Super 8 projectors (if screening video)
- Second VCR
- Video switcher or video mixer such as the Panasonic MX 10

Ten tips for screenings

1 Vary programme by length, subject and energy.
2 Choose an exciting venue.
3 Cover costs by selling food and drink.
4 Make sure that the sound is of good enough quality and loud enough.
5 Keep the programme under one and a half hours.
6 Involve a charismatic and/or funny presenter.
7 Invite the video activists to the screening.
8 Stay on time.
9 Include audience gimmicks, like gongs, and live performances.
10 Use a projector if you can.

Other Distribution Outlets

Over the last few years, video activists have found new ways to distribute their material – from producing activists' shows on cable channels and community television stations to incorporating video in CD-ROMs and Internet pages.

Such outlets provide huge opportunities for the video activist, opening up vast audiences to radical images for the first time.

Many of these new opportunities have emerged as a result of new technology being developed and becoming widely available. In some cases – as with the Web – their full potential has not yet been realised, and we shall have to wait a few years to find out their true usefulness.

COMMUNITY TERRESTRIAL BROADCAST

Television distribution started with terrestrial broadcast – images and sound sent in the high-frequency radio spectrum from ground-based transmitters. For over fifty years this has been the main outlet for the major television broadcasters. But there is a limit to the width of the radio spectrum available. So governments have been extremely reluctant to hand space over to community broadcast. This may change as more space, and therefore channels, becomes available with the digitisation of broadcast signals. For example, in the UK, up to 80 new channels will become available with the advent of digital TV in 1998. There is no sign, however, that any of these will be handed over to community stations.

Some tenacious video activists have managed to persuade their governments to allocate space to community programming. Where

this exists, video activists have been able to broadcast their material to huge audiences.

One example is TV Stop in Copenhagen, which has a weekly slot on a local broadcast station. The group pumps out radical and controversial material that would otherwise not be seen on mainstream television. One week, for example, they followed residents successfully evicting neo-Nazis from their village. They have a regular audience of over 100,000 people – an incredible opportunity for the ambitious video activist.

Ten-point plan for using community television

1 Research technical possibilities before approaching the government with proposals for a channel.
2 Agree who is going to run the station before you start.
3 Find independent means for financing the channel.
4 Advertise programme schedule in local press.
5 Get long-term licence to use the channel from the government.
6 Develop popular programming that will attract viewers to more 'worthy' shows.
7 Produce programmes targeted at specific niche communities.
8 Attract film and video student volunteers to staff the channel.
9 Experiment with the limits of what is possible to broadcast rather than assuming what they are.
10 Negotiate deals with local video facilities houses for cheap deals on equipment use.

Community broadcast in Australia

In 1995, after years of test broadcasts, community groups won the right to transmit on local television channels in Australia. They won a two-year temporary licence. There are now six 'free to air' stations around the country, in Sydney, Melbourne, Darwin, Perth, Adelaide and Hobart. Each station is made up of a consortium of programme providers, often defined by the geographical urban community they come from or an ethnic group they service.

Perhaps the most successful of all the community stations in Australia is Melbourne's Channel 31. Most of their costs are financed

by giving over Saturday's broadcast to a company that covers horse-racing. Not only does this provide funds but also attracts an audience of over 200,000 to the station (figures taken from a survey carried out by an independent audience ratings company). One of the programme providers is Bent TV, which makes a gay and lesbian show that attracts a weekly audience of over 80,000 people. One of Channel 31's great successes has been having its daily programme schedule publicised in the local paper's television listings section.

Another programme provider for Channel 31 is Ska TV. It makes three half-hour shows each week under the banner of *Access News*, each focused on one of three different issues: union affairs, the environment and social justice. Each programme includes two 15-minute features, usually consisting of interviews and action footage. *Access News* is produced by Steve Miller and a bunch of his mates. No one is paid.

Access News has produced over 150 programmes since 1993 and shoots most of its footage in Melbourne. They finance their work by having 26 local groups join as members. In return for their $50, the groups are guaranteed a programme about their campaigns in each 13-week season. The money covers editing and tape costs. *Access News* is watched by over 30,000 people every week.

With access to such large numbers of people comes power. In some cases, this has led to fighting for the control of the station. There are two main points of conflict: which groups should gain access to the airtime, and how commercial the station should be (i.e. whether there should be advertising, sponsorship, etc.).

According to John Jacobs from CATv, who was involved in the early community television test broadcasts in Sydney, 'Free-to-air broadcasting is the most perfect type of distribution. You can send subversive sounds and images directly into people's living rooms. They can be exposed to material they would never chose to spend energy seeking.'

CABLE

Since the 1970s, cable stations have emerged around the world as distribution mechanisms for video material. Today cable is becoming a mainstream broadcast medium, not only in North America but also in Western Europe and now parts of Latin America. And, of course,

with the proliferation of channels comes a proliferation of opportunities for the video activist. In many places, cable has become *the* distribution mechanism for radical video material.

In Germany and Sweden the governments support cable Open Channels. These offer space for radical and controversial programming. The Stockholm Open Channel has a fairly structured schedule. For instance, they have a weekly show that takes alternative features from around the world. German Open Channels, such as in Bremen, tend to have a more flexible approach, with the schedules being set on a first-come first-served basis.

Perhaps the most developed area for cable is the United States. For over twenty years, Public Access and Community Cable stations have been obliged by law to give local people access to airtime, and in some cases to equipment and training as well. Since the beginning, social and environmental justice groups have made use of this opportunity to provide local residents with news and views that they cannot find on the mainstream news networks.

It is common in the States to find that a campaign group has a slot on its local station. For example, in New York, Carl Grossman runs a weekly half-hour environmental cable show called *Enviro Close-up*. This invariably involves only studio discussions and interviews, as they don't have the resources to video any action footage outside the studio.

However, many of these channels suffer from low audience numbers. The explanation often given by the mainstream media for low viewing figures is that programme quality is poor. However, in my experience the vast majority of channels broadcast programmes with at least 'good enough' quality, which is made up for by the excitement of watching something different from normal television.

According to Carla Lesche of Paper Tiger (see the case study below), a more likely reason for the low viewing figures is that people don't know about the programme, given the mass of other channels, and that this is then made worse by the fact that local newspapers won't list the public access programme schedule, as they do for all other television programming.

Another problem is that radical programme-makers have little or no control over the running of the stations. This can mean that, even if they have managed to build up a regular and large audience, the station manager can switch times and change schedules, and the programme-makers have to start again to build an audience.

To combat some of these problems, an increasing number of activist cable providers offer packages (hours of completed programmes) to public access stations around the country. One such example is Free Speech TV (FStv). This group was created after a successful PBS show called *The '90s* was shut down. FStv is a cable network programme-provider that is dedicated to social and environmental justice issues. It obtains non-exclusive licences to such programmes and then distributes them as part of four-hour-per-week packages on video cassette to over 50 cable stations around the country. They send tapes initially to a first batch of stations. After two weeks or so the tapes are sent on to a second group, and after two more weeks they are sent to a third. In this way the distribution costs are reduced and the programme broadcast is staggered over a six-week period.

By late 1996 their programmes were being broadcast to over 6 million homes. All their affiliates are non-commercial access channels. They hope to become a full-time national satellite-fed network in the future. Programme-makers are paid $50 per title when they sign their license agreement and then $5 per minute for any material that is actually released.

Ten tips for running a cable channel show

1 Get a good name for your show.
2 Win a long-term contract to produce the show so that you can build up an audience.
3 Be realistic – don't take on too much.
4 Be very clear about who does what tasks and who has responsibility for them.
5 Link up with other video activist networks to fill up the programme time.
6 Publicise the show wherever you can, e.g. hand out leaflets at activist events.
7 Develop a reputation for doing something that no other channel provides.
8 Get the show listed in the local newspaper. It won't be easy, but be persistent.
9 Use the mainstream media to win publicity for the show.
10 Hook up with another enterprise to help finance the project.

Paper Tiger and Deep Dish, USA

One of the most successful groups to make use of cable as a distribution vehicle has been Paper Tiger TV. Based in New York, Paper Tiger also has offshoot groups in other cities such as San Diego and San Francisco. Set up in 1981, its main work has been making political videos and then distributing them on public access television.

Paper Tiger programmes provide analysis and critiques of issues involving the media, culture and politics. They feature scholars, community activists and journalists addressing the ideological assumptions and the social meanings of the mainstream media as well as exploring opportunities for alternative communication sources. 'The goal of the work is to provide viewers with a critical understanding of the communications industry'.

For many years, the Paper Tiger group in San Francisco ran a cable-based community news programme. Volunteer producers ran around with camcorders covering local happenings, street protests and challenging politicians. Paper Tiger producers handed out leaflets about the show at community events, telling people when and where they could find it on the cable schedules.

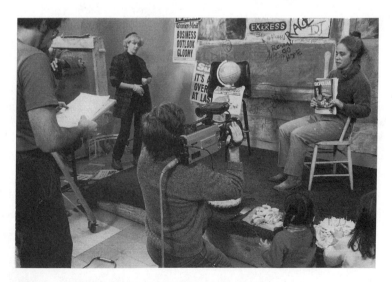

**Photo 11.1 Paper Tiger TV Anniversary Show, 1986
(photo: Diane Neumaier)**

In New York the work was more studio-based (Photo 11.1). They made over 200 programmes, which were then distributed to both the cable and educational markets. A common feature was the 'readings' (critiques), where video activists took apart the work of the mainstream media. A typical show started with a caption 'IT'S 8.30 DO YOU KNOW WHERE YOUR BRAIN IS?' and ended with a budget for the show, a waving control booth operator and a caption 'TUNE IN NEXT WEEK'.

Paper Tiger's most popular programmes have included documentaries about the career of Mumia Abu Jamal; the emergence of the Zapatistas; the business behind Barbie dolls; and the rightwing commentator Rush Limbeau.

Meanwhile, in New York, Deep Dish (associated with Paper Tiger) rents cheap satellite time and then uplinks radical features to public service cable operators around the country. Perhaps Deep Dish's greatest success was the Gulf War TV Project. Throughout the Gulf Crisis, video activists collected footage of anti-war demonstrations and then distributed the material, packaged into two series, to cable stations around the country via the Deep Dish satellite. This was the only place that the American public could see the activities of the huge anti-war movement. Since then, Deep Dish has continued its radical television work by packaging completed alternative video features into 13-week 'seasons', and then uplinking such packages in one go to public access stations across the country.

VIDEO LETTERS

The most direct form of distribution possible is when you send a campaign video directly to your target audience by post. This is called a video letter. It has the great advantage of being extremely focused as a distribution strategy, but requires careful preparation to establish who exactly needs to see the proposed video.

In 1997 I helped a group of residents from Pentre Maelor, in Wales, who were suffering from a nearby noisy and polluting aluminium factory, Deeside Aluminium. The first thing we had to do was try to find out who the owner of the factory was. This proved a difficult task, as the company involved was wholly owned by a series of companies including Aluminium Holdings UK, AS Products Holdings Malta, Corporate Services Nominee Malta, and ultimately Access

Industries. We knew that this last company was entirely owned by one man, Leonard Blavatnik, and we decided to send the letter to him, hence the video's name, 'Dear Lenny'.

Once we'd worked this out we went around collecting testimonies from the residents and workers from other nearby factories who were also suffering from excessive noise and pollution. We intercut this with video evidence collected by the residents themselves over a number of years (see Chapter 5, p. 69) and footage that I shot when I spent some nights on the estate myself.

During the production of the video letter we thought hard about the likely response it would provoke. We guessed, for example, that they would say that things had been bad in the past, but were now better. So we made sure that we had some up-to-date video evidence of the factory causing pollution, and a witness (in this case a local Conservative Party candidate) saying that it was still as bad as ever.

Once the video letter was complete, we realised that sending the video to the owner wasn't enough. He could simply ignore it. We therefore constructed a whole video letter campaign. We sent it to key people in the local and national media, environmental agency departments and the local council. We even sent it to the bank that held a large loan with Deeside Aluminium as well as the companies that supplied and purchased products from the company. In this way it was hoped the video letter could have a large impression. At the time of writing we are still waiting to hear about the outcome.

CATALOGUES

If video activists do not have access to community or cable stations, or if those stations are limiting the radicalness of the features they are making, a good option is to set up their own mail-order catalogue.

Video activists started producing catalogues of their work as soon as video became available. It was incredibly easy to compile a list of alternative features, print them up on a couple of sheets of paper, and distribute it to potentially interested markets.

Catalogues compilers have a certain degree of control, in that they can choose the titles for the list. They don't, of course, have any input into the production of the programmes, however, as these are likely to be made by other people. Despite this, catalogues are an effective

alternative distribution outlet, which even people with limited resources can establish. Here are a few examples:

- Since 1980, Frameline has been the only national distributor in the United States solely dedicated to the promotion, distribution and exhibition of lesbian and gay film and video. Based in San Francisco, Frameline's catalogue contains over 160 titles for rental and sale, from experimental to narrative, documentary to short fiction. Their market includes colleges, libraries, community groups, theatres, television and youth audiences.

- Concorde Video is one of the longest-running catalogue distributors of issue-based films and videos in the United Kingdom. They include hundreds of titles on the environment, human rights, animal protection, and gay and lesbian issues.

- The Enviro Video catalogue was set up in the early 1990s in New York. The catalogue includes mainly environmental and animal welfare programmes. They distribute to individuals as well as to public access and cable channels across the country.

There are a few major drawbacks with running a catalogue. Chief among these are that titles tend to get out of date quickly, as many catalogues aren't updated often enough. Part of the reason for this is the undynamic nature of the outlet. Unlike screenings, the Web, cable and CD-ROM, the catalogue is one step away from the viewing process. You don't actually watch the programme when reading the catalogue; the closest you can get is a still taken from the video accompanied by some evocative text.

Another difficulty is that catalogues are often so diverse in their titles that they fail to establish a market. A customer might buy one or two titles, but no more. This means that the catalogue has little security in the long term, and many catalogues fail after a short time.

VIDEO MAGAZINES

Another ambitious alternative distribution strategy is to produce a regular magazine programme published on video cassette – normally

VHS. These have become increasingly popular over the last few years as editing equipment has become more widely available and duplication costs have come down.

One of the great advantages of a video magazine is that you can build up a database of customers who subscribe to the system. This enables you to underwrite future editions with money that people have put up front. Of course, this means that you have to produce new programmes continually – often beyond the budget generated from subscriptions – but not as frequently or with as much pressure as for cable or community television shows.

Another benefit of producing a video magazine – at least until now – is that they are a 'new thing'. This means that video activists can attract mainstream media attention to the magazine, in the form of news, editorials and reviews, which then attracts customers. A video magazine can then develop a 'profile', which attracts contributors. In this way the project builds on itself.

More importantly, a video magazine can be controlled entirely by the people who manage it. Unlike community television, cable or mainstream television, editorial control rests with the video activists. This is an exciting opportunity for people frustrated with the limitations imposed by other distribution outlets.

Probably the biggest problem with a video magazine is administration. No longer can you go out and shoot a campaign event and send it to someone else to distribute. Now you have to do all the legwork – packaging tapes, maintaining a database, advertising, winning publicity, liaising with suppliers, and so on. Long tiring hours are a norm. Pace yourself. And if you are to produce a product that you want to sell to a wide market, you have to find a way to keep the quality up so that people don't compare it badly to commercial television. This is not always easy if you want to work with grassroots campaigners to make the programmes.

Here are some examples of video magazines (Photo 11.2).

Northern Newsreel (UK)

Set up in 1986, *Northern Newsreel* was a pioneer video magazine produced by Channel 4 workshop Trade Films in Gateshead, Tyne and Wear. Eighteen issues were produced up to its close in 1990. Each tended to be around 20 minutes long. The main subject was labour and union issues. Around 200 copies were sold each issue.

Photo 11.2 A selection of video magazine covers (photo: Paul O'Connor)

AK Kraag (Germany)

Set up in 1992, there have been twelve issues of *AK Kraag* published so far. It tends to cover stories about the anarchist and squatting movement in Germany. Much of the footage involves police, water cannons and protesters. The style is experimental verging on grungey.

News Unlimited (Australia)

Set up in 1996 and based in Sydney, one issue of *News Unlimited* has been published so far. It covers mainly environmental activism, and uses footage contributed by a variety of video activists from around the country. It makes use of the equipment and experience of grassroots video collective CATv. Some of the features have been broadcast on local community television.

Stoom (Netherlands)

Set up in 1995, two issues of *Stoom* have been published so far. It is a collaborative effort between Small World Netherlands and ASEED Europe. It covers a range of issues and events, including a gay and lesbian rally, demonstrations protesting the execution of Ken Saro-Wiwa in Nigeria, and the campaign to stop the expansion of Schipol airport.

Planet News (Canada)

According to producers Channel Zero, *Planet News*, first published in early 1996, was 'founded to establish an alternative universe to that of broadcast television. But we know it's not enough to create another medium for criticism.' It was launched with a big advertising and publicity campaign in Canada and the USA, and became stocked by mainstream stores such as HMV and Tower Records. Channel Zero intends to produce four 20-minute issues each year. It's MTV meets cyberspace, and its style is verging on the arty.

undercurrents (UK)

Set up in 1994, **under***currents* was the first ever alternative news service to be published on video in Europe. Seven issues have been published so far. The video comes out every six months and includes mini-documentaries on environment and social justice issues in the UK and around the world. The features are made by campaigners themselves and are shot on domestic camcorder. (See page 246)

To produce a video magazine you will need:

- a stable address;
- an edit suite (or access to an affordable one);
- a camcorder kit with good sound accessories;
- a network of video activists who can produce material to fill the magazine;
- a computer to run a database;
- video material that people can't find on television;
- a person to take orders, package tapes, publicise video and maintain a database;
- a person to coordinate the editing of the video magazine;
- money to pay for initial duplication costs;
- someone to design tape covers.

Mail order

At **under***currents* we have found that selling video tapes by mail order has been far more successful than through retail outlets like bookshops and video rental outlets. We are able to sell many more video units and we keep a far larger percentage of the sales price. We gain exposure for the tapes by organising joint leaflet drops with campaign groups, setting up special offer deals on the back page of sympathetic print journals, and winning reviews in the alternative and mainstream press.

Ten tips for producing a video magazine

1 Invite people to send in their unedited footage.
2 Keep quality as high as you can, at all stages.
3 Vary the material to attract a wider audience.
4 Keep the features short (under ten minutes).
5 Assume your audience knows nothing.
6 Get the media excited about the project.
7 Keep the price of the video cheap (e.g. £10; £5 for unwaged).
8 Have plenty of camcorders around – they break, often.
9 Work as hard as you can to get your own edit equipment (with title generator if possible).
10 Don't plan on getting any sleep.

The making of under*currents* 6

by Paul O'Connor

In July 1996, having worked in various roles on five editions of the **under***currents* alternative news video, I felt the time had come to grab the steering wheel, and became captain of **under***currents* 6.

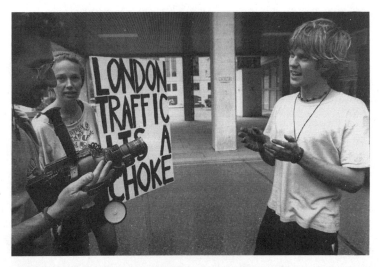

Photo 11.3 Paul O'Connor videoing anti-car action outside the Department of Transport, London, 1994 (photo: Nick Cobbing)

The first thing to do was to make a list of possible issues to be covered. These included Romany Gypsies, Newbury bypass protests, sales of British warplanes to Indonesia, the DIY underground music scene and video activism in Australia. We also made space in case other short pieces popped up during the production which I would have to fit into the schedule somehow as we went along.

The next step was to find people to make the features. Some we knew already as they had proposed the ideas in the first place. Others we had to find. These were almost always from within the campaign groups themselves.

Throughout July, August and September the cameras rolled and the research was in full swing. All the video activists were trained to cut their first versions on our easy-to-use VHS–VHS edit suite.

We've learnt that video activists must have as much hands-on experience as possible if their complete feature is going to be effective.

One of my main roles was to make sure that each separate feature of **under**currents 6 was finished in time to allow the next video to be edited (there is limited space on our edit suite's computer hard drive). This at times proved extremely difficult, as some people came in earlier than expected while others were weeks late.

The most demanding part of any **under**currents issue is supporting the twenty or so video activists involved in making the features. They must be housed, fed, emotionally comforted (as the experience can be quite stressful), and coached on the technical and creative sides. Most of the people we support have very limited or no experience in video-making, but they do have the passion for creating social change. This is what gets them through the ordeal, against the odds.

October. As deadlines loom (we're trying for a pre-Christmas launch to catch all the holiday-season buyers), stress levels rise. One video-maker walks out when he realises he can't take advice or criticism from the campaign he's making the video for. Two women campaigners stay on and work around the clock to complete the video in time. Our mistake was choosing a video-maker who was more interested in his own agenda than the campaign's. Other problems occur. A video activist fails to get all her footage in time for the organic food video. Her feature is postponed till the next edition. The computer crashes for a whole week, stopping all on-line editing. We're faced with re-editing another feature as it looks like we can't get permission for some music we've already used.

November. A last-minute video is compiled in a 'round the clock slap it all together' style on anti-car culture. The result is a rough, dynamic, enjoyable grassroots activist video. But we hit another crisis. We count up the running lengths of all the features and work out that the final compilation is going to be 95 minutes. This is at least five minutes too long, as tape duplication costs jump rapidly over 90 minutes. We spend an anxious few minutes talking about which feature we're going to drop. An awful choice. That night I re-count, and realise – with great relief – that we've rounded up all the times to the nearest minute and are under the dreaded 90-minute mark.

November 15. I am at last compiling all the finished videos to produce **under**currents 6. I start seeing the advantage of having a wide diversity of videos. They compliment each other – the rough with the smooth, the long with the short, the humorous with the

serious – and I can see that people are making a change in all walks of life, in many different ways.

A week later we have 500 tapes back from the duplication house. Our next step is to send all the tapes off to our subscribers, then mail out thousands of flyers, organise screenings around the country, etc. etc. For now I realise my task is over. I am pleased. It seems the captain had steered the boat in the right direction.

CD-ROM

With an increasing number of people having access to computers that can read CD-ROMs, video activists have begun to use this format to distribute their footage.

In the early 1990s, some of the larger environmental groups, such as WWF, dabbled with making progressive CD-ROMs. At the time they were criticised for being pioneers of new technology where more commercially orientated outfits could be doing the same. But now, with the technology mature and relatively cheap to use, increasingly grassroots groups are making use of the new medium.

One of the most radical attempts to use this format has been made by Neil Pike in Australia (Photo 11.4). Neil was a founder member of folk music group the Pagan Love Cult, and has been videoing community activism for years. In particular he has provided video support to pro-hemp and legalise cannabis groups in the Nimbin area of Queensland.

In 1995 he began work on a CD-ROM that would give a multimedia background to the counterculture. The CD-ROM focuses on the environment, drugs, music and sex. It includes things like moving images of an activist sitting atop a tripod in a forest blockade; a virtual jukebox with a choice of activist tunes; text giving the background to the political history of drug use; an animation of a bulldozer knocking down a tree; instructions on how to monkey-wrench a piece of machinery (with accompanying editorial waiver); and a cybergame where the aim is to dose the coffee of a timber worker with LSD. It's irreverent but extremely funny.

Neil intends to make 1,000 copies of the final CD-ROM and sell each copy for A$50, distributing them through environmental groups and mail order.

Photo 11.4 Neil Pike and his Gaia CD–ROM (video grab: under*currents*)

There still remains the question of how appropriate this format is to radical organising. At the moment, relatively few people have the facilities to read CD-ROMs. And although they prove useful as an installation (in museums, for example) or as an educational tool for schools, institutions of this kind are unlikely to buy radical environmental CD-ROMs. Even some commercial publishers, producing the kind of educational CD-ROMs that would appeal to schools and libraries, scaled down their CD-ROM programmes when they found that the market wasn't as big as they'd hoped. However, things are changing rapidly; most new PCs and Macs are being supplied with CD-ROM drives as standard, and these are becoming increasingly affordable. By the millennium, far more people who have PCs will also have CD-ROM drives.

THE WORLD WIDE WEB

To Web or not to Web?

Since 1995, the Internet-based World Wide Web has developed as a major new medium for the distribution of information. There are now

over 20 million home pages and over 50 million users worldwide. With the introduction of browser software such as Netscape, plus the increasing availability of affordable high-memory computers and fast modems, this is only likely to increase.

Around the world, video activists are turning to the Web as a complementary medium for distributing their material. Some are designing home pages that advertise their activities and footage, others are placing short video clips as part of a moving image catalogue, while others are using the Web to make live video broadcasts.

For the video activist, however, the Web presents a difficult problem. Clearly, there is now a vast and new audience out there ready to be tapped. But can you access them? And if you do, will they listen?

There is a great deal of hype about the Web. Manufacturers and software developers eager to expand a new market are quick to exaggerate it. Therefore, before diving feet first into cyberspace, clear-thinking video activists should ask themselves whether the Web is an effective use of their time, given alternative opportunities. The following sections should help you to answer this question.

Purpose

It is difficult to assess the purpose of putting images on the Web because, as with CD-ROMs, the situation is changing so fast. Long pieces of moving images on the Web are still a dream of the future. Similarly, live broadcasts are fun to play with, but as yet no one has found a political purpose for them. Therefore, given the technological limitations, the current best uses of the Web by video activists are:

- a home page, to provide information about your work and to link to other Web sites;
- a catalogue, with stills or short video clips linked to an order form for the full-length video;
- a news service, with grabbed images or video clips complementing text.

Audience

Until recently, the majority of people 'surfing' the Net were stereo-typically students, academics, and corporate yuppies. But in the past

two years this has dramatically changed as more and more people are hooking up to the Web. This trend can only accelerate.

However, the Web is still a minority medium. It will take some time for a large number of people to have the right equipment to access the Web, let alone try finding radical images. It is interesting to note that it took about ten years for the VHS cassette format to become an affordable and available tool for most grassroots groups.

Quality

A big problem with putting moving images on the Web today is that the quality is so poor. This is because, at present, most people's computer systems have too little memory to handle full-length movies. The longest clip is still only 30 seconds – hardly enough time to make an impact on a target audience.

Another problem is that it still takes so long to download the moving images from the Web onto your hard drive. A 30-second clip can take as long as an hour. This is likely to change in the future, and people who keep their virtual ear to the Web's fast-moving ground say that soon users will be able to view moving images live – like we can do already for sound.

A temporary, and popular, solution to all this is to grab high quality still images from a video and put these on the Web. Once up, they can be easily and quickly viewed online and, if ordered in sequence like a video storyboard, they give an impression of what the video would be like.

Existing activist Web sites

Here are some examples of groups who have successfully used the Web to distribute their radical footage.

McSpotlight
One of the most ambitious activist Web sites is the McSpotlight Home Page. This is a multinational effort, designed by different activists in many countries. McSpotlight was launched in February 1996 as a clearing house for information associated with the environmentally and socially destructive activities of McDonalds (Photo 11.5). It

Photo 11.5 McSpotlight Web site is launched by Helen Steel and Dave Morris
(videograb: under*currents***)**

Photo 11.6 McSpotlight Home Page

includes the entire transcript of the libel suit being taken by McDonalds against unemployed activists Helen Steel and Dave Morris (the McLibel Trial), photos of anti-McDonalds protests as well as copies of a brochure put together by campaigners. McSpotlight also includes images taken from activist videos. For example, it has a listing for the anti-McDonald video 'Attack of Big Mac'. To attract potential viewers the designers have grabbed stills from the video and laid them out in storyboard fashion. The images are accompanied by a synopsis of the video in general as well as a detailed transcript. The page also includes information explaining how and where to order the video (Photo 11.6).

Cat@lyst

Cat@lyst is a collective in Sydney, Australia, that is committed to providing community support through the Internet. They have set up a number of home pages carrying the latest news on radical events in the local area. One of these is the Critical Mass home page. Critical Mass is a pro-bicycle rally that takes place in many different cities around the world, on a set day each month, where large numbers of cyclists ride in a group, taking over the streets as a form of protest. The home page contains stills taken from a video of the rally, accompanied by text describing what is taking place, the background to the problem and contact information. The pages also include links to Web sites of other video organisations. Cat@lyst has also experimented with live video Web broadcasts of activist events.

How to use video on the Web

If you want to start using video on the Web, you'll need to have some basic knowledge of the Web and know how to write HTML (Hypertext Markup Language). If you have little experience of this, try to find someone who can introduce you to the world of cyberspeak. There are also plenty of books around that can take you through the first few steps. After that, it's down to wasting hours in front of the computer trying to work out how the thing works.

You're going to have to do your own research if you want to get into this field, because it's an area that's changing so rapidly. Scan the latest Web and Internet magazines for news. Take a look at the home pages of video software houses (for example, www.quicktime.apple.com and www.info.apple for Quick-Time

movies); browse the Web for subjects like 'Video Plug In' and 'Video Frequently Asked Questions' (FAQs).

Once you've learnt how to design basic text-based Web pages, it is quite easy to put video footage on the Web – so long as you have the right tools. With a little practice you can produce exciting results.

Putting video stills on the Web

Putting stills on the Web is far easier than putting moving images on the Web. You need less equipment, a far less powerful computer, and less time on the phone to the server asking for help.

The equipment you will need is:

- a 386 or higher personal computer (PC), or equivalent Apple Macintosh, with at least 4 megabytes (MB) of RAM;
- a camcorder/VCR source;
- tape to grab stills from;
- a stills grabber.

There are two ways to grab stills from video. The first is to use an expensive video card that converts moving images to computer language. The second is to use a far cheaper box (for example, a Snappy, available in the United States for around $100) that grabs still images and converts those to computer language.

Remember that even still images take up a lot of memory. You must be careful about the size of the still image. You can reduce the size of the image files by using:

- smaller images;
- fewer colours (ranging from 1 to 32 bits);
- lower definition – it's possible to download a small picture, then stretch it out to double size;
- file compression – a TIFF file can be shrunk to a thousandth of its original size by compressing it as a GIF or JPEG file.

Here's how to get a video still on the Web:

1 Grab a still from a video.

2 Convert the still to a GIF (best for artwork) or JPEG (best for stills and photographs) file.
3 Incorporate the image into your HTML using the line:

4 Upload the HTML document onto your server, using File Transfer Protocol (FTP).

Putting moving images on the Web

To put video on the Web you need at least the following equipment:

- a 486 PC or higher (or Mac equivalent) with at least 8 MB RAM and 100 MB free hard disk;
- a video digitiser with audio/video connections and software to view/produce movies;
- a video source (e.g. a camcorder or VCR);
- a fast modem (at least 14.4 KBps);
- Internet-related software such as Winsock, and FTP for uploading.

Once you've got the equipment, think hard about what you're trying to achieve with your Web site, who your target audience is, and what impact you want to have. Then select the video material that you want to put onto the Web.

If you really want to put a large movie up on your site for people to download, it's best not to embed the movie directly on the page. Rather, save a grabbed still of the video, convert it to a GIF and use that image as a map to the actual movie. Or make a short clip of the movie the size of a postage stamp, with a 'download fullsize' option. Try not to put too many movies on a single page. The download times add up and this can keep users with modems waiting.

Here is the step-by-step process to getting video on the Web:

1 Negotiate space with your server to put video on (at least 5 MB).
2 Digitise the material from the VCR onto your computer hard drive.
3 Write the HTML document, including the line:
<embed src="yourmovie.mov" HEIGHT=150 WIDTH=300>
4 Load HTML onto the server using FTP.
5 Load digitised images from computer onto the server using FTP.

6 Make the Web site accessible to the people you want (the public, a select group, yourself).

Publicity

Once your Web site is up and running with still or moving video images, you must now tell everyone about it. There is no point waiting for people to 'find' your site by chance; you need to advertise.

- Register at search engines (such as Yahoo and Alta Vista).
- Mention the URL (Web address) on your leaflets, stationery, etc.
- Put announcements in appropriate Internet newsgroups.
- Regularly update your Web site, so that people can be invited to come back and find new stuff.

This all sounds quite hard, but in fact it's not. Once you've got the hang of writing HTML for the Web, the jump to stills and then moving images is not that great. Have a go, it's great fun, and have plenty of warm milky tea handy to keep you awake through the night as you fiddle with getting that still image to look 'just right' next to that perfectly aligned stylish text.

Free Speech TV

by Webmaster Joey Manley

Our materials come from a wide variety of activist and community-based organisations as well as from various independent producers. Most of the material is originally broadcast on FStv's cable operation, but we often work deals with producers to netcast new and original materials not available on television. If we netcast a producer's work, the netcast can also be made available on their own Web site with few or no technical hurdles – just some lines of HTML code. We work with Dyke TV, AIDS Community Television, People's Video Network and others under this arrangement. Every day we post at least one new programme in VDOLive and RealAudio formats.

The equipment: we have a T1 line (which runs to about $800 per month), two Windows NT servers (one dedicated to RealAudio & VDOLive, one for standard HTML and graphics), and two production machines – one Mac and one Win95. We also have two videotape decks (SVHS and 3/4'), a Marantz portable cassette player/recorder, a bizarre hookup to record phone interviews and a Mackie audio-mixing board. Frankly, we consider all this to be the minimum required to run a full-time netcasting station.

The software: RealAudio and VDOLive server software, Netscape FastTrack server, Macromedia Director Suite (including Deck II for audio editing), Adobe Premiere and Photoshop are our primary software tools. We edit all the HTML ourselves. I should note that Progressive Networks has a program to help get non-profit organisations hooked up with their software, and they have a bias toward lefties like us. You still need access to your own server, though.

The most difficult thing about running the site is getting the daily updates online, although we are working on developing a custom application to automate this process. The easiest thing has been finding good content: people are falling over themselves to give us a look at their work for consideration. Not that I'm complaining. We're always eager to see good work.

Free Speech TV runs a full-time 'netcasting station' on the World Wide Web at: www.freespeech.org

Training Video Activists

It may seem odd to include a chapter about training in a handbook about video activism. Many people will feel that training others goes beyond their skills level and that information about it is not that important. Wrong!

From a political point of view, training others to use a camcorder is probably the most important thing a video activist can do. Why? Because there is so much in society that needs video support and yet there are not nearly enough video activists around to provide it. And training does *not* require a high level of skill. Anyone, with a bit of experience, can show someone else at least how to operate a camcorder. From there it is mostly down to practice.

And there's another reason. What happens if a video activist leaves an area to go and work somewhere else? Who is going to carry on their responsibilities? The knowledge needs to be reproduced to a new generation of radical video activists. Similarly, what if a video activist can't stay in a community 24 hours a day, and something needs to be recorded but no one knows when it's going to happen? The person who will be there needs training to be able to capture the event when it does take place.

In my travels, the comment I most frequently heard from video activists was 'There aren't enough of us. There are too many people asking for my support. I can't do it all. I'm exhausted!' Almost none of these invested time in training others in how to use video, and therefore had little assistance in their work. They either didn't realise the need to train or felt unable to do it.

Figure 12.1 Camcorder training workshop

Yet training isn't that hard. All it requires is a bit of thought, some preparation, and most of all time and attention given to the trainees. This can be an informal process, where a few skills are swapped at the back of the bus on the way to an event. At other times it can be formal, with set courses run over a period of time, open to anyone interested to learn.

Some video activist groups have always placed training at the centre of their work, realising the need to decentralise the skills base. For instance, organisations like Paper Tiger in the USA, CATv in Australia and the Channel 4 Workshops in the UK have carried out training for years. These are open to the public, and generally encourage people to use video for social good in the community.

Other programmes arise out of a specific need. For example, women tend to be disproportionately under-represented in the video activist community. To help remedy this, Zoë Broughton and Mel Gunasena have run over twenty workshops for women across Europe on how to use video in their campaigns (see the profile on pp. 221–2).

Despite the need, there is surprisingly little up-to-date literature available that can support such work – hence the need for this book, and specifically this chapter.

TYPES OF VIDEO ACTIVIST TRAINING

At **under**_currents_ we have developed four different types of video activist training programmes, each geared to the needs of the group and trainer involved:

1. General media training – This would be for a group who wants to learn media skills beyond the camcorder. It might include interview training, how to write a press release, how the media works, and how to attract media to an event. It would include how camcorder work fits into a media campaign.

2. Basic camcorder training – This includes basic functions, how to improve shot material, different uses of camcorder, and development of strategy. It would be suitable for the individual who wants to use a camcorder for the first time.

3. Advanced camcorder training – This tends to be given to activists who have had some experience in using camcorders and want to learn ways to make better use of their material. It may take the form of how to edit, how to use video in court, or how to sell footage to television.

4. Training trainers – This is the sadly rare but important work of training video activists to train others.

Figure 12.2 Interview technique

ISSUES AND PROBLEMS

Equipment
You can train someone to use video with just one camcorder, a battery, a tape and a pair of headphones. Once you have shot some material, you just have to replay the footage through the viewfinder. It is basic but it works. With groups, the more camcorders you have the better. People love to get their hands on these toys, and, if you want to get them excited about using video in the future, this is the way to do it. The list of essentials would be:

- camcorders (preferably one per three people);
- TV monitor (to play material back);
- VHS video player;
- blank VHS tape for VCR;
- cables to be able to play from camcorder to video player;
- cheap camcorder tapes for practice work;
- big sheets of paper and thick pens for making group notes;
- fact sheet handouts.

Location
You can do a workshop pretty much anywhere. A covered space is good in case it rains and so that you can see the images clearly. Having access to electricity is useful for running the equipment. And it helps if you're near a busy road so that people can go out and practise interviewing strangers and learn about the problems of background noise.

Alone or in partnership?
If you are training one person, you can do it by yourself. If you are training a group of more than three, it is far better to work with another person who can share the burden of the day. It is particularly useful for outside videoing, as each person can work with a sub-group when they go out and practise using the camcorders. Working with someone is also beneficial because workshops can be stressful, and it can be valuable to have someone else there for support.

Time
Workshops can vary enormously in length. My experience ranges from training people for half an hour in the back of a bus on the way to an

action at two o'clock in the morning to running a week-long media workshop in Freiburg, Germany. A good length to aim for initially would be five to seven hours. But you'll find that there isn't enough time to train someone fully in one day. It is important to learn to prioritise the most important things you have to cover and then schedule future follow-up sessions.

Content
As I've already said, the content of a training will depend on the needs of the trainees. However, in any workshop you should at least do the following.

- Talk to the participants about their needs and their prior experience with video.
- Go through the basic functions of the camcorder.
- Go through the various different ways you can use it.
- Give people a chance to hold the equipment and practise (with feedback).
- Show them how they can practise by themselves.
- Tell them where they can get more information.

Boredom
Some people find it boring to train others how to use video. 'After doing it ten times, I had enough of it', I heard once. The trick, as with all training, is to vary each workshop according to the people who attend it (see pp. 220–1 below). But don't make assumptions about the abilities of the people you're training. I once gave a one-day workshop to some Welsh villagers. When I walked into the room I saw that their average age was 65 and thought, 'Oh no, they aren't going to get it at all!' Of course, I was completely wrong and we had a great day. By the end of the workshop everyone had had a go with the camcorders I had brought along and were very excited. The key I found was giving them plenty of time at the start to tell me about themselves and for them to design the day as they wished it to be.

Training for money
One common reason for people to start training is to bring in money. For example, they set up scheduled sessions that the non-campaigning public can attend, arguing that, although this is not focused on video activists, is does bring in much-needed cash, which can then support

more political work. Of course, an issue here is that video activists begin providing support to those with money rather than those without, and, perhaps worse, ultimately drift away from activist work. Groups have got round this by applying to foundations for a grant to cover the costs of activist video training. Another way is to get enough activists into the workshop and for them pay a small amount each to the trainer.

Know-it-alls

There is always one person in every group who thinks he or she knows more than the trainer. This can be a constant source of frustration when you're trying to win the respect of the group. I suggest that you give these people space to share their experiences, but limit their talking time. One useful tactic is to have an agenda already set up on the wall on a big piece of paper and, if someone is dominating a discussion, interrupt and explain the need to cover other issues.

Video training for community organisers

by Gloria Walker

In 1995, I worked with four women on a video called 'Immigrants shaping their image' throughout my job as trainer with CO-TV (Community Organizer Television), a programme of the Educational Video Center in New York City. When we started training in September we covered the basics of working with a camcorder, microphones and a tripod. We also looked at and analysed various videos and discussed how we cannot depend on mainstream media to tell the truth.

Because all the women came from organisations that worked with immigrants, they were acutely aware of the growing problem of immigrant-bashing that was becoming so popular with politicians. As our class project, we decided to produce a video we could use to encourage immigrants to organise and stand up for their rights, and to inform legislators and others about the tremendous economic and cultural contributions of immigrants.

We started out in Chinatown, taping an organising meeting to fight moves to destroy the rent control in New York City. I heard many moving stories and left with a new appreciation for the courage of people who had come half-way around the world to

find 'freedom' and a better life for themselves, only to find discrimination and poverty.

We taped a demonstration against police brutality, and later a teach-in held by the Center for Immigrant Rights. We interviewed people on the streets and vendors from Africa and Latin America in Harlem. As everyone became more confident with the camera, they started going out on their own to capture images of people in their communities and New York street scenes.

Using statistics and lively music from various sources, we put together a ten-minute video we felt really proud of, especially once we'd seen the effect it had on people when we had our first screening in February. It sparked a lively discussion and we could see how empowering it is for people to see positive images of themselves on a television set.

We went on to show this video in several places, including the Other America Film Festival in San Antonio, Texas. They were so delighted with it that they scheduled it to be screened eight times throughout the festival, and they organised a panel discussion around one of the screenings.

Even though it was sometimes challenging to work through a collaborative effort, we all learnt from each other. We proved that you don't need fancy equipment or years of experience to produce an effective video. All you need is determination, access to a camcorder, an external microphone and editing equipment, and some training in basic video production.

Activists who do video have a critical role to play in confronting the images of mainstream media and in helping to give a forum to the unheard voices in our communities. Training community organisers to use video is fun. Even more sublime is working with them to produce and use video as an organising tool that can make a real and significant difference in the world.

TRAINING STRATEGIES

Tailor

Each individual or group will have different needs, so you have to tailor your training accordingly. One group may be strong on shooting but won't have a clue about how to distribute footage; another may want

a workshop on how to sell footage to television; and another may want a general media strategy workshop.

Spend time preparing
Talk to individuals or groups beforehand to find out what they need most and agree an agenda together. Find and cue up any tapes that you plan to show. Invite any guests who you want to contribute.

Know your purpose
A central role for a trainer is to enable the video activist to develop media purpose and strategy: how to provide and sustain effective support to a group; what video actions are needed to do this; and as a result what skills need to be improved the most.

If the people you are working with have never used a camcorder before they are going to be excited about learning how to do this. Clearly then you are going to have to run through the basic skills of how to operate a camcorder and give them a chance to practise. But you'll also have to go through the theoretical background, outlining the benefits and problems of video activism, otherwise their camcorder will be no more than an expensive toy.

Becoming a trainer

by Melisa Gunasena

On 20 July 1994, after only one hour of camcorder training, I went off to video my first assignment: a demonstration outside Hackney Town Hall on homelessness and the right to squat. The police waded in and began to attack people, and although I was scared I jumped right in. I tried to recall what I'd been told about using a camcorder, and videoed what took place before me. Afterwards I remember stuffing the tape into my knickers and feeling that I had something incredibly precious – a record of what really happened. Seven people were arrested that day for public order offences. My footage was used by lawyers working for the defence to track down witnesses and to work out the positions of the police, and it helped to acquit some of the protesters of their charges. The experience was incredibly empowering for me.

The more you practise videoing the more you realise which shots illustrate the message you want to get across. It becomes easier to spot what will be interesting, and you can cut down dramatically on endless scenes of people standing around not doing very much. Over the next year I went out and videoed various actions, and, following on from this, a friend and I made a women's direct action and empowerment video with the help of **under**currents.

I then got into running camcorder training workshops. I was terrified that people would 'find out' that I didn't really know how to use a camera, that I'd forget to tell them something crucial, or that I'd be asked an intricate question about the inner workings of a camera, not know the answer and look a fraud. None of these things happened, and I went on to run training workshops with women's groups in Central and Eastern Europe. Language was sometimes an issue, but it's surprising how much I was able to convey with body language and hand signals.

My main aim for these workshops was for people to feel comfortable dealing with the mainstream media, and to learn how to video their own stories. Most of the women in the workshops had never been near a camcorder before and many had had bad experiences with journalists. Role-playing in a light-hearted and supportive atmosphere alleviated many of these fears. I found that the experience of videoing and being videoed demystified television and gave the participants the sense that for the first time they could control the media.

After just a few hours training, women felt confident enough to give press interviews without being drawn into negative arguments or side-tracked. Similarly, they were able to use a camcorder to document their campaigns and community work. Some of those I worked with are now making short features in their own countries on the subjects of women's health and the environment. The joy that comes with learning a new skill and passing it on to someone else is truly wonderful.

TRAINING SCHEDULES

Schedules are vital tools for video activist training. They help you structure your workshop and give participants an opportunity to input their own requirements.

In March 1996 I ran a one-day workshop for Aid Watch, a group that lobbies and campaigns on overseas aid issues in Sydney, Australia.

First I spoke with the group to find out what their needs were. They said that they had a camera, had shot lots of footage, but had not had much success in distributing the footage. They also said that only two of the members of the group knew how to use the camera and they wanted others to learn as well.

Given this information I asked a couple of experienced local video activists to talk during the workshop. Their task would be to inspire the group with success stories and to share their specific knowledge in terms of their video use.

I then made sure that the right equipment would be available (see p. 217 above). I set up the television, VCR and camcorder in a corner so that everyone could see it. I hooked the camcorder to the television monitor so that the group could see what I could see in the viewfinder as I changed the settings, and showed them techniques like zoom, pan and focus.

I then wrote the agenda up on the wall in big letters before the workshop started. Once introductions were made, we then went through the agenda.

10.00–10.30 a.m.
Introductions, go through the agenda, ask people what experience they have had with cameras.

10.30–11.00
Testimony by a video activist who sold footage to national TV. He tells a specific story that's funny as well as inspiring and shows examples of his work on the VCR. Time to ask him questions about details of how he did it.

11.30–12.00
Discussion of why shoot video. Facilitator goes through different most common options for video use, i.e. witness, campaign video and selling to TV. Opens up debate about comparative virtues of each one, in particular challenges participants about the effectiveness of working with broadcast television. Encourages group to work out their own media strategy that is suitable to their needs, and proposes that a multi-option approach may be most effective.

12.00–12.15 p.m.
Break for tea/coffee.

12.15–1.15
Run-through of basic camcorder skills. Useful to hook camcorder to television monitor to demonstrate some of the more difficult concepts, such as manual focus and white balance. Session should include:

- Basic functions (battery/tape input, turning power on and off, tape eject)
- How to hold the camera (different positions, importance of steady shots)
- Functions (exposure, focus, white balance, digital effects)
- How to record good sound (close-up/external mics, background noise)
- How to compose picture (power difference of tilts and rules of thirds)
- How to video to tell a story (ask people to tell story of your workshop)

1.15–2.00
Lunch and screenings of inspiring videos.

2.00–3.00
Participants go outside in small groups of two or three (if there are enough cameras to go round) to make their own one-minute video. They can chose their own subject so long as it has a social or environmental change component. They are limited to using a maximum of five minutes of footage, and are encouraged to think about what shots they need before they start videoing. They are also told that they should video as if they will be editing the footage later, so they should not edit 'in camera', nor do they have to video chronologically. This is to encourage them to take more care setting up shots and to think about cutaways.

3.00–4.00
Group returns to the workshop room and looks at each other's footage. They are encouraged to make comments about each other's efforts and the facilitator points out mistakes as well as successes.

4.00–4.30
Testimony by another local video activist who has distributed his own tapes by mail order and through grassroots groups. He shows examples of his footage on the VCR. This is another chance for the group

to be inspired by real success stories and to quiz someone who has actually been out there as a video activist.

4.30–5.00
The facilitator then goes through the various options for editing, ranging from basic camcorder–VCR editing to two-machine edit suites and non-linear systems. Time is spent discussing the differences between all these, and the issues of quality versus ease of access to and use of the equipment. Then the trainer shows the group the basics of editing using one of the tapes shot earlier in the day. A camcorder is hooked up to the VCR. First they log the tape, using camcorder counter and writing down on a log sheet. Next they paper edit, and finally they edit using pause and record buttons from camcorder to VCR. They are encouraged to see this as a blueprint for any kind of editing, irrespective of the quality of machine used, and to realise the importance of taking the time to prepare and think while off the equipment.

5.00–5.15
The facilitator asks for feedback on the workshop, going around to each person in turn, and invites the group to suggest future strategies. The group may decide, for example, to have a follow-up session when they can work out where to go from here. The trainer should finish by praising the quality of the group's video work that day and telling them that they can now video well enough to cover an event. The workshop is wrapped up with some fun game or activity.

Ten tips for running a successful workshop

1 Talk to activists about their needs before workshop.
2 Bring lots of camcorders.
3 Invite a local video activist to share stories.
4 Stick to the agenda and time schedule once agreed.
5 Include games.
6 Be positive.
7 Include examples of successful video.
8 Talk about strategy.
9 Give fact sheets with basic skills and tips which people can take away with them.
10 Have fun.

Resources

RECOMMENDED READING

Books

Barnouw, Erik (1983) *Documentary – A History of the Non-fiction Film*, Oxford: Oxford University Press. (A brilliant look at the history of documentaries, especially from 1890 to 1960.)

Chomsky, Noam (1991) *Necessary Illusions*, 2nd edition, London: Pluto Press. (Cutting-edge critique of mainstream media and how our minds are being controlled.)

Curran, James, and Seaton, Jean (1991) *Power Without Responsibility*, London: Routledge. (Good introduction into the politics of the mass media, particularly the rise and fall of alternative media outlets over past hundred and fifty years.)

Deep Dish Directories I and II (1986, 1988) New York: Deep Dish TV. (Describes content and process of effort at alternative network. Includes useful mailing lists.)

Directory of Film and Video Festivals 1997–98 (1996) London: British Council. (The most comprehensive Guide.)

Dowmont, Tony (ed.) (1993) *Channels of Resistance*, London: Channel 4 Books. (Companion book for Channel 4 series on alternative TV groups around the world with essays written by different media activists.)

Faber, Mindy (ed.) (1990) *A Tool, A Weapon, A Witness The New Video News Crews*, Chicago: Randolph Street Gallery. (Short essays on camcorder activism. Includes resource lists.)

Fisher, Paul, and Peak, Steve (annual) *The Guardian Media Guide*, London: Fourth Estate. (Essential annual handbook with all UK's

media contacts and much more. Most countries have an equivalent. Call your local journalist association to find it.)

Glasgow Media Group (1976) *Bad News*, London: Routledge & Kegan Paul; (1995) *News, Content, Language and Visuals*, London: Routledge. (Excellent sources for analysis of how television news is constructed.)

Herman, Edward, and Chomsky, Noam (1988) *Manufacturing Consent*, New York: Pantheon Books. (Describes how government gets its message across. There's a fantastic film of the same name made about Chomsky himself.)

Jones, Chris, and Joliffe, Genevieve (1996) *Guerrilla Film Makers Handbook*, London: Cassell. (Great book for 'becoming a TV/film professional'.)

Karwin, Thomas (ed.) (1988) *Cable Access Advocacy Handbook*, Washington: National Federation of Local Cable Programmers. (Tells how to organise for access in your community.)

McNair, Brian (1995) *News and Journalism in the UK*, London: Routledge. (A comprehensive survey of issues relating to television journalism.)

Marcus, Daniel (ed.) (1991) *Roar! – The Paper Tiger Guide to Media Activism*, New York: Paper Tiger TV Collective. (Humorous handbook from pre-eminent video activist group in US; includes how to shoot at demos, how to build your own radio transmitter and very good US resource lists. See below for Paper Tiger contact details.)

Plugging In: A Resource Guide for Media Artists (1996) New York: Media Alliance. (A useful guide to funders, festivals and screening fora.)

Shamberg, Michael (1973) *Guerrilla Television*, New York: Raindance Corporation. (Manifesto of early video activists.)

Videomaking Magazine (1996) *The Videomaker Handbook*, Newton, MA: Focal Press. (One of the best technical books around on video production.)

Worldwatch Institute (annual) *Vital Signs*, London: Earthscan. (Source of information on major global trends.)

World TV and Radio Handbook (annual) London: Watson-Guptill Publications. (Handbook with national TV and radio contacts around the world.)

Journals

Clips, c/o Videoazimut. (Quarterly magazine which is the best source of information on current trends in the international video activist

scene. See below for Videoazimut – international network of video activist organisations – contact details.)

Earth first! Action Update, PO Box 9656, London N4 4JY, UK. Tel: +44 (0)171 516 9146. Email: actionupdate@gn.apc.org. URL: www.hrc.wmin.ac.uk/campaigns/earthfirst.html. (Quarterly magazine, good source of UK environmental campaign news.)

Ethical Consumer Magazine, ECRA Publishing Ltd, 16 Nicholas Street, Manchester M1 4EJ. Tel: +44 (0)161 237 1630. Fax: +44 (0)161 228 2347. Email: ethicon@mcr1.poptel.org.uk. (Monthly magazine produced by the Ethical Consumer Research Association, promoting the use of ethical purchasing to help address issues of universal human rights, environmental sustainability and animal welfare.)

Next 5 Minutes Video Catalogue, Stichting Beheer IISG, Cruquiusweg 31, 1019 Amsterdam, Netherlands. Tel: + 31 20 668 5866. (Generated from biannual international video activist conference with contacts, essays and video listings.)

Schnews, PO Box 2600, Brighton BN2 2DX, UK. Tel: + 44 1273 685913. URL: www.cbuzz.co.uk/SchNEWS/index. (Weekly news update carrying news and views from Britain's grassroots DIY movement.)

Watching the World and *What in the World is Going On?,* Third World and Environment Broadcasting Project, c/o International Broadcasting Trust, 2 Ferdinand Place, London NW1 8EE, UK. (Regular reports that survey quantity and quality of UK television's environment and development programming.)

VIDEO ACTIVIST ORGANISATIONS

Access News. PO Box 1252, St Kilda South, Melbourne, Victoria 3182, Australia. Tel + 61 (03) 9525 3551

Adbusters. The Media Foundation, 1243 W 7th Avenue, Vancouver, British Columbia, Canada V6H 1BT. Tel: +1 604 736 9401. URL: www.adbusters.org

Artist TV Access. 992 Valencia St, San Francisco CA, USA. Tel: +415 824 3890

Cascadia Uncut. PO Box 1411, Eugene Oregon, USA. Tel: +1 541 343 7305

CATv/Cat@lyst. PO Box 42, Erskineville, Sydney NSW 2043, Australia. Tel: +61 (02) 161138

Channel 31. 247 Flinders Lane, Melbourne 3000, Australia. Tel + 61 (03) 650 5610

Channel-Zero. 507 King St, Suite 16, Toronto, Canada M5A 1M3. Tel: +1 416 868 1851. Email: zero@channel-zero.com. URL: www.channel-zero.com

Coalition For the Homeless. 'Street Watch Programme', San Francisco, USA. Tel: +1 415 346 3740

Conscious Cinema. c/o Justice?, Prior House, Tilbury Place, Brighton BN2 2GY, UK. Tel: + 44 1273 685913. Email: justice?@intermedia.co.uk

Deep Dish. 339 Lafayette St, New York NY 10012, USA. Tel: +1 212 410 9045. URL: www.deepdish.com

Endangered Species Project. Fort Mason Centre, E-205, San Francisco, CA 94123, USA. Tel: +1 415 921 3140

Film Arts Foundation. 346 Ninth St, San Francisco, CA 94103, USA. Tel: + 1 415 552 8760

Flying Focus Video Collective. 2305 NW Kearney, No 231, Portland, OR 97210, USA. Tel: +1 503 321 5051

Free Speech TV. 2010 14th St, Boulder, CO 80302, USA. Tel: +1 303 442 5693. URL: www.freespeech.org

Global Witness. PO Box 6042, London W2 3GH, UK. Tel: + 44 (0)181 563 7779

Moonshadow Media. Tel: + 1 423 949 5922. Email: mediarts@aol.com

National Federation of Local Cable Programmers. PO Box 27290, Washington, DC 20028, USA. Tel: +1 202 393 2650

News Unlimited. PO Box 42, Erskineville, Sydney, NSW 2043, Australia. Tel: +61 (02) 161138

Open Channel (Stockholm). Stadledningskontoret, 105 32 Stockholkm, Sweden. Tel: + 46 (08) 785 7327. URL: www.openchannel.org

Oxford Film and Video Makers (OVFM). The Stables, North Place, Oxford OX3 9HY, UK. Tel: +44 1865 60074

Pagan Love Cult. URL: www.om.com.au/nimbin

Paper Tiger East. 339 Lafayette St, New York, NY 10012, USA. Tel: +1 212 420 90945. URL: www.papertiger.org

Paper Tiger West. PO Box 411271, San Francisco 94141-1271, USA. Tel + 1 415 695 0931. URL: www.papertiger.org

Small World Netherlands/Stoom. Minahassastraat 1, 1094 RS Amsterdam, Netherlands. Tel: + 31 20 6938661. Email: smallworld@antenna.nl

Small World Television. PO Box 78121, Grey Lynn, Auckland D, New Zealand. Tel + 64 9 376 6060. Email: swtv@smallworld.co.nz. URL: www.smallworld.co.nz

TV Stop. Griffenfeldcape 29, 2200 KBHN, Copenhagen, Denmark. Tel: + 45 35 36 0022.

under*currents Productions*. 16b Cherwell St, Oxford OX4 1BG, UK. Tel: +44 1865 203661. Email: underc@gn.apc.org, URL: www.undercurrents.org

VideoActive. c/o Access News (above)

Videoazimut, 3680 rue Jeanne-Mance, Bureau 430, Montreal, Quebec H2X 2K5, Canada. Tel +1 514 982 6660. Email: videaz@web.net

Video Databank. 37 S Wabash, Chicago, IL 60603, USA. Tel: +1 313 899 5172

Video News. PO Box 10395, London N7 7HY, UK. Tel: +44 (0)171 700 766

Witness. c/o Lawyers Committee for Human Rights, 330 Seventh Avenue, 10th Floor, New York, NY 10001, USA. Tel: + 1 212 629 6170. Email: witness@lchr.org. URL: www.witness.org

TELEVISION STATION NEWSDESKS

National

The best way to find the contacts for television stations in your country is to look at the television listings in a national newspaper, write down all the stations' names, get their contact details from the capital city's telephone directory, then call the station to get the newsdesk's direct numbers.

Here are the contacts for the United Kingdom, United States and Australia:

United Kingdom
BBC (1 and 2)	0181 743 8000 (London)
ITN (Channel 3)	0171 833 3000 (London)
ITN (Channel 4)	0171 833 3000 (London)
ITN (Channel 5)	0171 421 7100 (London)

(Check newspaper for regional BBC and Channel 3 news stations, find contact through telephone directory.)

Australia

ABC	+61 02 995 04771 (Sydney)
SBS	+61 02 430 2828 (Sydney)
Channel 7	+61 02 877 7777 (Sydney)
Channel 9	+61 02 990 69999 (Sydney)
Channel 10	+61 02 844 1010 (Sydney)

United States

NBC	+1 818 840 4444 (Los Angeles)
CBS	+1 213 852 5000 (Los Angeles)
ABC	+1 310 557 7777 (Los Angeles)
Fox	+1 310 369 1000 (Los Angeles)
PBS	+1 212 708 3000 (New York)

Each city has its own regional affiliate, which you can find in local telephone directories or on the Internet. Try www.tvroundup.com (for all network numbers) or for individual networks: www.cbs.com, www.abc.com and www.nbc.com

International

UK bureaux

BBC World TV	+44 171 240 3456
Sky News	+44 171 705 3000
Reuters TV	+44 181 965 7733
MTV Europe	+44 171 284 7777
CNN International	+44 171 637 6800
APTV	+44 171 427 4141
WTN	+44 171 410 5200

For non-UK numbers check your capital city's telephone directory.

VIDEO ACTIVIST FESTIVALS

Amsterdam International Documentary Film Festival. Kleine-Gartmanplantsoen 10, 1017 RR Amsterdam, Netherlands. Tel: +31 20 627 3329. Fax: +31 20 638 5388. Email: idfa@xs4all.nl. (Has separate 'Silver Wolf' video award, must be made within 15 months of festival. Entry in September, held in December.)

Athens International Film and Video Festival. PO Box 388, Athens, OH 45701, USA. Tel: +1 614 593 1330. Fax: +1 614 593 1328. Email: RBRADLEY1@ohiou.edu. (General competition, run for over 24 years. Entry fee 1996 was $25. Awards given.)

Atlanta Film and Video Festival. C/o Ann Hubbell, Image Film/Video Centre, 75 Bennett St, NW Suite N-1, Atlanta, GA 30309, USA. Tel: +1 404 352 4225. Fax: +1 404 352 0173. (Showcases new independent media. Works must be completed within two years of festival. Entry fee varies. Awards given.)

Big Muddy Film and Video Festival. Department of Cinema & Photography, Mailcode 6610, Southern Illinois, University of Carbondale, Carbondale, IL 62901-6610, USA. Tel +610 453 1482. Fax +610 453 3492. (Showcases independently produced films and videos. Entry fee 1995 varied between $30 and $40. Entry in February, held in April/May. Awards given.)

British Amateur Video Awards (BAVA). What Video Publications 57–59 Rochester Place, London NW1 9JU, UK. (General home-video festival. Entry in September. Awards given.)

Canary Video Festival. C/Bravo Murillo 23, 35002 Las Palmas de Gran Canaria, Spain. Tel: +3428 371 011. Fax: +3428 364 239. (Includes documentary section, must be produced within two years of festival. Max. length 30 minutes. Entry in mid-August, held in October. Awards given.)

Edinburgh Fringe Film and Video Festival. 29 Albany St, Edinburgh, EH1 3QN, UK. Tel: +44 131 556 2044. Fax: +44 131 557 4400. (Includes documentary section. Max. 30 minutes length, produced on a low budget. Entry in January, held in April. Awards given.)

Festival International du Court Métrage de Montreal. 4205 St Denis St, Suite 326, Montreal, Quebec, H2J 2K9, Canada. Tel: +1 514 285 4515. Fax: +1 514 285 2886. (Includes video documentaries. Must be made within two years of festival. Entry in beginning December, held in April. Awards given.)

Golden Knight International Amateur Film and Video Festival. C/o Malta Amateur Cine Circle, PO Box 450, Valletta CMR 01, Malta. Tel: +356 222345 or 236173. Fax: +356 225047. (General amateur video festival, includes documentaries. Entry in mid-September, held in November. Awards given.)

Hiroshima International Amateur Film and Video Festival. C/o Chugoku Broadcasting Co., Culture Department Business Division 21–3 Motomachi, Naka-Ku, Hiroshima City 730, Japan. Tel: +81 82 222 1133. Fax: +81 82 222 1319. (Highlights 'efforts towards peace and reverence for life, a tribute to humanity or the relationship between nature and humans'. Takes place in June, odd years only, entry in February. Awards given.)

Hometown Video Festival. C/o Alliance for Community Media, 666 11th Street, Suite 806 NW, Washington DC, USA. Tel: +1 202 393 2650. Email: aliancecm@aol.com. (Celebrates outstanding contributions to community programming. Largest of its kind in US. Awards given.)

Human Rights Watch Film Festival. 485 Fifth Avenue, 3rd Flr. New York, NY 10017, USA. Tel: +1 212 972 8400. Fax: +1 212 972 0904. Email: hardinh@hrw.org. (Highlights videos with human rights theme. Entry in end of January, held in June. No awards given.)

International Okomedia Ecological Film Festival. Habsburgerstrasse 9a, D-79104 Freiburg, Germany. Tel: +49 761 52024. Fax: +49 761 555724. (Documentary festival, mainly for TV. Has been known to include non-TV documentaries. Awards given.)

International Videofest. Mediopolis Berlin e.V, Potsdamerstrasse 96, D-10785 Berlin, Germany. Tel: +49 30 262 8714. Fax: +49 30 262 8713. Email: videofest@mediopolis.de. (Covers political, social and

cultural topics. Works must be shot within two years of festival. Entry in mid-October, held in February. Awards given.)

Jug'end Video Forum. Filmforum der VHS Duisburg, Am Dellplatz 16, D-47049 Duisberg, Germany. Tel: +49 203 284 914. Fax: +49 203 284 919. (General video festival for directors under 30 years old. Max. length 30 mins. Entry in mid-April, held in September. Awards given.)

MIX: New York Lesbian and Gay Experimental Film/video Festival. 341 Lafayette St - 169, New York, NY 10012, USA. Tel: +1 212 539 1023. Fax: +1 212 475 1399. Email: mix@nyo.com. (Largest experimental film and video festival in world, with network of similar shows in other countries.)

Mons International Festival of Short Films. 106 rue des Arbalestriers, 7000 Mons, Belgium. Tel: +32 65 318 175. Fax: +32 65 313 027. (Has 'amateur' and 'independent' categories. Takes video work. Must be produced within two years of festival. Max. length 30 minutes. Entry in mid-February, held in March. Awards given.)

OSTranenie International Video Festival. OSTranenie Bauhaus Dessau, Akademie - studio EMI, Gropius Allee 38, D-06846 Dessau, Germany. Tel: +49 340 650 8313. Fax: +49 340 650 8326. (General festival including video documentaries, especially cultural issues. Max. length 20 minutes. Entry in July, held in November. Awards given.)

Tokyo Video Festival (JVC). Send entry to local JVC headquarters. For UK: Eldonwall Trading Estate, 12 Priestly Way, London, NW2 7BA. Everywhere else: Contact local JVC headquarters. (General amateur video award. Entry in June, held in December. Awards given.)

Videoazimut Video Olympiad. See video activist organisations for contact details. (Hold annual video conference/festival, each year in a different country. Award given.)

Women in Director's Chair. 3435 North Sheffield Avenue, Suite 202, Chicago, IL 60657, USA. Tel +1 312 281 4988. (International film and video festival run for over 15 years celebrating alternative realities to mainstream media as told by women.)

Glossary

aerial cable Normally, cable that connects TV to antenna on roof; can also be used to connect TV to VCR. Also known as RF cable.

AFM Audio frequency modulation. Standard sound available on camcorders.

aperture Adjustable opening of lens that is used to control how much light enters the camera. Also known as iris.

assemble editing An edit method whereby sound and picture are copied together from one tape to another, breaking the **control track** in the process. The alternative to **insert editing**.

atmos sound Background sound recorded on location. Also called 'live sound'.

autofocus A system whereby the camcorder automatically focuses the lens on a part of the picture so that it appears sharp. See **manual focus**.

AV (audiovisual) The channel on **VCR** and TV monitor that requires an external video input other than **aerial** (RF). Normally will be **phono**, **scart** or **BNC**.

backspacing An automatic function on VCRs and camcorders whereby the machine rewinds the tape when paused and then winds the tape forward the same amount when recording starts again. The exact amount is different for each machine. Also known as 'pre-roll'.

battery belt A number of batteries that are connected in parallel and can be tied around the waist, allowing for lengthy recording.

battery discharger Device that discharges batteries to prevent **memory effect**.

BetacamSP Broadcast standard tape format. Also known as BetaSP and Beta . Note that Betacam (without the 'SP') is a lower quailty format rarely used by broadcasters today.

blacking a tape The method of recording a new **control track** onto a tape to allow **insert editing.** Also smoothes out glitches on the tape.

boom A long pole on which is mounted a microphone allowing a sound operator to get the mic near to the subject.

BNC cable A cable with a bayonet socket at either end that carries high-quality video connector. Common to find on professional equipment.

browser A software programme that allows the user to search for and view data on the Web, such as Netscape.

browsing Searching for information on the **Web.** Also known as **surfing.** See also **search engine**.

burnt-in timecode Timecode numbers that appear in vision when a video tape is played back.

camcorder Generic word for a video camera that can both record and playback. Typically used to describe domestic equipment.

captions Text that appears in vision on the final edited video. Can either be motionless (stills), or move horizontally (crawls) or vertically (rolls). Also called 'titles'.

cardioid mic See **directional mic**.

CCD (charge couple device) The electromagnetic sensors inside the camcorder that convert light into electronic signals. Also known as 'chips'.

CD-ROM (compact disc read-only memory) An optical disc on which the consumer can only read, not write. CD-ROMs can carry text, still images, moving images and sound.

clip Complete section of original footage which has been selected to be included in edited video, beginning at an **in-point** and ending with an **out-point**.

clip mic A microphone that attaches on a clip to a subject. Also called 'lapel mic' and 'tie mic'

close-up A description of a shot that focuses on a small part of the subject.

composing Preparing the contents of the image and the position from which it is shot, so that it looks right.

control track A series of electronic pulses found on all tape formats that keeps the tape heads aligned. See also **assemble editing**.

conventional video-maker Someone who spends all his or her time looking through glossaries like this trying to become a 'technical video expert' and not enough time out there providing video support to campaigns.

cut An editing term meaning a stage, as in 'the first cut'. Also can mean to remove, originating from film terminology, when film frames were literally cut from a sequence. Hence also the name 'cutting room', meaning **edit suite**. See also **fine cut**, **jump cut** and **rough-cut**.

cutaway shot A shot that is part of the scene of the main action which can later be used in the editing process to link two similar shots without the **jump cut** effect.

digital audio tape (DAT) An audio tape with sound signals digitally recorded, giving more faithful sound reproduction than a conventional recording.

digital editing See **non-linear edit suites**.

digital recording A method of recording sounds or images in which the information is not stored in a continuously variable way, but in bits, as many as 30,000 per second, resulting in greater precision and therefore lower distortion.

digital video camcorders New generation of high-quality camcorders that record and play back using digital tapes. Also known as 'DVCs'.

digital video effects Digital manipulation of video sound or image, such as wipes, **tumbles**, **fades** and **dissolves**. Also known as 'DVEs'.

digitise Process of recording video and sound from tape to computer hard-drive.

directional mic A microphone that records sound in front and not to the side of or behind the mic. Also known as cardoid mic.

dissolve Image transition effect of one picture gradually disappearing as another appears.

editing Selection and recording of images, sound, **captions** and **digital video effects** from one machine to another in an order that gives them meaning. See also **assemble** and **insert editing**.

edit controller A machine that controls a tape player and a tape recorder, often with **jog shuttles** and the ability to **insert** or **assemble edit**.

edit decision list (EDL) Handwritten or computer-processed list of all editing **in-points**, **out-points**, **digital video effects**, sound edits, etc., to happen in final **on-line edit**.

edit suite Term describing either location where editing takes place or the collection of edit machines themselves.

8mm Tape format developed by Sony; also known as Video 8. See also **Hi8**.

exposure The amount of light entering the camcorder, and the function that controls this by changing the size of the lens **aperture**.

external mic A microphone that operates away from the main shell of the camcorder, connected by either a cable or by radio link.

fade/fading Image transition effect where a picture intensity or sound is increased or decreased. For example 'fade to black' means transition from full moving image to black.

fine cut The final stage of the editing process when a video is complete.

flash frame An editing error where a stray frame, usually black, is included between two clips, giving the viewer the impression of a flash.

focal length The distance from the centre of the lens to the image sensor **(CCD)**. A long focal length is called a **telephoto** and a short focal length is called **wide angle**.

focus ring Piece of circular plastic on lens which when twisted changes the focus on the camcorder.

format Type of tape used in a camcorder, including **8mm, VHS, SVHS, Hi8, U-Matic, DVC and BetacamSP**.

GIF (graphics interchange format) Graphics software used to **grab** and compress still images. Best for artwork. Alternative to **TIFF** and **JPEG**.

grab To use a computer to take a single frame from a series of moving images. Normally saved as a **TIFF, JPEG** or **GIF** file. Useful for compiling storyboards on the **Web**.

hard drive A comuter's main memory storage system.

Hi8 High-quality version of 8mm format.

home page The welcome or index page on an individual or organisation's **Web site**.

hotshoe Metal slot on some camcorders via which you can attach a microphone or video lamp. Also known as Accessory shoe.

HTML (Hypertext Markup Language) Computer syntax that allows a user to structure and design the document that forms a **Web page**. Provides labels (hypertext) for different parts of the document (such as headings) and creates **hyperlinks** to images, sounds, video, and to other Web pages. The document can then be accessed using a **browser** program.

hyperlink Link between one **Web page** and another, or from one place on the same page to another, using **hypertext**.

hypertext See **HTML**.

in-camera editing Recording images in the sequence of the final completed video with a view to showing the footage straight from the camcorder.

in-point Moment on video tape chosen for start of clip to be transferred from player to record machine in edit process, expressed as a single **timecode** or as counter numbers.

insert editing Superimposing sound or images on top of existing shots with a clean edit, a process that can be done with most **edit suites**. Allows separation of audio and video. Alternative to **assemble editing**.

Internet Global network of academic, government, military and commercial computer networks, or 'internetwork'. Had its origins in an experimental US military network started in 1969, and developed during the 1980s, as a system that could survive a nuclear holocaust. Can be accessed through **servers**, either by menu-based interfaces or by the **Web**.

jog shuttle Circular manual control on sophisticated VCRs and edit suites that allows precision viewing and editing by moving tape forward or back a frame at a time, or at speed for fast scanning.

JPEG (Joint Photographic Expert Group) Graphics software that compresses still images. Best for stills and photographs. Alternative to **TIFF** and **GIF**.

jump cut The effect of editing together two shots that are very similar in angle and content.

line in/out Socket used for **phono** and **RCA** cables.

log/log sheet A record, made while viewing original video footage, of all images, with appropriate timecodes or counter numbers noted down in sequence.

long shot A shot that is taken at a distance from an object, normally with a **wide-angle lens**.

looking space Area in shot between the front of a subject and the edge of the frame.

manual focus Ability to adjust focus by hand, rather than leaving it to the camcorder to set focus automatically. See **autofocus**.

manual sound Ability to set sound levels by hand, rather than leaving it to the camcorder to set levels automatically.

memory effect Reduction in carrying capacity of **nickel cadmium batteries** that takes place when a battery is not fully discharged after use.

mic Microphone – industry standard abbreviation.

modem Telecommunications device that connects computers to the telepone network and allows access to the **Internet** and **Web**.

narration Spoken soundtrack recorded over images where the person explaining the action is not seen in the shot. Also known as 'voice-over' or 'commentary'.

nickel cadmium batteries Popular type of battery found with camcorders. Lasts for long periods and can be recharged many times, but suffers from **memory effect**.

non-linear edit suite A computer-based edit suite that stores digital sound and images on its **hard drive** and provides instant (non-linear) access at any time.

NTSC The TV colour system set by the National Television Standards Committee, used in the USA, Canada, Japan and some countries in Latin America.

omnidirectional (or omni) mic A microphone that takes sound from all directions, including from behind the mic.

on-line edit Final stage in editing process where video is completed. Takes place after off-line edit by transferring the **edit decision list** from one suite to another.

out-point Moment on video tape chosen for the end of a clip to be transferred from player to record machine in the edit process, expressed as a single **timecode** or as counter numbers.

PAL Phase Alternate Line, the TV system used in Western Europe (except for France), Australia, India, China and most of Africa.

panning Swinging a camcorder horizontally, from left to right or right to left.

paper edit Written list of selected **clips**, ordered in the sequence that they will be used in the final video.

PCM (pulse code modulation) A high-quality audio track found on some better quality Hi8 camcorders.

phono cable Connection that carries audio or video. Commonly found at the back of domestic hi-fi equipment. Carries better quality sound and video than **RF cable.** Also known as **RCA cable.**

pre-roll See **backspacing**.

Quick-Time movie Common type of software used to store and view short clips of moving images on the **Web**.

radio mic A cordless microphone that transmits radio waves from the subject to a receiver near the camcorder. Commonly used for mobile and distance recording (e.g. people talking as they walk).

RAM (Random Access Memory) The 'short-term memory' brains of the computer which allows you to do more than one thing at any one moment.

raw footage Unedited recording. Also known as 'rushes'.

RCA cable see **phono**.

RCTC (Readable Consumer Timecode) Found on many Hi8 camcorders. There are two types: professional and domestic.

RF (radio frequency) cable See **aerial cable**.

rough-cut A middle stage of the editing process when a video's structure is fixed, most of its contents are in place, and it is viewable for feedback from an audience, but which is not yet fully polished.

scart cable A cable with rectangular square black box at end, increasingly found on VCRs, which is higher quality than **RF**. It carries separate audio and video signals. **TV** and **VCR** must use **AV** channel. Commonly has either another **scart** or a **phono cable** at the other end.

search engine A tool used to search for specific **Web sites** according to key related words.

Secam TV standard found in France, Russia and parts of Africa.

server A computer used as a store of software and data for use by other computers on a network. In particular, a computer permanently linked to the **Internet** and accessible to subscribers via menu-based interfaces or the **Web**.

sound mixer Electronic device whereby sound can be modified. For instance, volume can be increased, tone and bass changed, different levels set for the left and right channels. Can be either a stand-alone appliance or part of a computer edit suite.

sound overlay A new sound track that's laid on top of a different image, achieved through **insert editing**.

steady shot A camcorder function that stabilises the image when wobbly. This can either by through electronic or optical means; the latter is preferable as it causes less image loss.

still An image taken from from a single video frame.

storyboard A written description of the main scenes and sequences in a video structure before shooting takes place, traditionally accompanied by drawings. It can be a useful device, but more probably will be an obstacle to getting anything done, because of the effort involved and the lact of spontaneity, and is therefore normally avoided by video activists.

surfing See **browsing**.

SVHS (super VHS) Tape format that records better quality than standard **VHS**.

S-video High-quality video only connection found on both domestic and professional equipment. Also known as **Y-C**.

telephoto Camcorder function that makes an object seem closer. Also known as close-up and zoomed in. See also **focal length**.

TIFF (Tag Image File Format) Common type of computer software used to store graphic images in files known as TIFF files. Alternative to **GIF** and **JPEG**.

tilting Moving camcorder vertically, up–down or down–up.

timecode Numbers that are recorded on the video tape, with each frame having a separate number.

titles See **captions**.

tumble digital video effect used in editing to merge one clip with the next, like an acrobat flipping into a circus ring.

U-Matic $^3/_4$-inch tape format developed in the 1970s by Sony.

URL (uniform resource locator) The file address that enables a computer to find a **Web page** on the **Internet**. For example, 'http//www.channel.zero.com/index.html' gives the location of the

first page (index.html) of the Channel Zero Web site (channel.zero.com) on the Web (http//www).

VCR (video cassette recorder) Common name for any type of video equipment that can record and play back. Typically a domestic VHS recorder. Also known as 'VTR' (video tape recorder).

VHS (Video Home System) Extremely common $\frac{1}{2}$-inch tape format developed by JVC.

VHS-C A smaller version tape that records **VHS** quality signals and can be played in standard VHS equipment with an adapter.

video magazine Documentary, news and current affairs features regularly published on VHS cassette. Also known as Videozine.

video toaster Computer hardware and software package (initially a brand name, now generic) that generates digital effects and that can control editing machines using an edit decision list, yet, unlike a non-linear suite, cannot store digitised video material on the computer's **hard drive**.

VITC (Vertical Integrated Timecode) Common timecode found on most professional equipment.

VNR (video news release) A ready-for-broadcast news feature made by a non-broadcast body.

vox-pops Used to describe interviewing people at random in the streets. Comes from the Latin *vox populi*, meaning 'voice of the people'.

Web Short for World Wide Web, a system by which thousands of independent **servers** can publish information over the **Internet**. Users entering the Web can use a **browser** to access the text, graphics, moving images and sound available in various **Web sites**.

Web page A single page on the **Web** with its own **URL**, which can be viewed using a **browser**. Created using **HTML**, it commonly includes text, graphics, sound and moving images, with **hyperlinks** to other Web pages, making up a **Web site**.

Web site A place on the **Internet**, in which an individual or organisation publishes information. It consists of several **Web** pages connected together using **hyerlinks**.

white balance Function that ensures that the camcorder is set for the correct type of light source (i.e. indoor lighting, outdoor lighting).

wide angle Camcorder function that increases the angle of view to allow a greater width and height of the image to be recorded. Also known as 'zoomed out'. See also **focal length**.

wide-angle lens An adaptor added to a camcorder that widens the angle of coverage, allowing a video activist to get closer to a subject while getting more of the image recorded. Also known as a 'wide-angle converter'.

wipe Digital video effect used in editing, where a line wipes accross the end of the first clip and reveals the start of the second.

World Wide Web (WWW) See **Web**.

zoom Function that enables camcorder to get near to or far away from a subject without physically moving. This is done by varying the **focal length** of the lenses.

Index